Arab–Byzantine Coins

T0338931

Arab–Byzantine Coins

AN INTRODUCTION, WITH A CATALOGUE
OF THE DUMBARTON OAKS COLLECTION

DUMBARTON OAKS BYZANTINE COLLECTION PUBLICATIONS 12

Clive Foss

Published by Dumbarton Oaks Research Library and Collection

Distributed by Harvard University Press, 2008

© 2008 Dumbarton Oaks
Trustees for Harvard University, Washington, D.C.
All rights reserved
Printed in the United States of America

Second Printing, 2016

Library of Congress Cataloging-in-Publication Data
Foss, Clive
 Arab-Byzantine coins : an introduction, with a catalogue of the Dumbarton Oaks
collection / Clive Foss.
 p. cm. —(Dumbarton Oaks Byzantine collection publications ; no. 12)
 Includes bibliographical references.
 ISBN 978-0-88402-318-0
1. Coins, Arab—Syria. 2. Coins, Arab—Egypt. 3. Coins, Byzantine—Syria.
4. Coins, Byzantine—Egypt. 5. Coins, Arab—Catalogs. 6. Coins, Byzantine—Catalogs.
7. Dumbarton Oaks—Catalogs.
I. Title.
 CJ3876.F67 2008
 737.49569109'021—dc22
 2008019628

Series editors: Gudrun Bühl and Alice-Mary Talbot
Copyeditor: Joel Kalvesmaki
Designer: Kachergis Book Design

Cover illustrations (front and back): Bilingual bronze *miqsam* of Scythopolis,
Dumbarton Oaks acc. no. BZC.2004.21 (=cat. no. 83 in this volume)

www.doaks.org/publications

CONTENTS

Introduction vii

How to Use This Book xiii

Syria

1. Byzantine Syria, 602–14 3

2. The Persian Occupation, 610–630 9

3. The Byzantine Restoration, 629–640 13

4. The Early Caliphate, 636–660 18
 Post-Conquest Byzantine Issues 20
 The Earliest Arab–Byzantine Coins 22
 The Imitative Coinage 25
 The Derivative Coinage 30

5. The Caliphate of Mu'awiya, 660–680 38
 Late Byzantine Types 40
 Gold Issues 41
 The Bilingual Coinage 42

6. The Civil Wars, 680–692 56

7. The Caliphate of Abd al-Malik, 685–705 58
 Transitional Coins 60
 Experimental Types 64
 The Standing Caliph Coinage 66
 Anonymous Types 68
 Muhammad Type 69
 Standard Type 74
 Conspectus of Syrian Coinage by Mints 81

Egypt

8. Byzantine Egypt, 602–621 87

9. The Persian Occupation, 618–630 92

10. The Byzantine Restoration, 630–646 95

11. Egypt under the Arabs, 642–705 99

Conclusions

12. The End of the Arab–Byzantine Coinage 109

13. Conclusions 112

Catalogue

14. Catalogue of Arab–Byzantine Coins in the
 Dumbarton Oaks Collection 121

 Maps 158
 Coins from Hoards and Excavations 163

 Abbreviations 177
 Glossary of Arabic Inscriptions 179
 References 181
 Photo credits 189

INTRODUCTION

This volume aims to present "Arab–Byzantine" coinage in its numismatic and historical context. It includes a catalogue of such coins in the Dumbarton Oaks collection, most of them acquired from a private collector in 2000, together with specimens previously in the collection and a few that have been added subsequently. The idea of producing it was inspired by the Seventh Arab–Byzantine Forum, held at Dumbarton Oaks in 1999. Although the collection is not large, it is representative of a complex coinage produced in a period of transition, which saw the Umayyad caliphate replace the late Roman (or Byzantine) Empire as the dominant power in the Near East. The Arab–Byzantine coins are notable for the use of images, some taken or derived from the Byzantine coinage, others original to the new Islamic regime. Their inscriptions are in Greek, Arabic, or both; they represent an unfamiliar mélange of the Christian and Islamic, but were all produced under a state run by Arabs and professing the religion of the prophet Muhammad. They exist in a large and confusing variety and pose considerable problems, many of them awaiting solution. To understand them better, the coins will be presented here in the broad context of numismatics and the history of seventh-century Syria, Palestine, and Egypt. The discussion will encompass the entire seventh century, beginning with the last Byzantine issues of the region and concluding with the new Islamic coinage from which images were completely banished.

Arab–Byzantine coins are complicated and generally not well known. They begin with types that imitate the Byzantine and include many that have no indication of a mint; none of them bears a precise date. The series poses major problems: who issued them and where? When and why were they struck? Such questions have been under serious investigation only for the last fifty years; this is a new field, compared with Classical or Islamic numismatics. These coins long tended to fall into a limbo between the Byzantine and the Islamic, especially because most of them are small, unattractive, badly struck, and difficult to understand. As a result, relatively few have been

included in major collections, and then often grouped under a category like "barbarous imitations."

Serious study of Arab–Byzantine coins began with the British Museum catalogue of John Walker published in 1956. He listed around 200 coins, classifying them according to the Byzantine prototype from which their types were derived. Although this method is not now considered appropriate, Walker at least made many varieties available for serious study. Michael Bates of the American Numismatic Society put the field on a scientific basis in 1976 by subjecting one series, the issues of Damascus, to a close analysis (further developed in his studies of 1986 and 1989; publication details for all works mentioned here will be found in the bibliography). He concluded that the great majority of Arab–Byzantine types were issued in a relatively short time at the end of the seventh century. Bates's work stirred much discussion, but its chronological conclusions find little following today. In 1985, the Israeli numismatist Shraga Qedar published an influential article that proposed a new classification based on type and mint, and suggested that the coins were produced over a long period, from the Arab conquest of 640 down to the reform of the coinage at the end of the seventh century. Cécile Morrisson of the Cabinet des Médailles in Paris summarized the state of the question in 1992, independently reaching conclusions similar to Qedar's. Meanwhile, Tony Goodwin had begun his pathbreaking work that focused on a series whose difficulty and general lack of appeal had kept it from being studied—the types that imitate the Byzantine coinage of Constans II (642–668). In a series of articles (notably 1993a), he identified and classified different types and put the study of this important coinage on a new basis. His work includes the second catalogue that embraces the entire series, published in 2002 in the sylloge of the Ashmolean Museum, Oxford (*SICA,* reviewed in Foss 2003a). This not only provides careful description and full illustration of 227 coins but discusses all the problems associated with them in a comprehensive introduction. Equally valuable is his 2005 catalogue of the Khalili collection *Arab–Byzantine Coins,* which presents a clear survey of known types and detailed analysis of specific mints. Goodwin is one of several English numismatists whose work on these coins is ensuring rapid progress. Among them, the prolific Andrew Oddy has produced a survey of the whole series with a comprehensive bibliography, an essential work of reference (Oddy 2004b).

Ever since the catalogue of Walker, these coins have been called "Arab–Byzantine," meaning coins struck by Arabs and employing Byzantine types; the parallel coinage of Iraq and Iran, which uses Persian images, is correspondingly known as "Arab–Sassanian." Strictly speaking, the coinage discussed here was struck by or under Mus-

lim authorities (not quite the same as Arabs, since some of them were Christians, while others never left the Arabian peninsula). All the coins employ images—unlike the later, more characteristically "Islamic" issues—but those of the last series are not Byzantine at all, except insofar as they portray the standing figure of a ruler. It might be more accurate to call this whole series "transitional coinage of Syria and Egypt under early Islamic rule," "Byzantine–Muslim transitional coinage," or something similar, but the term "Arab–Byzantine" is convenient and rooted in the literature. It will be used here to designate the entire coinage of greater Syria (including Palestine and Transjordan—the Arabic *bilad al-Sham*) and Egypt from the Muslim conquest of the 640s until the abolition of images at the end of the seventh century.

The Arab–Byzantine coinage falls into a few clear divisions: coins that imitate Byzantine prototypes more or less carefully; types that have mintmarks and inscriptions in Greek and/or Arabic, but still feature the image of an emperor; and those that show an Arab figure, with or without the name of the caliph, and inscriptions in Arabic. These are here called "Imitative coins" (those that follow the originals closely, or try to), "Derivative" (those that develop new types or significant variations, but still use the standing figure on the obverse and the large denominational sign M on the reverse); "Bilingual" types (those that introduce mintmarks and are inscribed in Greek, Arabic, or both); and "Standing Caliph" coins (Arabic inscriptions only). The first two categories together are commonly called "Pseudo-Byzantine," while an alternative terminology employs the rather cumbersome and ambiguous "Umayyad Imperial Image" for the Bilingual coins. "Proto-Umayyad" is also used to describe this series.

The most difficult problem posed by these coins has been the lack of fixed points, chronological or geographical. Between the Arab conquest completed in the 640s and the reign of Abd al-Malik (685–705), there is no coin that offers clear internal evidence for dating, and except for the Bilingual and Standing Caliph coinage, none bears a mintmark. In other words, all the Imitative and Derivative coins are floating in time and space, while the Bilingual issues, though associated with known mints, are not securely dated. Consequently, for many of these coins the minting authority is unknown, and for even more the reasons and circumstances of their production is not clear. All this is now changing thanks to the innovative studies of Henri Pottier and his colleagues (2008), a major example of the rapid progress this field is making. Their revolutionary but convincing ideas will provide a new basis for the study of this coinage. By examining, weighing, and measuring over two thousand Pseudo-Byzantine coins, they have concluded that the most reliable criterion for dating is their weight, which—at first sight astonishingly—seems to conform to the ever-

declining standard of the official Byzantine issues. Since those coins were being imported into Syria in substantial quantities through the 650s, the types that imitated them were struck at the same weight standard. By these means, Pottier and his colleagues have determined that the types imitating the Byzantine issues of Cyprus are the earliest, beginning as soon as most of the region had fallen under Arab control, and produced probably from 638 to 643. They also postulate that the majority of the Imitative and Derivative coins were issued by about 660, with some types continuing until the introduction of the Bilingual coinage around 670. In other words, they support the "long chronology" first advocated by Qedar, maintaining that coinage was constantly being produced in this region through the seventh century. Their chronology, though still being developed, will be followed here. Many problems of classification remain, however, especially because it is not yet possible to determine where, why, or by whom these coins were struck.

The Standing Caliph coins are the least problematic, because most of them bear the name of the caliph Abd al-Malik—they were therefore official issues of an established state—and almost all of them have mintmarks. This series shows a close correspondence between the coinage and the Umayyad administrative system. In Syria, the administration was organized around militarized provinces called *junds*. There were originally four: Damascus, in southern Syria; Homs in the north; Jordan (al-Urdunn) in the center; and Palestine (Filastin) in the south. Later sources give enough details of these districts and their capitals and main cities to show that this coinage is organized along the same lines—that is, it reflects an administrative system explicitly attested only a century later (discussed in convincing detail in Bone 2000). Coins and literary sources here form a neat complement. Likewise, the Bilingual series exhibits the same structure, enabling it also to fit into known historical circumstances. These two series, then, lend themselves to easy classification, but the rest leave many questions to be answered.

This volume aims to present the series in the broad perspective of numismatics and history. It will survey the entire coinage of seventh-century Syria and Egypt, to show what preceded and influenced these issues, and what finally replaced their complex variety. Therefore the first part includes some strictly Byzantine coins in the Dumbarton Oaks Collection, to form part of the background of this series. For the Imitative and Derivative (Pseudo-Byzantine) series, it will discuss types that have been identified and studied whether or not they are represented in the Dumbarton Oaks collection, though without claiming to include every one that has been discovered. The chronology of Pottier et al. will be followed wherever possible. This survey will put the coin-

age into the context of a continuous historical narrative. Presentation of the coins and the history form the first part of the volume. The catalogue that follows describes and illustrates every coin in the Dumbarton Oaks collection, arranging them according to the categories discussed above, with the Egyptian issues following the Syrian, and the reformed coinage without images presented last. Since the material is complicated, the introductory chapters (1–7) on the Syrian coins are followed by a table that gives a synoptic view of the mints and the various types of coins they struck.

During the long time this work has been in production, it has received much help and incurred many obligations. My first thanks are to Shraga Qedar, who introduced me to these coins and stimulated my interest in them. I am especially grateful to Cécile Morrisson, who encouraged and helped the project at every stage. Michael Metcalf, Tony Goodwin, Alan Walmsley, and two anonymous readers read the manuscript at various stages and offered important improvements. Peter Lampinen donated the coin that appears on p. 6, while Gabriela Bijovsky, Stefan Heidemann, Brooks Levy, Henri Pottier, and Wolfgang and Ingrid Schulze shared unpublished or inaccessible information and willingly answered frequent questions. My sincere thanks to all.

HOW TO USE THIS BOOK

The first, and longest, part of this volume, chapters 1–13, provides an introduction to the complex coinage of seventh-century Syria and Egypt in the context of the history of the period. Every major type is presented, discussed, and illustrated, whether or not the coins are in the Dumbarton Oaks collection. Sample entries will illustrate the system employed here:

CAT. NO. 35.

OBV.: Standing imperial figure, ΔAMACKOC (often blundered)

REV.: M, ♉ above, ✳ below; دمشق وفيه جاز هذا *dimashq wafiya jāza hadhā*, "Damascus; this is legal; full weight"

Walker 1956, 12–17, *SICA* 564

On some obverses, the figure is portrayed not wearing the usual long robe, but with a shorter garment belted at the waist and flaring out below; the same type occurs on the pseudo-Damascus type with falcon on the figure's wrist (see below). The symbol on the reverse appears in various forms, while the star is often replaced by an upside-down crescent. The Arabic legend is usually blundered.

REF.: Goodwin 1998, Treadwell 2000, 11f.
FINDS: Jerash (1), Lachish hoard (7); Capernaum

Here, the "cat. no." indicates that the coin is in the DO collection, and may be found described in the catalogue that forms the second part of this book.

"Obv." and "Rev." describe the obverse and reverse types and legends. Note that this is the description of a normal example with complete legends; the coins illustrated may vary slightly in details or by having missing or blundered inscriptions.

"Walker," *"SICA,"* and *"DOC"* lists other published examples, with reference to

standard catalogues where the same type is described and usually illustrated. In the case of *SICA*, the number is the number of the coin in the catalogue; numbers preceded by "p." refer to introductory material. Similarly, *DOC* references without other indication indicate the number of the coin as listed under the emperor who struck it; those preceded by "*DOC* 2.1" refer to pages of discussion.

A discussion of varieties follows.

Finds indicates where the coins have been found, referring to the tables of Coins from Hoards and Excavations (pp. 163–75 below). Unless otherwise noted, the coins are from excavations. Note that the findspots are listed alphabetically within regions; semicolons separate the regions (ordered Syria, Israel, Jordan, Cyprus). In this case Capernaum is in Israel, Jerash in Jordan, while the Lachish coins will be found in the list of hoards. Random finds or coins in collections will not be included there, though the text will occasionally allude to them.

General discussions of the type often follow, with specialized or detailed treatment indicated by *Ref.,* denoting items in the References. References for the historical sections will not normally be given, since this work is primarily concerned with numismatics; only specific points subject to recent discussion will be noted. The history is largely based on the following sources (all in the References): Theophanes, Palmer 1993, Baladhuri, and Tabari, with much derived from modern works such as Butler 1978, Gil 1992, Hitti 1951, Hoyland 1997, Humphreys 2006, Petry 1998, Robinson 2005, Sijpesteijn 2007, and Stratos 1968–1980.

In some cases, the *Finds* entry is more complicated:

Later issues of Constans II, as well as coins of Constantine IV (668–85), struck in Constantinople or Syracuse, also appear in the Levant, where they apparently circulated in relatively small quantities.

FINDS: *late Constans II*: Antioch 653–55 (21), 660–68 (5), Apamea (7), Dehes (6), Epiphania 4 (3: 655–57, 1 K 659/60), Hama hoard 651–58 (30), Harran, Qalat Siman 650–68 (4), Raqqa; Bethany (SCL), Caesarea (3: 646–52, 655–57, 666–68), Capernaum (651/52, 655/56), Jerusalem (2), Khirbet Fattir, Khirbet Kerak; Jerash (6), Mount Nebo (K, 655/56)

Constantine IV: Dehes (SCL), Epiphania (SCL); Caesarea (KRT: 674–81); Jerash (2: CP, SCL)

In this case, there are coins of the K (20-nummus) denomination found at Epiphania and Mount Nebo, and several coins not struck in Constantinople. These are noted (here and in the table of excavation coins) by their mintmarks: SCL = Syracuse, KRT = Carthage, and where necessary CP = Constantinople.

Syria

BYZANTINE SYRIA, 602–614

At the beginning of the seventh century Syria was, as it had long been under the Romans, a rich and populous province in an extremely strategic location. A network of large cities surrounded by innumerable villages, in a region astride the main routes between the Mediterranean and the East, reflected a prosperity that had only recently been shaken. An unparalleled series of disasters struck the greatest city of the Roman Oriens, Antioch, during the sixth century. Fire, earthquakes, devastation in war, plague, and famine had left the city a shadow of its former self, but it still remained the capital and economic center of the region. Likewise, another metropolis of northern Syria, Apamea, had been captured and destroyed by the Persians in 573. Despite efforts at clearing and rebuilding, it never recovered its past glory. Though these cities were in decline, the neighboring countryside continued to flourish in peace, with a stable population still capable of adding to its already rich store of elegant stone buildings. Such troubles seem to have afflicted only parts of the north, while districts in the south, along with Palestine, continued their normal lives, with substantial Christianized Roman cities surrounded by villages.

All parts of the region provide clear evidence that they were on a money economy and that coinage circulated freely and in substantial quantities. The excavations of Antioch revealed some two thousand five hundred coins of the sixth century, while comparable quantities are found in urban and village sites. Excavations and individual finds show that coinage played an important role at every level and in every region.

This peaceful situation came to a brutal end after the murder of the emperor Maurice and the accession of the usurper Focas in 602. The Persian king Chosroes soon mounted a massive attack on the Roman Empire, ostensibly to avenge his friend and

former patron Maurice. Operations began on two fronts, in Armenia and Mesopotamia. Resistance from the heavily fortified frontier cities was fierce, but the most important of them had all fallen by the time Focas's reign was brought to an end: Dara, the bulwark of the Mesopotamian frontier, in 604; Theodosiopolis, the bastion of western Armenia, in 607; and Edessa, the greatest Roman city beyond the Euphrates, in 609. In August 610, Persian forces crossed the Euphrates; all Armenia and Mesopotamia were lost and Syria was under direct threat.

But by now the regime of Focas was severely shaken. In 608, violence erupted in Antioch, involving the rival factions of sports fans, and Christians against Jews. The rioting was so severe that the patriarch of the city was murdered. Imperial forces brought in to restore order reacted with extreme brutality through the whole region, further alienating the population. No sooner had the situation been restored than the regime was faced with a new and more serious threat.

Early in 608, Heraclius, the governor of Africa, revolted against Focas, appointing his son Heraclius and his nephew Nicetas to lead the campaign. Nicetas proceeded overland to Egypt, where Alexandria fell to him the same year. Focas responded by sending Bonosus, who had suppressed the revolt in Antioch, but, despite initial successes, he was defeated by the end of 609. The rebels then moved on to Syria, where they set up a mint and struck coins from the port of Alexandria ad Issum (Alexandretta). Meanwhile, Heraclius led his fleet to Cyprus, which became his base for the winter of 609/10. From there, he proceeded to Constantinople, where he was crowned emperor on 5 October 610.

Heraclius had defeated Focas, but not the Persians. Three days after he became emperor, Antioch fell to the invaders. Apamea succumbed a week later, then Emesa, the main city of central Syria, in 611. Although Nicetas gained a victory that held up the Persian advance, Damascus fell in 613. An attempt of Heraclius to make a stand near Antioch failed the same year, and in 614 the Persians entered Jerusalem. This was a real disaster for the empire and for Christendom, and a tremendous blow to the prestige of both, for the Persians massacred the population, inflicted severe damage on the holy city, and carried off the True Cross, on which Christ had been crucified. After a short period of consolidation, the Persians advanced on Egypt, where Alexandria fell in 619; they occupied the rest of the province during the next two years. The Roman Empire seemed doomed; the Persian triumph in the Near East appeared complete.

Antioch, normally the sole mint in the diocese of Oriens, was one of the most important in the empire. It supplied a vast district stretching from the Taurus Mountains to the Gulf of Aqaba, producing great quantities of base metal coinage throughout late

antiquity (and gold through the early fifth century). It struck continuously until the last year of Focas, 609/10, after which the city fell to the Persians. Archaeological evidence indicates that the minor coinage of Antioch circulated widely in northern Syria, especially in the immediate vicinity of the city, but that coins from the mint of Constantinople predominated in other parts of the region. Coins of Nicomedia also formed an important part of the circulating medium, while those of Cyzicus and Thessalonica appear less frequently. Until the mid-sixth century, the four copper denominations circulated in comparable if varying proportions at Antioch, but the smallest, E (5 nummi), virtually ceased to be minted after the reign of Justin II (565–578). Large quantities of 5-nummus pieces of Justinian, however, continued to provide small change.

REF.: Coin circulation: Noeske 2000, 1:154, 210–65 (especially 225–28), and 284–91; Waagé 1952, 182

Under Focas, Antioch (under the new name Theoupolis) issued copper coins in three denominations: the large M (40 nummus; also called the *follis*), the XX (20), and the X (10). In other reigns, the Greek numbers K (20), I (10), and E (5) are normally employed. The late sixth- and early seventh-century coinage of Antioch exhibits one striking peculiarity. Although the quality of its workmanship was comparable to that of the other imperial mints, or even of a higher standard, the obverse legends of Maurice and Focas are usually garbled. This is not the case elsewhere. No explanation has been offered.

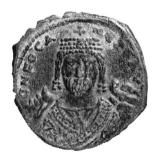
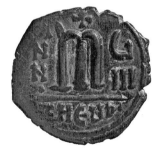

OBV.: � FOCA l., NEPEAV r., facing bust in consular robes

REV.: M, cross above; ANNO l., ЧIIII r., ƵHEUP in exergue

DOC 90, *MIB* 84 (*DOC* 90.1 illustrated here)

This is a typical example, struck in the last year the mint was in operation, 609/10. The coinage of years 1–7 has the standing figures of Focas and Leontia on the obverse, while coins of year 8 bear only the emperor's bust. Types of the XX (20 nummi) and X (10) are similar.

REF.: *DOC* 2.1:186–91

The major entrepôt Caesarea in Palestine, the most important port between Antioch and Alexandria, found a different solution for a shortage of small change. Excavations there have produced large numbers of extremely small cast copper coins of an Egyptian type:

OBV.: Head facing r., no inscription

REV.: I + B; ΛΛ⁊ in ex.

Dumbarton Oaks, BZC.2006.30

This tiny cast coin, 10 mm in diameter and weighing 0.33 g, is of a type commonly found in the Caesarea excavations. They were apparently issued in the mid-sixth century and later to compensate for a lack of small change in a city where comparably small coins, the *minimi* of the fifth century, had been in current use. They probably replaced the smallest denominations, especially the 1-nummus, last struck in the reign of Justinian. Since they are found primarily at Caesarea, they would appear to be local productions. The finds and evidence of a hoard (Hahn 1980) confirm the dating. These coins represent another local phenomenon: Caesarea had a wide network of maritime connections that brought quantities of coin from Carthage and especially Alexandria, whose 12-nummi with blundered inscriptions attributed to Focas are very commonly found in excavations. These Alexandrian coins are also found in the interior of Palestine at Jerusalem and Scythopolis. They are extremely rare, however, at Antioch, where only two were found among 2540 Byzantine copper coins.

REF.: Bijovsky (forthcoming); Ariel 1986; Evans 2006, 195f.; Waagé 1952, 182

Coinage of the Civil War (608–610)

During the revolt that deposed Focas, the rebels struck coins in the joint names of their nominal leader, Heraclius the elder, and his son Heraclius, who ultimately succeeded him to the throne. An extensive series in gold, silver, and copper was issued at Carthage, their original base, in 608–10; at Alexandria, the most important city they captured (gold, struck in 608–10, and undated copper); in Cyprus, their naval base for the assault on Constantinople (copper, struck in 610); and at one mint in Syria.

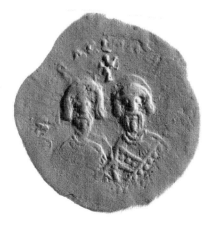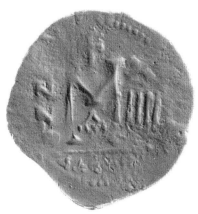

OBV.: ƆⴹⲚⲈRACLIOCONSULII, busts of the two Heraclii wearing consular robes, with the younger in the place of honor, the left. Cross between heads.

REV.: M, + above, A below; ANNO I., XIIII r., AΛⲈⵌANΔ in exergue.

DOC 15–17, *MIB* 16a (*DOC* 16 illustrated here)

This type also appeared as a half follis, with the denomination mark K (20) on the reverse (*MIB* 17). These coins bear anomalous titles, dates, and mintmarks. The Heraclii are called consuls, even though neither had held that office; this has been interpreted as a fiction, to give them an authoritative title before the younger became emperor. Normally, the date indicates the regnal year of the emperor; in this case, that is impossible. Instead, dating evidently is by indiction, that is, the year in the fifteen-year cycle of taxation. These coins were issued in years 13 and 14, corresponding to 609/10 and 610/11. The mintmark is unparalleled, and at first sight might suggest Alexandria in Egypt, where the rebels struck coins. Normally, though, the abbreviation for that city is AΛEΞ; besides, Egypt used its own idiosyncratic system of denominations, divisible by three, of which the largest in common use was the 12-nummus piece. (A unique example of this Egyptian revolt coinage has recently been published: see below, 90.) The homonymous city in Syria, Alexandria ad Issum, now called Iskenderun, has therefore been convincingly suggested as their place of minting. In that case, the coins provide valuable supplementary evidence for the revolt, identifying a new base used during its last stages and even after its success.

A variety struck in 610/11 shows both figures crowned, reflecting the actual accession of Heraclius: *DOC* 17, *MIB* 16b.

REF.: *DOC* 2.1:40

War against the Persians (610–630)

The year 613 was fateful for the Byzantines: Damascus fell and the emperor's forces were defeated near Antioch. Imperial resistance continued in Palestine but the capital, Caesarea, was soon taken and Jerusalem threatened. After an initial attempt to reach a compromise where the holy city would voluntarily admit a Persian garrison, an internal revolt removed all hopes of accommodation, and the Persians moved on the attack. The city fell in May 614 after a siege of twenty days; the victorious Persian forces massacred a large part of the population. The following exceedingly rare type evidently bears witness to these events, struck perhaps as a military issue when Jerusalem still had hopes of holding out as an imperial base or, in one view, issued as emergency money during the actual siege, where the inscription "Jesus Christ conquers" would be seen as a hopeful or defiant expression. It was issued in the fourth year of Heraclius, which began in October 613, and therefore could have been struck for only a few months.

OBV.: DℸhERACL PPAVG, facing consular bust

REV.: M, + above, ANNO I., II/II r., in ex., IEPOCO ´

MIB X27

Dumbarton Oaks, BZC.2001.5

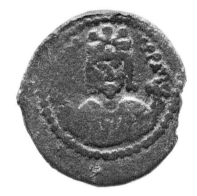 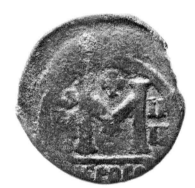

VARIETY: As above, but XC NIKA in ex.

MIB X28

Both types were struck from the same obverse die, whose increasing wear indicates that the variety followed the main type. Gold coins of this period assigned to Jerusalem are of doubtful attribution.

REF.: Bendall 2003, 313

THE PERSIAN OCCUPATION, 610–630

Persian rule lasted some twenty years in northern Syria, more than fifteen in Palestine, and ten or less in Egypt. During that time the Persians, whose unparalleled victories had virtually restored the empire of the ancient Achaemenids, ruled the conquered territories in a systematic and organized manner. They were not simply raiders or looters, or enemies determined to destroy what they found, but formed an administration concerned with maintaining good relations with the local populations and ensuring the regular collection of the revenues. Although surviving evidence is scattered and fragmentary, it presents a coherent picture of these decades. The new regime was concerned with civil and ecclesiastical affairs, as well as the military. Obviously, it brought in sufficient force to garrison strategic centers and maintain the appearance of power; the Persian cavalry became a prominent feature in the local scene.

Yet the society went on functioning without great change or disturbance. The Persians maintained considerable continuity by keeping the existing ruling elites in their place—whether the dominant rich families of the city or the chiefs of villages. The same officials collected the same taxes, for there was no reason to disturb a system that worked, nor time to impose anything different. When the Arabs later occupied this region, they followed much the same policy. In church affairs, the Persians encountered a population that mostly followed the monophysite interpretation of Christian doctrine, a heresy in the eyes of Constantinople, one that had poisoned relations between the central government and the population of Syria and Egypt. By favoring the monophysites, the new regime did much to conciliate the locals. As a result, the years of occupation seem to have been relatively peaceful—after a few initial atrocities like the massacres in Jerusalem—and remained so until the last years, when the Persians

tried to extract as much as possible from the region to maintain the war effort. Normal trade and business appear to have flourished.

This stable situation reached an unexpected end, far sooner than anyone might have anticipated. Beginning in 623, Heraclius embarked on a series of campaigns in eastern Asia Minor and the Caucasus that eventually struck deep into the heart of the Persian Empire. Late in 627, Byzantine forces descended into Mesopotamia, where they won a major victory near Nineveh. Heraclius led them farther south, capturing and destroying the Persian royal residence at Dastagerd, then retreating back into the mountains. In February 628, Persian disaffection with the war and its enormous expenses led to a coup that deposed and killed Chosroes. The new government of Kavad II immediately entered into peace negotiations and agreed to restore most of the occupied territories. Orders were sent to the great general Shahrbaraz, who had led the conquering armies and was still powerfully based in Syria and Egypt. He refused to cooperate until he and Heraclius actually met at Arabissus in eastern Asia Minor in July 629. Shahrbaraz agreed to evacuate the Roman provinces, and Heraclius promised to support his attempt to seize the Persian throne. Both plans were successfully executed: the last Persian forces left in 630, and Shahrbaraz took over supreme power in April of that year, though only lasting 40 days until his assassination continued the process of chaos and dissolution that fatally weakened Persia.

During their occupation, the Persians maintained a functioning and even prosperous economy in the conquered territories, with few major changes to the monetary system. Byzantine gold continued to circulate and taxes were calculated in *nomismata*, which were used in most large transactions. The Persians themselves, though, used silver rather than gold coins. Silver Persian *miliaresia* seem to have been brought in, perhaps primarily for use by the occupying forces. They appear occasionally in excavations in Syria and Palestine, and may be considered as representing this period. Some, of course, could be the product of the Umayyad period, when silver flowed into Damascus from the East, but those coins are often clipped to reduce their weight to a new standard (Heidemann 1997).

For a while, at least, Byzantine minor coinage also continued to circulate, as three important Syrian hoards reveal. They were found near Baalbek ("Coelesyria" hoard), at Tell Bisa (10 km north of Homs), and at an unspecified location ("Syria" hoard). The latest coins are from the end of the Persian occupation and the beginning of the Byzantine restoration, 629–31. All three hoards show a similar distribution, with numerous coins of Heraclius, of the issues of 610–16. Thereafter, the quantity diminishes sharply, suggesting that Byzantine copper coins were abundant when the Persians entered the region, and continued to arrive in quantity during the first few years of the occupation,

but dropped off notably as the war continued. An unpublished contemporary hoard from Malha south of Jerusalem confirms this picture. Its 136 coins included 35 of Heraclius, of which 24 were of his first three years, 3 of the year 20, and 8 bearing his countermark, indicating that the hoard was buried at the time of the invasions. The Syrian hoards can attest to continuing commercial exchanges across the frontiers of the two warring states, which perhaps did not reach very far south.

REF.: *miliaresia*: Foss 2003c, 161; finds of Persian drachms: Palestine: Sears and Ariel 2000, Syria: Nègre 1984, 1 (Apamea), Bellinger 1938, 496 (Jerash), Blanke et al. 2007, 368 (Jerash; plated); Stacey 2004 (Tiberias); hoards: Leuthold 1952, Bates 1968, Metcalf 1975, with discussion of Pottier 2004, 89–94; Malha hoard: *DOC* 2.1:56 and Arnold Spaer, personal communication

The Persian regime issued folles, closely resembling the Byzantine, in a complex series that has only recently been identified and classified. They seem to have been produced in relatively small quantities, perhaps not altogether compensating for the diminishing entry of Byzantine coin into the region.

CAT. NO. 1.

OBV.: ON I., ΓΑΛΙΝCΤΟ r., two standing figures, evidently Heraclius and Heraclius Constantine.

REV.: M, + above, B below; ANN I., XIII r., OCNKO in exergue

Pottier 2004, 52.6

This coin, typical of the series, has a clear Byzantine prototype: it derives from a follis struck from 613 to 616, that is, when the Persians were already in control of greater Syria. The peculiar obverse indicates that the coin being copied was itself overstruck on an earlier piece. Copying such a prototype confirms that issues of Heraclius were still circulating in the occupied territories when the present coin was struck in 622/23.

At first sight, the series seems chaotic, with obverses drawn seemingly at random from types of Justin II, Maurice, Focas, and Heraclius. Although the denomination mark M or Ⅲ always features prominently on the reverse, mintmarks, like the obverse legends, are garbled, appearing as many versions (some retrograde) of THEUP, CON, and NIKO, reflecting the mints (Theoupolis = Antioch, Constantinople, Nicomedia) that produced most of the locally circulating Byzantine medium.

Yet two consistent elements show that this was indeed an organized series. The dates form a continuous sequence from 1–21, representing the actual years of the occupation (or conceivably the regnal years of Heraclius, for Persian control of Syria began in the first year of his reign). The largest production is of the years 12–14 (621–24), when the occupation was most stable, followed by 8 and 9 (617/18 and 618/19). Likewise, the letters under the M seem to represent real *officinae* or workshops, for their number (which in a given year varies from one to five) corresponds to the actual volume of coinage as determined by analysis of the surviving specimens. Furthermore, most of the series is linked by use of common dies, indicating that the coins form part of a coherent whole. So far, 67 obverse and 119 reverse dies have been identified, suitable for a relatively small coinage, comparable to the emergency issue of Heraclius struck in Isauria during the war.

These coins maintain a consistent standard of weight, slightly lighter than the Byzantine issues through 616, but considerably heavier than later folles of Heraclius. Coins of one year are invariably of the same weight, yet again confirming that this is an organized series, issued by an authority capable of maintaining a high standard.

Coins of the years 1–3 that copy types of Focas stand apart. These well-engraved pieces with comprehensible legends are so close to the regular issues of Focas at Antioch that they seem to indicate a high degree of continuity. Perhaps the same mint workers were still being employed by the Persians, though whether or not at Antioch has not been established.

After the year 3, the standard of engraving is lower, though still comparable to contemporary Byzantine issues. Since these coins have been found in excavations and hoards from northern Syria—two at Apamea and three in the Tell Bisa hoard—it seems likely that they were struck somewhere in the region, perhaps at Emesa. There was only one example among the extensive finds of Antioch. Note that the Malha hoard contained no coins of 614–29, nor any of the Persian types, perhaps suggesting that coin circulation was limited in Palestine during the Persian occupation, and that the Persian folles did not circulate there. In any case, these coins all use well-known Byzantine types to produce a coinage that would have been familiar to the local user, and that evidently helped to fulfill a real need during the years of occupation. To some extent, small change may also have been supplemented by coins struck by the Persian regime in Alexandria, to judge by three examples found in Palestine—inland from Gaza, in the Negev, and near Lake Tiberias.

REF.: Pottier 2004

FINDS: Apamea (Napoleone-Lemaire and Balty 1969, 14); Tell Bisa (Pottier 2004, p. 91); Egyptian issues: Lachish (Metcalf 1964, 51), Nessana, and Kafr Harib (Goodwin 2005b, 3, 24)

THE BYZANTINE RESTORATION, 629–640

As a result of his meeting with Heraclius in June 629, the Persian general Shahrbaraz began to evacuate the Roman provinces of the East and agreed to return the True Cross. The emperor proceeded to Syrian Hierapolis on the Euphrates, where he received the sacred object, solemnly restoring it to Jerusalem on 21 March 630. A few months later, after Shahrbaraz had seized the Persian throne and been murdered, the weak successor regime, plagued by internal discord, agreed to return the Roman territories in Mesopotamia. With that, Roman rule was restored in all the lost provinces. A great victory, it seemed, had been achieved.

The Byzantine restoration was incredibly short-lived, thanks to events in a region that had been of little consequence to the great powers of antiquity. During the great war between the Romans and Persia, in 622 the prophet Muhammad emigrated with his followers from his native Mecca to the city of Medina, where he established a community that united the population under the aegis of a new monotheistic religion. By the time he died ten years later, most of Arabia had come under his control. A potentially great force, never before so organized, now faced the settled powers of the fertile crescent, offering a threat from a totally unexpected and largely undefended direction. The first probing Arab raids, which began already in the lifetime of the Prophet, entered a rich and relatively defenseless country. In 634, Arab forces penetrated into Palestine and won significant victories near Gaza and east of the Dead Sea. Another Arab victory in the Jordan valley in the next year left all Palestine open to invasion, with the major cities surrendering one after another as they saw their hopes of rescue fading. Syria was next: Damascus fell after a long siege late in 635, and at the decisive battle of the Yarmuk River in August 636, the imperial forces suffered a fatal and

final defeat. Syria was soon evacuated as Antioch and Qinnasrin, the main imperial bases on the north, were taken in 636–37. Heavily-fortified Jerusalem held out until early 638, when the patriarch finally surrendered it to the caliph Umar, who received the city in person. The last major imperial stronghold, the provincial capital Caesarea, which could be supplied by sea, was finally taken by the new governor Muʿawiya in October 640 (or early in 641) after a long siege. That left the offshore island of Aradus, three miles from Antaradus (Tartus), as the only remaining Byzantine outpost. Since Aradus could serve as a base for imperial harassment or potential reoccupation of the Syrian coast, and was in the way of Muʿawiyaʾs ambitious plans to advance against Cyprus and ultimately Constantinople, he attacked it in 649. Although this attempt failed, his return with a larger force the following year persuaded the inhabitants to surrender. With that, all Syria was permanently lost, as was Mesopotamia, which Arab armies had entered in 639. For most of Syria, the Byzantine reoccupation had lasted less than seven years.

Because of the short period involved, and the almost constant crises of reorganization and then defense, coinage of this period is limited. Hoards, where Byzantine issues of the period are generally scarce, indicate that the empire was not able to reestablish regular coin circulation (Noeske 2000, 1:261). The mint of Antioch was not reopened, nor were regular issues struck anywhere in the region. Those coins that did reach Syria came from Constantinople, where the long war had drastically affected the economy. The weight of the follis was constantly reduced from ¹⁄₂₄ of a Roman pound (the standard through 616) to ¹⁄₃₆ in 624, ¹⁄₄₈ the next year and finally ¹⁄₆₀ in 631 (despite a short-lived attempt to return to the original standard in 629–31). Consequently, the main copper coin in circulation in this period would have been the much smaller and lighter follis of the last years of Heraclius.

Enigmatic folles dated 634–36 appear to be a product of these last years of Byzantine control and resistance. There are two types, with some minor varieties:

OBV.: Heraclius in military dress and Heraclius Constantine in chlamys standing, к between heads; no legend

REV.: M, monogram, apparently ₨ above, A below, ANN I., XЧ or XXЧI r.; NЄA in ex.

MIB X24

The second type (*MIB* X23) has N (or E) below the M on the reverse, and CON in the exergue.

A 20-nummus (K) piece appears to belong to the same series, though its details are obscure.

These coins are apparently regular Byzantine issues of Heraclius, struck in 634–36 at a place called Neapolis. Since they are occasionally found in Cyprus where a town of that name existed, a mint there is a possibility, but the Cypriot coins struck only a few years earlier bear the mintmark ΚΥΠΡ. The balance of probability suggests these coins were struck at Neapolis in Palestine (Nablus). Two examples of the NEA type, year 25, bear a Heraclian countermark applied in 633–36 (class 1, type 2: see below), which confirms the date of issue. A coin of the CON type is countermarked with the letter Ɛ (see below). The CON issue was perhaps the first, with the die engravers using the "officina" mark N as the mintmark, then later employing the fuller NEA. If the attributions are correct, this would be a wartime issue during the Arab attacks, comparable to the coinage of Isauria and Seleucia struck by Heraclius during the Persian wars. Neapolis could then be considered a base of Byzantine resistance. Since the historical record of these events is so sketchy or unreliable, these coins, together with the Cyprus issues, can provide a welcome contribution to understanding the last years of Byzantine rule in Palestine.

REF.: Donald 1986, 1987, De Roever 1991, Schulze, Schulze, and Liemenstoll 2006, 126, 172 (countermarks)

Countermarked coins formed an important part of the circulating media during the last years of Byzantine rule. Monograms that appear to represent the names of Heraclius and Constantine were struck on earlier coins. There are three main classes:

(1) ⚭ resolved as HER (type 1) or, in a simpler version, HR (type 2) ⚭. This class is common.

(2) ⚭ resolved as HPAKΛIOY. Rare.

(3) ⚭ probably to be resolved as KωN[C]T. Uncommon, often applied together with class 2 (and so constituting class 4).

Class 1 was applied to coins of various denominations from Justin I through Heraclius; class 2 to folles (M) of Heraclius; class 3 most often to half folles (K) of Heraclius; and class 4 to the large reformed Heraclian folles first issued in 629/30. The countermarks normally consist of a monogram in a circle, on the reverse of the coin. Detailed study indicates that they were applied in Syria or Palestine. The purpose of these countermarks is under discussion: a recent plausible theory associates them with the need for currency for the army, suggesting that they validated earlier coins for military use.

The countermarks have been dated to the last years of Byzantine rule: class 1 to 633–36, and class 2 to 633–40. They were probably produced in Palestine, quite likely in Caesarea, where numerous examples of class 1 have been found or excavated.

OBV.: On l., Heraclius standing in military dress holding long cross; on r., Heraclius Constantine wearing chlamys and holding globus cruciger; + between heads; no inscription

REV.: M, + and C above, Δ below; ANNO l., XX r., CON in ex. Two countermarks, ₤ l. partly obliterated, ₤ r.

DOC 314

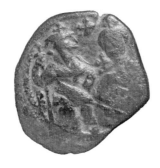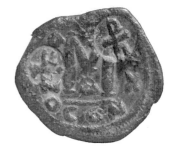

CAT. NO. 2.

OBV.: On l., Heraclius standing in military dress holding long cross; on r., Heraclius Constantine wearing chlamys and holding globus cruciger; + between heads; no inscription

REV.: K, + above, XX r., Γ below; on lower l., countermark of class 3

Class 3 (and with it, 4) is more problematic. Presuming (as seems overwhelmingly likely) that it is an imperial monogram, it necessarily refers to an emperor named Constantine. There were two in this period: Heraclius Constantine, long co-regent with his father and ruler in his own name for about three months at the beginning of 641, and Constans II (officially named Constantine), who came to the throne at the end of 641 or beginning of 642. Either seems possible, though the balance of probability favors Heraclius Constantine, since the monogram that appears on the coins and countermarks of Constans is of a different form. In either case, the question arises of where the countermark was applied. If Heraclius Constantine, possibly Caesarea. The accepted date for the fall of that city is late 640, but one source at least (Baladhuri 219) gives early 641 as an alternative, in which case Caesarea was still under the control of Heraclius Constantine. Constans II, on the other hand, ruled no part of Syria other than the heavily fortified offshore island of Aradus. If the countermark is his, it could be associat-

ed with naval activity to defend the last outpost, to face the growing power of the Arab fleet, or to attempt to regain parts of the Syrian coast. Note in this context that coins with the class 3 monogram have not been discovered at Caesarea. The question remains open, but there need be no doubt that this monogram is associated with the last Byzantine attempts to maintain a foothold in Syria.

REF.: Schulze and Goodwin 2005, Schulze, Schulze, and Liemenstoll 2006; Caesarea: Bijovsky (forthcoming), Evans 2006, 16f., 23f.

Other countermarks, consisting of individual Greek letters (as on the coin of Neapolis above), also occur on post-reform Umayyad types. They may have been applied in the early eighth century.

REF.: Schulze and Goodwin 2005, 54–56

Coins struck in Cyprus in 626–29, immediately prior to the Byzantine reoccupation, are relevant to this region because they are often found in the Levant, more frequently than in Cyprus itself (three were uncovered in the Antioch excavations). It is likely that they represent a military issue, and may indicate that an army was formed in Cyprus preparatory to recovering the eastern provinces. They consist of two main series, the first round and well struck, the second roughly struck on oval flans and almost certainly part of a series of imitations produced in Syria; the latter will be discussed in the following section. The evidence of finds and imitations suggests that this coinage was transported from Cyprus to the Levant, where it came to have considerable influence. Such a move would be most easily explained by the transfer of troops for the reoccupation.

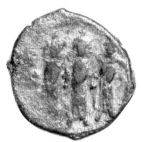 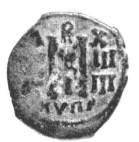

OBV.: Heraclius, Heraclius Constantine, and Martina standing facing; no legend

REV.: M, + above, Γ below; ANNO/XЧIIII; in ex., KVΠP

DOC 185bis

These coins were struck in regnal years 17, 18, and 19. In some varieties the mint-mark is followed by a crescent.

REF.: *DOC* 184, 195, Goodwin 2004a, Callot 2004, 73f.
FINDS: Antioch (3), Resafa (?); Salamis (2)

CHAPTER 4

THE EARLY CALIPHATE, 636–660

The Arab conquest was accomplished by several armies, operating separately under their own commanders, who received the submission of the local cities. Once the conquest of this vast and populous region was accomplished, a regular regime had to be constituted to keep it under control and to ensure continuity of revenue. For that, the caliph Umar came to Syria in 638, establishing his base at Jabiya, east of the Sea of Galilee, once headquarters of Rome's allies the Ghassanid Arabs in the sixth century, and the mustering point for Arab forces before the battle of the Yarmuk which took place nearby. According to tradition, Umar organized the new administration at Jabiya, establishing the principle that the central government should collect the taxes from the subject (non-Muslim) population and use them to pay the Arab fighters, who constituted a ruling military elite. He divided the conquered territories into four large provinces, called junds ("armies," for this was a military regime): Damascus, Homs, Jordan (al-Urdunn), and Palestine (Filastin); these long remained the kernel of the administrative system, with governors appointed directly by the caliph. For Syria as a whole, Umar named Yazid ibn Abi Sufyan, who had commanded one of the conquering armies. Administration at the local level was generally left to the authorities who had been in power under the Romans, often with the same urban and rural elites predominating. The Arabs were settled in military encampments, of which the most important was Jabiya. It was here that the Arab troops received their pay; it was functionally the regional capital. Other major camps were at Homs, Emmaus outside Jerusalem, Tiberias, and Lydda.

When the governor Yazid succumbed to a devastating plague in 639, Umar appointed in his place Yazid's brother Muʻawiya, who was to be the dominating figure in Syria for the next 40 years. Whether his initial appointment was over one or more provinces or the whole of Syria is uncertain, but he was certainly in control of all Syria

by 646. By that time, he had effectively completed the conquest of the region by taking the heavily defended seaport of Caesarea in 641 (though the offshore island of Aradus held out until 650).

The period of Mu'awiya's governorship is renowned for the advances he made against the Byzantine Empire. Astonishingly for an Arab whose whole career had been on land, he devoted considerable attention to the coastal regions, and to building a navy. His efforts were soon rewarded. Not long after the conquest of Tripolis, in the early 640s, Mu'awiya settled Jews and Persians there and made it a base for regular naval operations against Byzantium. In 649, he rebuilt the seaports of Tyre and Acre and used them to launch a successful attack on Cyprus. On the approach of the Byzantine fleet, however, he withdrew, stopping on the way to make an unsuccessful attempt to subdue the fortified island of Aradus. The next year, Mu'awiya moved again, this time with greater success: he subdued Aradus, evacuating its population, and descended on Cyprus, whose inhabitants agreed to pay him tribute. All this moved the emperor Constans II to send an embassy to the governor—whose authority was evidently considerable—and to conclude a truce. In 653, though, Mu'awiya attacked Crete, Cos, and Rhodes, where he established a garrison. This was preliminary to his most ambitious effort, in 654, when he had a huge fleet built in Alexandria and other coastal cities and assembled an army from all parts of the Islamic domain. His goal was Constantinople, which his forces actually reached, but they had to withdraw when the fleet was destroyed by a storm. The next year, 655, the emperor Constans II in person led a massive counterattack, only to see his fleet come to grief off the coast of Asia Minor. This overwhelming defeat shattered Byzantine naval supremacy, but Mu'awiya could not follow up on this victory because the assassination of his cousin, the caliph Uthman, embroiled him in a long civil war. He was obliged to make a treaty with the Byzantines in 659, agreeing to pay a tribute that supposedly amounted to 1000 nomismata, a slave, and a horse every day.

All this activity—launching armies and building fleets—implies a high degree of sophisticated organization, but the internal affairs and mechanics of rule in Mu'awiya's Syria are poorly known. This appears to have been a time when Arab tribal leaders, now settled in the region, established considerable dominance. But at the local level, the prevailing Roman systems were maintained, for the Arabs had not yet developed means of their own for administering a country that presented far more complex problems than their homeland. Consequently, the coinage, if it can be interpreted, could become a major source for understanding the history of these decades.

During this whole period and the next—through the reign of Mu'awiya and until the great coinage reform of Abd al-Malik (beginning in 696), Byzantine gold continued

to enter Syria and to circulate there. At that time, the local authorities issued very little gold and practically no silver. Excavations as well as casual finds reveal another striking and surprising phenomenon about coin circulation in these years: that a mass of regular Byzantine copper was reaching Syria after the conquest and was widely circulated. Most common are issues of Constans II, who came to the throne only in 641, after the conquest had been completed. Recently studied hoards from the regions of Hama and Aleppo allow the picture to be refined. They show clearly that numerous folles of Constans II (struck on the reduced standard of the last years of Heraclius) reached Syria from 641 to 658. By far most common are the first four types of Constans, issued 641–48; coins later than 658 rarely appear. Since the quantities seem too large to have arrived by regular or casual trade, their presence has been explained as part of a deliberate policy of the Byzantine government, perhaps with a propagandistic aim. Although this explanation seems far-fetched, neither the reason nor the mechanism by which these coins came to form a large part of the circulating media in Syria has yet been explained.

REF.: Morrisson 1972, Bijovsky 2002 (gold); Phillips and Goodwin 1997, Schulze 2007 (copper); O'Sullivan 2004 (events of 649–55); Theophanes 347 (tribute)

Post-Conquest Byzantine Issues

OBV.: Constans II standing facing, beardless, wearing chlamys and crown with cross; he holds a globe with cross (globus cruciger) in his left hand and a long cross in his right; inscribed ЄN TꙊTO NIKA ("In this [i.e., the cross], conquer"; the slogan that accompanied Constantine the Great's miraculous vision of a celestial cross)

REV.: large ℳ, cross above; ANA on l., NЄOS r. (*ananeosis,* "renewal"); below, combinations of letters and Roman numerals representing the date and mint workshop (these coins were all struck in Constantinople)

DOC 59–60, *MIB* 162 (*DOC* 60d illustrated here)

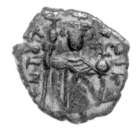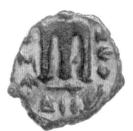

This type, a regular Byzantine issue, was struck 641–43 and 644–48. A major variety (*DOC* 61, *MIB* 163), struck 642/43, has OΦA left of the Ⲙ, ANA above and NEO r. It also was widely imitated.

FINDS (both types): Antioch (48), Apamea (15), Assur (2), Dehes (20), Epiphania (30?), Hama hoard (144), Qalat Siman (4), Tell Rifaat (3); Balis, Raqqa (7), Resafa (4); Bethany (3), Capernaum (2), Emmaus (2: M, K), Hammat Gader, Jerusalem (6?), Khirbet Kerak, Lachish hoard (2), Samaria, Scythopolis (3), Tel Jezreel (2); Amman (2), Jerash (26 + 1 K), Pella (3)

Another type of Constans II, struck only in 643/44, deserves attention since it has been found in large quantities in Cyprus and somewhat less frequently in Syria. It has been associated with the increased importance of Cyprus as a military base after the loss of Egypt in 642. Its appearance in Syria may be associated with the Byzantine raids on that coast:

OBV.: Crowned facing bust, IⲘⲠEP COⲚCT

REV.: M, Γ below; ANA l., III r.; NEO in ex.

DOC (Heraclonas) 5, *MIB* 166

BZC.2000.4.18

REF.: Phillips and Goodwin 1997, 79f., D. M. Metcalf 2003, 31

FINDS: Antioch (overstruck on Cyprus), Apamea, Assur, Hama hoard (17), Resafa; Bethlehem, Caesarea, Shiloh; Jerash; Salamis (59)

Later issues of Constans II, as well as coins of Constantine IV (668–85), struck in Constantinople or Syracuse, also appear in the Levant, where they apparently circulated in relatively small quantities.

FINDS: *late Constans II*: Antioch 653–55 (21), 660–68 (5), Apamea (7), Dehes (6), Epiphania 4 (3: 655–57, 1 K 659/60), Hama hoard 651–58 (30), Harran, Qalat Siman 650–68 (4), Raqqa; Bethany (SCL), Caesarea (3: 646–52, 655–57, 666–68), Capernaum (651/52, 655/56), Jerusalem (2), Khirbet Fattir, Khirbet Kerak; Jerash (6), Mount Nebo (K, 655/56)

Constantine IV: Dehes (SCL), Epiphania (SCL); Caesarea (KRT: 674–81); Jerash (2: CP, SCL)

The Earliest Arab–Byzantine Coins, 638–647

While the great majority of coins in circulation in Syria in the decades after the Arab conquest imitated the widely circulating issues of Constans II, some follow types of Heraclius. The analyses of Pottier and his colleagues allow some of these to be assigned fairly precise dates, and indicate that they are the first coins produced under the new regime.

Cyprus Imitations (638–ca. 645)

OBV.: Three imperial figures standing facing wearing chlamys and crown with cross, holding long crosses in r. hand; no legend

REV.: M, Γ below; ANNO/XЧII; KYΠP in ex.

MIB X45, X46

DOC 184a.3 illustrated here

OBV.: Three imperial figures wearing the chlamys standing facing, holding globus crucigers in r. hand

REV.: M, Γ below; [ANNO]/[X]ЧII; CΠP in ex.

DOC 184a.2 illustrated here

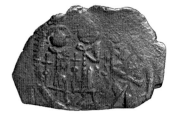
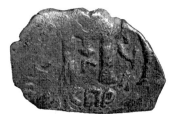

FINDS: Hama hoard (6), Syria 2 hoard (30); Antioch (2?), Apamea (3), Dehes (5?), Resafa; Bethlehem (2?), Nessana; Salamis

These coins form two main series. The first (top) is well executed on round flans, but often has garbled legends. Examples are commonly found in Syria, rarely in Cyprus. This is evidently an Imitative coinage, struck a few years after its prototypes, but probably not much beyond the mid-640s.

The second series (bottom) is far more complicated. It exists in at least nine ma-

jor types, showing one, two, or three standing figures or a bust, derived from coins of Focas, Heraclius, and Constans II. They are all fairly crude imitations of the original type. Those that imitate the type of Focas and Leontia, incidentally, appear to be the only Arab–Byzantine coins that actually attempt to copy an imperial inscription.

These coins exhibit a peculiar technique of production that identifies them as a coherent group and probably the product of a single mint or workshop. In each case, the flans were manufactured by cutting old folles in half and removing the angular corners to form an elliptical flan. The coins were struck at such a low temperature that the undertype often shows through. These techniques are peculiar to this series.

The great majority of these coins imitate types of Heraclius, with a few deriving from early issues of Constans II, with facing bust, of 643/44. Consistency of manufacture suggests that all were the product of a single mint, operating some time after the Arab conquest, as indicated by their copying of types of Constans II. The date of the prototype does not necessarily date the copies; their fabricators appear to have used promiscuously whatever material was at hand, much like the coins of the Persian occupation. Unlike the Persian issues, however, these coins do not employ a dating system of their own: the officina letters and dates they bear are evidently meaningless. Their extensive copying of issues of Heraclius and their rare imitation of types of Constans II suggest a relatively early date for many of them. Many are overstruck on coins of Heraclius, none on Constans II. Countermarks provide further evidence. Two published Cyprus imitation coins bear class 2 (Heraclius) and class 3 (KωNT) countermarks, applied between 633 and 640, during the years of the Arab invasions. Four other examples found in hoards in Cyprus bear countermarks of class 7, 𐌣, which was employed from about 660 to 673, showing that they were in circulation by this time. Furthermore, two of the three-figure coins have been described as overstruck with types of Constans II issued in 655–57, indicating that these types, at least, were produced by that date.

The detailed analyses of Pottier and his colleagues, based on the metrological study of 203 coins, conclude that the weight of these coins corresponds with a Byzantine standard, and that the most probable date of the great majority of them was 638–43, with a reduced production continuing for another couple of years. They are therefore the earliest identifiable Arab–Byzantine coins, issued during the last years of the conquest and the beginning of an established regime under the governorship of Muʿawiya. The bust types, because of their lighter weight, have been dated to 645–47. An apparent example in the collection, no. 24, may belong here because of its peculiar flan, but it anomalously has the bust positioned along the long rather than the short axis of the obverse, and is overstruck on another Arab–Byzantine type.

This was a very large coinage, employing at least 200 obverse dies. The coins were probably struck in Syria: that is the provenance of the published group, and examples have been excavated at Apamea and Dehes, both in the north of the country. A few pieces, though, have also been found in Cyprus, where they were countermarked, presumably to validate what may have appeared to be an irregular coinage. These could have been brought by the Arabs who frequently invaded and eventually settled in the island.

In any case, these coins form an important link between the Heraclian issues of Cyprus, which have often been found in Syria, and two types of the Bilingual series. The coins of Tiberias employ this three-figure obverse, while those of Damascus bear the frozen and meaningless date ХЧII. The Cyprus imitations may be considered as a major coinage in the early years of the Arab dominion of Syria.

REF.: Goodwin 2004a, Pottier et al. (2008); countermarks: Schulze and Goodwin 2005, 25, 27, 32

Two-Figure Obverse: 642–646

CAT. NO. 5.

OBV.: Two standing figures, cross between heads; l. figure with beard, in military dress, holds long cross; r. figure holds globus cruciger; monogram (?) or blundered Arabic inscription in r. field.

REV.: M, cross above, Γ below; ΛΝΝΟ l., monogram, apparently a reversed Christogram, r., ИVK in exergue

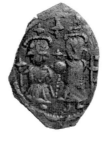

The "mintmark" is evidently a reversed **KYZ** for Cyzicus. These are part of an extensive series with several varieties, which imitate a type of Heraclius issued 630–40. One reverse bears a cursive **𝗠**, indicating that it derives from an early issue of Constans II. The metrological analyses of Pottier et al. indicate the probable date for this series.

REF.: Goodwin 1993b, Pottier et al. (2008)
FINDS: Hammath Tiberias (?)

Bust Type: 645–647

CAT. NO. 7.

OBV.: Bust of Constans II type (as on issue of 643/44), holding large cross in right hand, flanked by star (left) and crescent (right); in r. field below crescent: S

REV.: M with cross above, A below; ANA on l., AX on r., CON in exergue

Other examples show the more normal globe with cross on the obverse. The coin in the collection, no. 7, weighs only 2.47 g, far below the normal standard of this type, perhaps indicating that it is an imitation or that the coins were struck over a long period.

This type was struck from at least ten obverse dies. Consistency of type and execution suggests the work of a mint, which, to judge by limited evidence of provenance, may have been in northern Syria. Use of the star and crescent and portrayal of the bust might suggest a connection with Homs, where this type later became predominant. Metrology has suggested the date for this series.

REF.: Foss 2001, no. 6, Goodwin 2001b, Pottier et al. (2008)

The Imitative Coinage (647–ca. 670)

The most important part of the post-conquest coinage—very common though less often represented in public collections because most examples are unattractive and poorly struck—is a vast and complex series of imitations. Some copy the original Byzantine types closely; others deviate considerably, to the point of forming new types altogether. These may be termed respectively Imitative and Derivative coinages, recognizing that there will be some types that occupy a borderline between the two. A useful criterion is treatment of the obverse legend: the Imitative types try to reproduce it, or parts of it, while it is normally absent from the Derivative types. Reverse legends, however garbled, appear on both classes, though often absent or seriously transformed on the Derivative. Many Derivative types have their own (usually unexplained) legends, normally in Greek, though a few employ Arabic. In addition,

Imitative types have identifiable prototypes, with obverse and reverse both deriving from the same original, while the Derivative employ new variations of type or combine obverses and reverses that did not originally go together.

Tony Goodwin, who wrote the pioneering study of these coins, divided them into four classes: passable imitations; crude imitations with vestigial legends; free adaptations of good Byzantine style; and free adaptations with new stylistic components. The first three would correspond with what I call Imitative, the fourth with Derivative. Like many scholars, he now calls the whole series Pseudo-Byzantine. Most of the Imitative coins copy the early issues of Constans II, with the standing figure of the emperor, but types as early as Heraclius or as late as Constantine IV (668–685) can be the prototypes. Almost never, though, do they try to reproduce the names or titles of the emperors.

The Imitative coinage comes in a great and bewildering variety, ranging from close copies well struck on round flans, to poorly struck pieces on oddly shaped pieces of copper. The latter look like the products of a village blacksmith. They seem to have been struck in very large quantities with few types exactly alike. Much work of classification remains to be done.

For the moment, the places where the Imitative coins were produced have not been identified, but serious progress has been made in dating them. It had been assumed that they were struck as the supply of imported coin dwindled after 658; in that case they might belong to the following period. On the other hand, there seems no reason why they could not be contemporary with the coins they imitate, with their production beginning soon after the Arab conquest. Metrological analysis now suggests that weight is the prime means of dating, and that these coins were issued according to the prevailing standard of Constantinople. Since the Byzantine issues were growing ever smaller and lighter during the reign of Constans II, it appears that these coins, too, can be arranged by their weight. Study based on over 1000 specimens divides the imitations with the standing figure of the emperor on the obverse into two major groups, a heavier, with a standard around 3.6 grams, and a lighter around 2.6 grams. The former comprises issues of 647–58, the latter 658–64. Some types continued being produced until around 670, when the reformed Bilingual coinage began. In the discussion that follows, types that have been assigned dates will be indicated, with suggestions for others according to the weight of published specimens. Since the metrological studies have only begun, no attempt will be made here to arrange the Imitative and Derivative (Pseudo-Byzantine) coins in a strict sequence, but only to indicate the range of types.

These coins are commonly found in Syria and Palestine; whether they were the

products of official mints or some sort of local initiative has not been determined. The poor quality and great variety, especially of the less careful types, would seem to support the latter. Extensive die studies, publication of excavation coins, and—ideally— new hoards would be needed before such questions can be resolved.

REF.: Goodwin 1993a (pioneering work), 1995, *SICA* pp. 77–80, Pottier et al. (2008)

Close Imitations

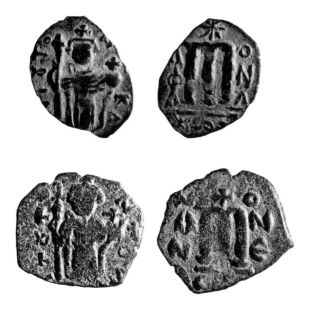

CAT. NO. 8.

OBV.: Standing imperial figure of Constans II type, with cross on crown, holding long cross in r. hand, globus cruciger in l. (henceforth, "standing imperial figure"), [ЄN] TⰟTO NIKA

REV.: ⲘⲘ, star above; l.: AФA, r.: ONΔ; illegible inscription in ex.

CAT. NO. 10.

OBV.: Standing imperial figure, TⰟT N TO

REV.: ⲘⲘ, cross above; l.: NAN, r.: ONЄ; C below

Poor Imitations

 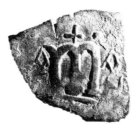

CAT. NO. 19.

OBV.: Crude standing imperial figure, with long cross on globe; no legend

REV.: ⲘⲘ, cross above, l.: A, r.: AN

Struck on a triangular flan

CAT. NO. 20.

OBV.: Crude standing imperial figure with large head; garbled Greek inscription

REV.: Ⓜ, crude Greek letters around, of which HΛEO can be read on r.

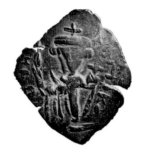
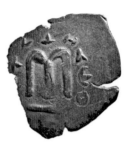

The ΛEO of the reverse inscription, which appears to be a deformation of the final letters of the original ANANEO, is of real interest, for it somehow migrated to the obverse of an important series, the Bilingual coins of Damascus, where it became the characteristic, and so far enigmatic, inscription.

REF.: Foss 2001, no. 4

FINDS: Of close or poor imitations: Antioch (16), Apamea (13), Çatal Hüyük (4), Dehes (9), Qalat Siman, Epiphania (1?), Hama hoard (65), Balis (2), Harran, Raqqa; Bethany (2), Bethlehem (9 + 1 late type), Caesarea (4), Gezer, Hammat Gader (3), Hammath Tiberias (2), Horbat Nashe (square flan), Jericho, Jerusalem (5?), Khirbet Fattir (3), Lachish hoard (17), Nessana (4), Neve Ur (3), Samaria (4), Scythopolis (8?), Shiloh (2), Tel Jezreel (2), Tiberias (2); Irbid hoard (6), Jerash (12), Pella (2); Salamis (23).

Imitations of Heraclius types: Antioch (3)

Although the Imitative coins generally consist of closely related types, connections between them have proved hard to establish because of the immense variety of style, quality and technique. Some distinctive types, however, represented by several or many examples, can be considered as products of mints whose identity has not yet been established.

"ΛΙΤΟΙЄ" Type

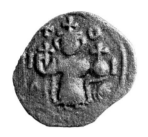
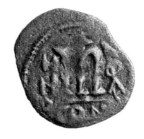

OBV.: Standing imperial figure, various fragmentary or blundered legends, some reading ΛΙΤΟΙЄ, with a prominent Є under the globus cruciger.

REV.: ℳ, + above, often flanked by letters or symbols: o, ⌣, or a crescent; a large variety of inscriptions, some containing the letters AX.

The symbols by the cross on the reverse resemble those used by the mint of Emesa in the Bilingual coinage and have plausibly suggested that these coins are early issues of that mint, before the more standardized series was produced. If so, they would be the only group of Imitative coins that could be assigned to a mint. The varying weights of this group suggest that they were struck over a long period.

REF.: Oddy 2003

"Lazy B" Type

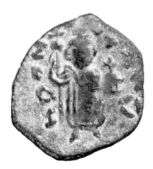
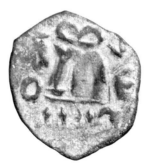

OBV.: Standing imperial figure; vestigial legend

REV.: ℳ, AO l., NЄΛ r., IIII below; above "lazy B" ∽

Several varieties, with NO or OA l. of M, or the full legend ANA NЄO flanking the M.

These are generally of good style, as well struck as the Byzantine originals. They form an extensive series, with about ten obverse and reverse dies. Die linking and the peculiar symbol above the M, like a letter B on its side, indicates that they are the product of one mint. Their provenance is unknown. The light weight of this series would suggest a date of ca. 658–64.

REF.: Goodwin 1995

The Derivative Coinage

Many of the Imitative coins were apparently struck in the period of the early caliphate, during the first twenty years of Arab rule, though some were evidently issued in later years. The Derivative types, however, are more difficult to date. They may have been contemporary with the Imitative, representing simply local variants or less careful attempts to copy the originals; they may have been the product of the following period, or of both periods. It seems possible that the more coherent independent types, which make consistent use of some novel image or device, represent a time of increasing organization after what appears to have been a period of considerable local economic variation or independence. Consequently, they are presented separately here, beginning with types that are closest to the Byzantine. Some of these are not represented in the Dumbarton Oaks collection.

Datable Type: "Year 20" Reverse

OBV.: Facing bust, beardless or with long beard; blundered legend

REV.: M, + above, A or Δ below; ИИ l., XX r; ƆИO in exergue

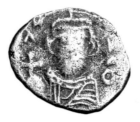

The beardless type is known in about twenty examples, all from the same obverse die. Die links show that this is part of the same coinage as the type with long beard, of which twenty examples have been recorded. Although the weights vary considerably, the die axes are similar, confirming attribution to a single mint. The prototypes are mixed, with obverses derived from Constans II and the reverse from Heraclius. Most examples come from Beirut, indicating a Syrian origin. Their weight standard has suggested a date of 658–60.

REF.: Mansfield 1992, Pottier et al. (2008)

Undated

Single Military Figure

OBV.: Standing figure in military dress, l. hand on hip, r. holding long cross; unidentified object, probably a blundered monogram l. Some have fragmentary legend.

REV.: Μ, + above, officina letter below, AN l., KK or blundered legend r.; one example has officina A, XX on r.

FINDS: Hama hoard

This has no clear Byzantine prototype; the obverse figure may derive from one of the two figures on the folles of Heraclius struck 630–40.

REF.: Goodwin 1993b

"Lazy S"

CAT. NO. 27.

OBV.: Usual standing imperial figure, except that the cross on the staff has been transformed into something like a trident. NA l., ЄN r.

REV.: ₥, pellets within, ANA l., ΔNЄ r., o ᔉ o below.

This type offers many varieties, but they all have in common the peculiar S, the final letter of the inscription ANANЄOS, written on its side in the exergue. On the present example, the reverse inscription seems to have migrated, in a garbled form, to the obverse; others have no inscription at all or just a couple of letters. Normally, these coins show crosses in the customary places, obverse and reverse; this one is unusual in that the crosses on the obverse (the reverse detail is missing) have been transformed, like those on the de-Christianized types below. The reverses of this type characteristically lack dates or officina letters. The small pellets in two published examples may suggest a connection with the enigmatic series of pseudo-Damascus coins (see below,

p. 47). Note that these coins are more neatly and regularly struck than most of the Imitative series, as are the following types. In that respect, they more closely resemble the Bilingual series, which are of a far higher quality than the Byzantine issues or their copies. Their generally heavy weight, however, would associate them with issues of 647–58.

REF.: Oddy 1995, Foss 2001, no. 5

FINDS: Irbid hoard (6); Jerusalem (?)

Two Long Crosses

OBV.: Standing imperial figure with cross on crown, holding what appear to be two long crosses; no legend or a few fragmentary letters.

REV.: Cursive ⲙ, + above, flanked by A N or N A; OKE, ONK, or ИKE in exergue.

In this type, the hem of the emperor's robe that normally stretches down from the globe has been misinterpreted as a second staff supporting a long cross. Some reverses have A И beside the ⲙ.

Fifteen of these have been published, struck from three obverse and six reverse dies; they are united by their similarity of style. One reverse has pellets below the ⲙ, suggesting a connection with the pseudo-Damascus coins as well as the previous type.

Most of the published examples are supposed to have come from Israel, but one was excavated at Dehes in northern Syria.

REF.: Karukstis 2000a

FINDS: Dehes

De-Christianized Types

 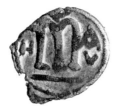

CAT. NO. 29.

OBV.: Standing figure with detached crown holding orb on staff in r. hand; ; elaborate scepter (or palm branch? or conceivably a bird on a stand) on l.; cross on longer staff on r.; no legend

REV.: ጠ, Ѵ above; H on l., AV on r.

This type, which is unusually well struck, occurs on both square and round flans. The letters **HAV** on the reverse, which do not copy any Byzantine inscription, may have had some meaning, even indicating the authority that issued them. Note that the cross has disappeared from the reverse, nor does it appear on the globe on the obverse; the emperor's crown, also without cross, is detached from his head.

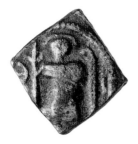 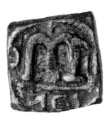

OBV.: Standing figure between staff ending in Ѵ and an object that resembles a shepherd's crook; Э in left field.

REV.: ጠ, Ѵ above; Э l., ИЄI in ex.

A variety, which appears to be struck from the same obverse die, has **TЄP** in the exergue.

REF.: Foss 2001, nos. 7 and 8, Goussous 2004, nos. 55–63, 112, 114, 145, 170

palm branch: Schindel 2005

FINDS (all types): Bethlehem, Gergesa, Hammat Gader, Jerusalem (3), Lachish hoard (6)

On this type, struck on square flans, Christian symbols have completely disappeared. Two of the published examples were excavated in Jerusalem. This may have been a local Palestinian issue, but the number in the Goussous collection, primarily formed in Jordan, suggests that they circulated in Transjordan, if not actually struck there. A related type, also square, has a palm branch in place of the obverse image.

Types with Arabic Legends

Muhammad Type

CAT. NO. 31.

OBV.: Crude standing figure with detached crown, flanked by long cross r., [مد]محد *muḥ[ammad]* l.

REV.: Cursive ᵐ, + above, بعض *baʿḍ* in exergue

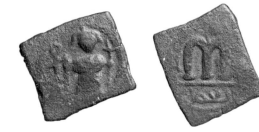

The obverse design is so simplified that the long cross normally portrayed in the figure's right hand has deteriorated to a line more-or-less parallel to his robe, while the orb of the globus cruciger seems to merge with the left shoulder, leaving its cross rather detached. This figure has much in common with the obverses of the previous two types, but its closest stylistic affinity is with the two long crosses type described above (fig. 25). The three published examples are all from different dies.

The reading of the obverse presents no problem; the reverse inscription, though, has been subject to various interpretations. Current consensus favors a word meaning "part"—i.e., the name of the denomination. A variety has *baʿḍ* on the obverse, *muḥammad* on the reverse. All published examples of this type are struck on square flans.

The identity of "Muhammad" has not been established. If the figure were intended to represent the Prophet of Islam, it would offer a real iconographic anomaly, for it is portrayed holding a cross. In the present state of uncertainty about early Islam, though, almost anything seems possible. On the other hand, the name need not be associated with the image at all, for it also appears on the reverse. This Muhammad could have been a governor or local official, but the name is so common that identification seems impossible without further evidence.

Coins of this type have been found in Palestine and Transjordan, perhaps indicating a Palestinian issue. Most of them are relatively heavy, suggesting an issue of 647–58.

REF.: Foss 2001, no. 9, Goussous 2004, nos. 181–89

Al-Wafā Lillah Type

CAT. NO. 32.

OBV.: Standing imperial figure, with usual crosses, sometimes with a bird on l.; الوفا لله *al-wafā lillah* "good faith is with God" or no legend

REV.: ɰ, + above, often with pellets between stems; l. ANA, r. NЄO (usually blundered); in ex.: الوفا لله *al-wafā lillah*

SICA 595–604

The Greek inscriptions are meaningless and the Arabic often blundered. These coins, which were evidently struck in large quantities and bear no mintmark, were previously assigned to Damascus on stylistic grounds and because they appeared in the same hoard as issues of that mint. Many of the hoard coins, however, have now been attributed to the "pseudo-Damascus" mint (see below, p. 47). In weight, style, and fabric these two series have elements in common. These coins also have a strong stylistic affinity (though no certain die links) to the lazy S coinage, which they also often resemble in fabric. With their use of Arabic and neat striking they share characteristics of the Bilingual series. They may be the product of an unidentified mint, perhaps in northern Palestine. Their lack of a mint name and the fact that they are found with countermarks that also appear on the Imitative coins suggest that they are an early issue relative to the Bilingual coins. In fact, the weights of numerous published examples would suggest that they were produced in 647–58.

REF.: Milstein 1989, Karukstis 1997, *SICA* p. 90.

FINDS: Gergesa, Gezer, Hammat Gader (2), Horbat Nashe, Khirbet Fattir (?), Nabratein (8), Nessana, Scythopolis, Sepphoris, Tiberias; Irbid hoard (40)

Countermarks

CAT. NO. 34.

OBV.: Standing figure holding long cross, ЄNT႘ l.

REV.: M, details obscured by two round countermarks reading بلد *bld*

Schulze and Goodwin 2005 type B1b

FINDS: Pella

OBV.: Standing figure with flowing hair, holding long cross and globus cruciger; cross on crown; large crescent in r. field

REV.: Ⅲ, three crosses above, pellets within and below; creature, perhaps a bird r. In ex., countermark in the form of an elaborate Greek monogram

Schulze and Goodwin 2005 type A11

The Byzantine coins of Constans II, as well as many issues of the Imitative and Derivative series, are occasionally found countermarked with a bewildering variety of letters or words (both Greek and Arabic), monograms (Greek), and designs. These also appear on the *al-wafā lillah* coins and the standing emperor types of the Bilingual series of Damascus and Emesa (see below, pp. 42–43), but not on later issues, suggesting that their application ended not long after this first standardized series was introduced. More than forty types are known; they may have been intended to make certain coins acceptable for circulation in some specified area, and may have been applied in the period 660–80. The significance of most of them is unknown, but there is some agreement that type B1a (ـلـ as on cat. no. 33) is to be read as *bi-ludd*, and taken as indicating the city of Ludd/Diospolis, whose coins are excessively rare. An alternative suggestion, that it is to be read *jayyid*, "good," has also been raised. The Greek monogram is perhaps to be resolved as *Paulou chartoulariou*, "Paul the chartoularios," to give the name and title of a treasury or mint official. Its presence on this Arabic coinage would reflect the continuing use of Greek in the higher levels of the Umayyad administration. A lead seal from Umayyad Syria with similarly elaborate Greek monograms (naming the *hypatos* Yazid) has been published by Heidemann and Sode (2000, 544 no. 1). The present monogram is one of several that appear as countermarks, most of them having some letters in common.

REF.: Schulze and Goodwin 2005; cf. Karukstis 1996

FINDS: Hama hoard no. 113 (*tayyib* on Constans II imitation)

Anomalous Types

CAT. NO. 33.

OBV.: Three crowned standing figures, details obscure; no inscription

REV.: M, + above, Ω below; ƆƆƆ l., XXЧ r., CON in ex.

At first sight, this appears to be an imitation of a class 6 follis of Heraclius (*DOC* 125). But that type was issued only in the last two years of his reign, 30 and 31 (639/40 and 640/41), not in the year 25, which this coin appears to bear. The type then current (*DOC* 112) bore two standing figures, with Heraclius in military dress. Likewise, the reversed crescent under the M is not Byzantine, but appears regularly on the Bilingual coinage of Damascus. The letters on the left, which could be a deformation of ANNO, might equally well be derived from an Arabic inscription. Finally, the size and weight do not correspond with anything Byzantine, but would suggest a connection with the coinage of Tiberias, which bears a similar obverse type. The three-figure type might also suggest a connection with the Cyprus imitations, but they are of a much heavier standard and are struck on distinctive flans, quite different from this round concave coin.

Pieces like this, which do not seem to belong to any recognizable class, are part of an abundant series of imitations that vastly complicate study of this coinage. They often copy obverses and reverses from different coins, producing a real incongruity, or introduce new and inexplicable elements. Many will appear in the present discussion.

The Dumbarton Oaks collection includes another example, cat. no. 56, which looks like an ordinary Imitative coin, but whose small flan and pellets under the reverse 𝕸 would suggest connection with an identifiable series, the pseudo-Damascus.

REF.: Bates 1994, 388–94 (but few would accept his notion that these imitations were struck in the eighth century)

CHAPTER 5

THE CALIPHATE OF MU'AWIYA, 660–680

When the caliph Uthman was assassinated in 656, Mu'awiya refused to recognize Ali, who was accepted as caliph in Medina, but soon moved his headquarters to Kufa in Iraq. In the civil war that followed, after an inconclusive battle at Siffin in northeastern Syria, both sides agreed to an arbitration, which ended the violent phase of the conflict. Finally, in July 660, Mu'awiya was formally proclaimed caliph in Jerusalem, where he received the homage of the Arab tribal chiefs. With the assassination of Ali in 661, Mu'awiya succeeded to supremacy in the entire Islamic realm. He made Damascus his capital, and from there embarked on an aggressive policy of expansion. His forces struck deep into central Asia and North Africa and made constant raids on Byzantine Asia Minor, usually twice a year, from their bases in northern Syria. The fleets of Syria and Egypt also struck Byzantium at the same time. These raids culminated in a long attack on Constantinople itself: the Arab fleet seized bases on the Sea of Marmara and attacked the Byzantine capital for four years (674–78), but ultimately failed.

One reason for Mu'awiya's withdrawal from Constantinople was trouble closer to home. In 677, the Christian mountaineers of northern Syria, called Mardaites by the Byzantines and Jarajima by the Arabs, struck deep into the Lebanon and Palestine, carrying off captives and causing a flood of refugees. They were apparently provoked by the Byzantine emperor to relieve pressure on his capital. As a result, in 678 Mu'awiya was forced to make a very unfavorable treaty that obliged him to pay three thousand nomismata, fifty prisoners, and fifty horses annually. He died in Damascus in 680.

Mu'awiya was always concerned with Syria, seat of his capital and the region most

directly threatened by Byzantium. Its coastlands remained one of his priorities. Already in 662, soon after achieving sole power, he settled Persians, particularly cavalrymen from Iraq and inland Syria, in Antioch, Tyre, and Acre. In 669, he strengthened the population of Antioch, and installed carpenters and artisans in Acre, preparatory to his great expedition against Constantinople. He also rebuilt the fortifications of Jabala and Antaradus, placing garrisons of Arabs in them. The whole coastal region became the scene of great building and industrial activity.

In general, though, the internal affairs of Syria are poorly known. It is clear that Mu'awiya maintained the division of the region into junds, appointing governors often from his own family. He may have divided the large jund of Homs, creating the new province of Qinnasrin; he also seems to have modified the provincial organization of Palestine, subordinating its southern part to Gaza, now raised to a regional capital. For most administrative purposes, he continued to rely on the existing Roman elite, from the powerful Sergius ibn Mansur, his secretary in charge of the tax bureau (whose father had held the same position under Byzantines and Persians), down to local village chiefs. Documents from the small town of Nessana in southern Palestine reveal the process of raising taxes, and also make it clear that the district was very much on a money economy, by calculating the taxes in nomismata or their Arabic equivalent, dinars, and by mentioning the silver miliaresion. Such evidence suggests that Mu'awiya's regime was also responsible for an organized coinage, as indicated by a remarkable passage from a contemporary Syriac chronicle:

"In 971 [of the Seleucid era, counting from 312 BC], Constans's 18th year, many Arabs gathered at Jerusalem and made Mu'awiya king. . . . In July of the same year the emirs and many Arabs gathered and proffered their right hand to Mu'awiya. . . . He also minted gold and silver, but it was not accepted, because it had no cross on it." (Palmer 1993, 31f.)

The gold issue may actually be identified (see below), but there is no evidence that silver was struck locally. The Roman regime had relied on a bimetallic coinage in gold and copper, while their Sassanian Persian neighbors and rivals heavily favored silver. Consequently, when the Arabs conquered the Persian Empire, they maintained the existing coinage, striking abundant dirhams of Sassanian style, though increasingly with names of governors, as well as dates and mintmarks that leave no doubt that these alien-looking coins were the product of Mu'awiya's administration. The silver coins of the chronicle were most probably issues of the eastern provinces introduced to this region, as already suggested by the mention of miliaresia in the documents.

It is therefore reasonable to suppose that a systematic coinage in copper was also

produced at this time. This is the Bilingual series (also termed Umayyad Imperial Image coins). Its first issue employs a standard type, familiar from the Byzantine coinage and its imitations, of a standing imperial figure holding a cross. These were struck at Damascus, Homs, and apparently Tiberias, Jerusalem, and Diospolis/Ludd. Subsequently, the number of mints increased, each producing a distinctive type of its own: Homs with a bust (also at the subordinate mint of this jund, Antaradus/Tartus), Damascus (standing figure), Baalbek (two standing figures), Amman (one standing, one seated figure) and Tiberias (three standing figures). The issues of Damascus are especially complicated. In addition, Scythopolis and its subordinate mint Gerasa struck coins on a heavy standard, imitating Byzantine types of Justin II and showing two seated figures.

REF.: Foss 2002a

Late Byzantine Types

According to metrology, the coinage of the first decade of Mu'awiya's caliphate consisted of the lighter series of the Imitative and Derivative coinage discussed above, where the light standard has been assigned to 658–64, with some types extending into the late 660s. The following is necessarily one of the latest, since it copies a type first issued in 668. After about 670, the new Bilingual series came into production, replacing the previous jumble with an organized coinage, distinguished by its mintmarks.

Constantine IV Obverse, ca. 670

CAT. NO. 25.

OBV.: Facing bust, beardless, wearing plumed helmet and holding globus cruciger; unread inscription that may be in Pahlavi.

REV.: M flanked by two standing imperial figures, Ⴑ above, SCL in ex.

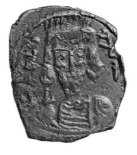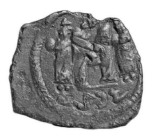

This peculiar piece appears to be one of the latest in the Imitative series for which a terminus post quem can be determined, since the type it copies was issued in 668–

73. It was thus necessarily struck after Muʿawiya became caliph. The obverse inscription has so far resisted interpretation: the letters appears to be Pahlavi, the language of Persia, but could possibly be read as Arabic. Its fabric and the indicated provenances of some specimens point, however, to a north Syrian origin. The reverse is die-linked to coins of the standing emperor type, indicating that it is part of the Imitative series, and that some of those were being produced at this time.

REF.: *SICA* 530, with discussion p. 79

Gold Issues, ca. 660 (?)

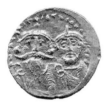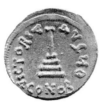

OBV.: Two facing busts; the left figure has a long beard; crosses on the crowns have been transformed into simple staffs. Illegible garbled inscription.

REV.: Staff on three steps, crudely inscribed VICTORIA AYϤϤO, CONOB in exergue.

Miles 1967, no. 3, *SICA* p. 91

This coin is most probably the type described in the *Chronicle:* it lacks crosses, but otherwise follows the Byzantine model. An example found in a hoard buried near Antioch before 680 shows that it belongs to the reign of Muʿawiya, while the fact that this coin was struck from worn dies would correspond to an issue that was produced in quantity but then withdrawn from circulation. It may therefore be attributed to the reign of Muʿawiya, as may a similar type that imitates early *solidi* of Heraclius (emperor with short beard: Miles 1967, no. 2).

REF.: Miles 1967, 207–10, Foss 2002a, 363

FINDS: Daphne hoard

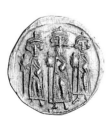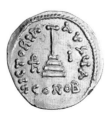

OBV.: Three standing imperial figures holding globes; no inscription

REV.: Transformed cross (resembling a T) on steps, VICTORIA AVϤYA, CONOB in exergue, I B or Heraclian monogram in field

Walker 1956, 54, Miles 1967, nos. 4 and 5; *SICA* 606

This extremely rare type derives from the coinage of Heraclius, where he is portrayed with his two sons on issues of ca. 632–41. The prototype also had no obverse inscription, but the figures each held a globus cruciger and had crosses on their crowns. The present type is entirely de-Christianized, with all the crosses transformed or simplified. On two published examples, the monogram of Heraclius that appears in the reverse field has been replaced by letters whose significance has not been established. The third, however (published in *SICA*), bears the monogram as well as the letter I.

In general characteristics (notably the debased Greek inscription and minimal transformation of the reverse cross), this resembles the type assigned above to the beginning of the reign of Muʿawiya. Its obverse type and the letters of the reverse suggest a link with the experimental issues of Abd al-Malik, though those, unlike this type, have inscriptions in Arabic.

The Bilingual Coinage

The First Bilingual Series

Damascus

CAT. NO. 35.

OBV.: Standing imperial figure, ΔΑΜΑΣΚΟΣ (often blundered)

REV.: M, ⚹ above, ✳ below; دمشق وفيه جاز هذا *di-mashq wafiya jāza hadhā,* "Damascus; this is legal; full weight"

Walker 1956, 12–17, *SICA* 564

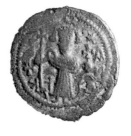

On some obverses, the figure is portrayed not wearing the usual long robe, but with a shorter garment belted at the waist and flaring out below; the same type occurs on the pseudo-Damascus type with falcon on the figure's wrist (see below). The symbol on the reverse appears in various forms, while the star is often replaced by an upside-down crescent. The Arabic legend is usually blundered.

REF.: Goodwin 1998, Treadwell 2000, 11f.

FINDS: Jerash (1), Lachish hoard (7); Capernaum

Emesa/Homs

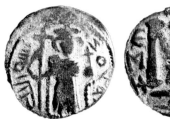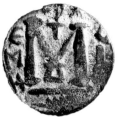

CAT. NO. 40.

OBV.: Standing imperial figure, r. ΚΑΛΟΝ, l., بسم ألله *bism allah,* "in the name of God"

REV.: M, ⳨ above flanked by stars or star and crescent; A, Δ, or Ω below; l. and r. ЄМН/CIC; in ex., طيب *ṭayyib,* "good."

One variety omits the *bism allah* of the obverse. There are also minor variations of symbols and spelling of mint name. The Greek obverse legend is often blundered.

REF.: Walker 1956, 28–31, *SICA* 531–37

FINDS: Antioch (2), Balis; Jerash

These coins sometimes have very small punchmarks whose purpose is unknown; they occur less frequently on the bust type (below, p. 50): Goodwin 1993c. A variety in the collection, no. 43, which has an obverse typical of the Imitative series, adorned with large crosses and without an inscription, is possibly a mule, where obverse and reverse dies of different types are matched; if so, it would indicate that the Imitative coins were being struck also in Emesa. More likely, however, it is an imitation where the artisan has combined obverse and reverse from quite different coins (Foss 2001, 8).

These two issues may represent the beginning of an organized Arab–Byzantine coinage, the product of a central authority. They bear the name of the issuing mint and inscriptions attesting to their validity; "legal" (Damascus) or "good" (Homs). Such inscriptions would be suitable to an innovative coinage whose unfamiliarity might raise doubts in the mind of the user. Their use of the traditional standing imperial figure indicates continuity with the past, producing a coin that could be easily acceptable, while the validating phrases suggest that some reassurance was needed. Overstrikes indicate that the coins of Damascus and Homs are early issues: numerous examples of the former have been found overstruck with the Damascus Bilingual (Arabic) type or with the type of Baalbek, while several examples of the Homs coinage were overstruck with the Bilingual bust type of the same mint.

REF.: Treadwell 2000, 10–12, Goodwin 2001a, 98f.

Two mints, Jerusalem and Diospolis, produced coins with a standing figure and mintmarks, though they do not bear a validating phrase, and have inscriptions only

in Greek. Extremely rare, they were evidently struck in small quantities, and may represent an experimental issue before the main series was organized (Goodwin 2005a, 18f.).

Jerusalem

CAT. NO. 45.

OBV.: Standing emperor, fragmentary inscription, И in l. field, C under orb.

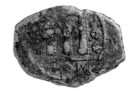

REV.: ₥, cross (?) above; l.: IЄPO, r.: COΛY, in ex.: MѠN

Qedar 1989, pl. 6, no. 16; *SICA* p. 90; Goodwin 2005a, 87f.

FINDS: Jerusalem

The coin in the Dumbarton Oaks collection, no. 45, appears to be an irregular production of this mint: the reverse inscription reads POЄ r., and perhaps MON in the ex. It might equally well be an imitation; but is in any case related to the Jerusalem type.

Diospolis (Ludd)

OBV.: Standing emperor, ΔΙΟCΠΟΛ, + in lower right field

REV.: ₥, + above; NNO l., ЧΙΙ r., NIKO in ex.

This type bears a frozen (or meaningless) year 7 and the mintmark of Nicomedia, features that otherwise appear only on the coinage of Scythopolis.

Qedar 1989, pl. 5, no. 13; *SICA* p. 89

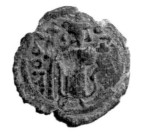
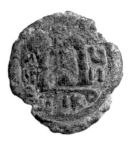

The products of another mint are probably to be associated with this group, but pose special problems:

Tiberias

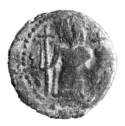

CAT. NO. 44.

OBV.: Standing imperial figure with cross on crown holding long cross and globus cruciger

REV.: ⲙ, cross above; r.: ΧΑΛΕ; l.: ΑΛΛΑ

Walker 1956, pp. 46–49

The legends of these coins are usually blundered, with many varieties (no two of the nine known examples are alike). On some examples the mint name is written in blundered Greek or correctly in Arabic, *ṭabariya,* on the obverse. The reverse inscription appears to denote a name, perhaps Khalid ibn [Abd] Allah. On some examples, BON appears in the exergue. Since this type always occurs with inaccurate or incomplete reverse legends, it is possible that it derives from a coinage like that of Damascus, whose original has not survived.

REF.: Foss 2001, 7f.

FINDS: Nabratein, Scythopolis; Pella

The Main Bilingual Series

Jund of Damascus

Damascus

This is a complex coinage, with many varieties (see *SICA* p. 86); mules also appear. The relationship of the various types is still to be resolved, as is the vexed question of which are official issues and which are imitations.

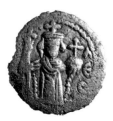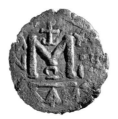

CAT. NO. 46.

(A) OBV.: Standing figure in long robe holding staff with cross and globus cruciger; outline of robe continues to globe; l., bird on stand or palm branch or symbols; r., ΛΕO

REV.: M, ⚓ or + above, ⌒ below; l., ΑΝΟ, r. ΧЧΙΙ; ΔΑΜ in exergue.

Walker 1956, 7–11, *SICA* 560–63

This type has many varieties, especially of obverse symbols and details of robe; legends often blundered. The enigmatic ΛЄO of the obverse apparently represents a deformation of the last half of the reverse inscription ΑΝΑΝЄO that appears on the copper coins of Constans II and their imitations (see pp. 20, 28 above). The reverse type, with its meaningless date 17 (ΧЧΙΙ), derives from imitations of the Cyprus issues of Heraclius (see p. 22 above)

FINDS: Capernaum, Hammat Gader, Khirbet Kerak, Neve Ur, Scythopolis, Sepphoris; Irbid hoard (27); Salamis

(B) OBV.: Seated figure holding scepter and globus cruciger, bird on stand on l., ΛЄO

REV.: as previous, sometimes blundered.

Walker 1956, 4–5

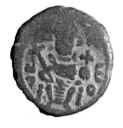
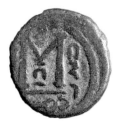

This unusual type may in fact be a product of the "pseudo-Damascus" mint, since several examples were found in a hoard with coins of that attribution.

(C) OBV.: Standing imperial figure; outline of robe continues to globe; ΔΑΜΑСΚΟС (often blundered). A major variety has a bird on stand or palm branch left of the figure.

REV.: M, ⊹ above, Ω below; ضرب دمشق جآئز duriba (or darb) dimashq jā'iz, "struck in [or issue of] Damascus; legal" around.

Walker 1956, 12–17, SICA 566–68

This type has many varieties.

CAT. NO. 52.

(D) OBV.: As previous but legend ΛЄO on r.

REV.: M, crudely drawn ⊹ or + above, Ω below; ضرب دمشق جآئز duriba (or darb) dimashq jā'iz around.

Walker 1956, 18–25, SICA 569–72

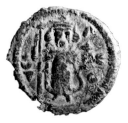
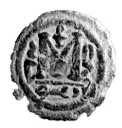

FINDS: Antioch (4), Apamea (2); Hammat Gader, Nabratein; Amman

Types (a) and (d) are very common, forming the bulk of the coinage of Damascus. The evidence from overstrikes (Goodwin 2001a, 99f.) suggests that the Greek types are earlier than the Arabic.

Pseudo-Damascus

This is a coinage closely related to that of Damascus with Greek legend, but displaying an extravagant variety of types, many unparalleled in this series. The date, place, and circumstances of their production are unknown, but the high quality of design and striking suggests an official issue, perhaps of a mint in northern Palestine or Jordan. The classic discussion is that of Milstein 1989; cf. *SICA* p. 87.

(A) OBV.: Standing "imperial" figure, but with many variations

REV.: ᛘ, usually retrograde, with cross above, often with pellets between legs; sometimes fantastic decoration. The legends are usually garbled. The mintmark sometimes resembles ΔΘM, sometimes is missing.

SICA 578, 580

FINDS: Capernaum (4), Hammat Gader (2), Nabratein (8); Irbid hoard (63), Jerash (3)

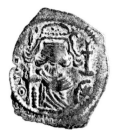 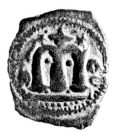

CAT. NO. 56.

(B) OBV.: Standing figure with a long beard and prominent mustache (apparently imitated from late issues of Constans II)

REV.: as previous

SICA 579

The example in the Dumbarton Oaks collection has some additional peculiarities: the figure has an elaborate headdress and in place of the normal globus cruciger is a cross ending in a crescent. In the l. field is a pellet in a circle and on the r. a star. Above the ᛘ of the reverse is a cross flanked by stars. Such symbols are characteristic of the Bilingual bust type coins of Emesa, but whether they indicate a connection with that series or are simply the product of an engraver's fancy has not been determined.

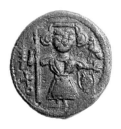 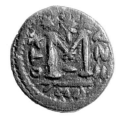

(C) OBV.: Standing figure with long hair in hunting garb, holding a falcon on his l. wrist

REV.: M or ᛘ, garbled Greek legend.

SICA 581–82

FINDS: Irbid hoard (11)

The obverse representation differs notably from the normal imperial image. Instead, this figure has long flowing hair and a short garment belted at the waist, as on some of the Damascus issues of the first Bilingual series. The bird on the wrist has been taken to reflect falconry, with the implication that the figure represents the caliph indulging in a favorite pastime, for which Yazid I (680–683) was especially well known. As appealing as this suggestion may be, it faces a real problem, for the figure is usually, though not inevitably, represented as holding a cross. Considering the traditional aversion of Muslims to this symbol, it seems an incongruous accompaniment for a caliph.

REF.: Oddy 1991

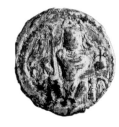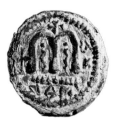

CAT. NO. 57.

(D) OBV.: Seated figure holding staff and globus cruciger

REV.: as type (A)

Milstein 1989, 143–54; *SICA* 577

This type also occurs with garbled Greek legends on the reverse, apparently imitated from Damascus type (A).

Heliopolis/Baalbek

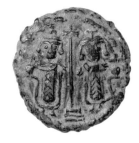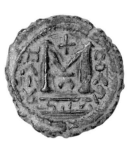

OBV.: Two standing crowned figures holding globus crucigers; tall cross on steps between them

REV.: M, + above, Ω below; HΛI8 l., ΠΟΛЄ r., بعلبك *baʿlabakk* in ex.

Walker 1956, 14 no. ANS4; *SICA* 583

This variety is larger and better struck than the following main type. The type of cross it bears may be derived from the Byzantine gold coinage, where it is a common feature of the reverse (never the obverse) on issues of Heraclius; more specifically, it may owe its origin to a late type of Constans II, issued ca. 661–63, which shows such a cross between the two standing figures of his sons.

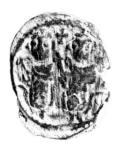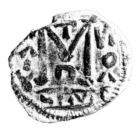

CAT. NO. 60.

OBV.: Two standing figures, both holding scepters; fig. on r. also holds globus cruciger; cross between heads.

REV.: M, + above, Ω below; HΛΙȣ l., ΠOΛЄ r., بعلبك *ba'labakk* in ex.

Walker 1956, 35–41, *SICA* 584–86; the Greek legend is often blundered as in cat. no. 60, which has ИOΛЄ on r.

This was an abundant issue, accounting for the vast majority of the Baalbek coins.

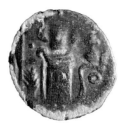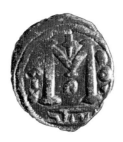

CAT. NO. 63.

OBV.: Standing imperial figure holding long cross and globus cruciger; pellet and palm branch on l., O in r. field

REV.: M, + above, Ω below; HΛΙȣ l.; ΠOΛ r.; بعلبك *ba'labakk* below

Walker 1956, 6; Foss 2001, no. 6; Goodwin 2001b, 12

FINDS: Antioch, Jerash; Lachish hoard; Salamis

A detailed study of the Baalbek coinage based on examination of a thousand coins and analysis of the links between the dies used (48 obverse, 69 reverse) indicates that the type with cross on steps was the first, soon abandoned in favor of the much more common cat. no. 60, which was itself struck only for a short time. The third type, which combines a characteristic obverse of Damascus with a Baalbek reverse, belongs to a smaller series (about 10 percent of the coins) that closely associates types of the two cities. The most plausible explanation seems to be that these are late issues, the product of a time when the Baalbek mint had been moved to Damascus. Alternatively—and typical of the complexities that plague this series—they may all be imitations.

REF.: Goodwin 2005a, 49–83, Oddy 2004b, 135

Amman

OBV.: Two figures, one seated, one standing, holding a long cross between them.

REV.: M, هذا ضرب عمان *hadhā ḍuriba ʿAmmān* (readings uncertain)

Qedar 1989, pl. 6, no. 18; *SNAPalästina* 492; Goodwin 2005a, 21

These extremely rare coins employ a type not used elsewhere. The examples so far published have inscriptions only in Arabic.

Jund of Homs

Emesa/Homs

CAT. NO. 64.

OBV.: Facing bust wearing cuirass and paludamentum, with cross on diadem, holding globus cruciger; KA/ΛON l. and r.; ⊙ l., ✳ r. of cross

REV.: ⅏, ◠✳◡ above, flanked by ЄMI/CHC; in ex., طيب *ṭayyib*, "good"

Oddy 1987, 193

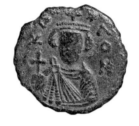

This very rare type may have formed an intermediate stage between the standing emperor coinage and the common type below.

CAT. NO. 75.

OBV.: As previous, but Bilingual legend: KAΛON l., بحمص *bi-ḥimṣ* r. Various symbols above or below.

REV.: ⅏, o✳o above, flanked by ЄMI/CHC; in ex., طيب *ṭayyib*; there is a great variety of symbols above the ⅏

Walker 1956, 57–72; *SICA* 538–58; Oddy 1987

This is the most extensive issue of the whole Arab–Byzantine series (at least 59 obverse and 63 reverse dies); coins of Emesa are more common than those of any other mint, including that of the capital, Damascus. These coins appear to form a highly controlled and organized production. Because of its regularity and the complexity of its symbols, it may have had eight (and possibly sixteen) periods of minting. There

is also an abundant series of imitations (as cat. no. 77), with at least twenty obverse dies.

REF.: Oddy 1987, Oddy 2004b, 135f.

FINDS: Antioch (9), Çatal Hüyük (?), Qalat Siman (2), Tell Rifaat; Jerusalem, Scythopolis; Salamis

Antaradus/Tartus

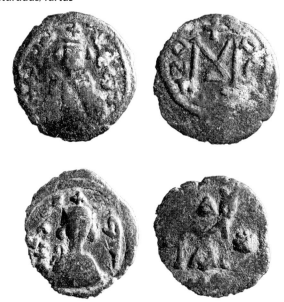

CAT. NO. 79.

(A) OBV.: Facing bust in paludamentum and cuirass (as on coins of Emesa), cross on diadem; l. بطردوس *bi-ṭardus;* r. KAΛΘN

REV.: M, + flanked by ✳ and crescent above, Δ below; l. ANT, r. APO; طيب *ṭayyib* in ex.

Walker 1956, 55–56; *SICA* 559

CAT. NO. 80.

(B) OBV.: Facing bust as above, with globus cruciger; l. KAΛN or KAH, r. طيب *ṭayyib*

REV.: Monogram of ANTAPAΔOY flanked by crescent and star; طيب *ṭayyib* below

These coins of the secondary mint of the jund of Homs follow the obverse type of the provincial capital. They were evidently struck in very small quantities.

Jund of Jordan

Tiberias/Ṭabariya

CAT. NO. 81.

OBV.: Three standing figures, each holding a globus cruciger, crosses on crowns, no legend

REV.: M, ⚓ above, C or A below; l. and ex.: THBЄPIAΔO, r. طبرية ṭabariya

Walker 1956, 43–51, *SICA* 587–91

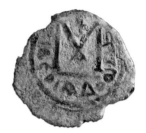

These common coins are often well struck on large flans of up to 30 mm, but there are many examples about half that size. That may suggest a development from the large to the small. The small pieces, which usually have an abbreviated or blundered mint-mark, can be related to other issues of the same module, but with enigmatic types, discussed below.

FINDS: Antioch (2); Capernaum (3), Gergesa, Hammat Gader (7), Samaria (2), Scythopolis (2), Sepphoris, Tel Jezreel, Tiberias (2); Amman (2)

Scythopolis/Baisan

M denomination

CAT. NO. 82.

(A) OBV.: Two enthroned imperial figures each holding a cruciform scepter pointing over r. shoulder; cross between heads, CKVΘO/ ΠOΛIC

REV.: M, + above, A below; l.: ANNO, r.: ЧII; in exergue NIKO

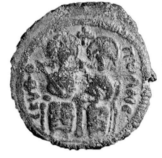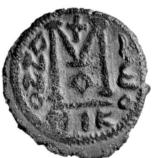

In many variants legends are blundered or reversed or retrograde; some have CON or CIOH in ex., and dates XI or XII. A few, like the present specimen, have what appears to be a poorly written Arabic word (perhaps بيسن *baisan*) in place of the "date." Occasional examples of this type bear the Arabic countermark طيب *ṭayyib,* carefully applied to the bottom of the obverse. This is a relatively large issue, with about 25 obverse and 45 reverse dies.

Walker 1956, pp. 1–2; *SICA* 594; Amitai-Preiss, Berman, and Qedar 1999 A1–A16; Oddy 2004b, 136f.

FINDS: Syria 1 hoard; Jerash (31), Pella, Scythopolis (6); Capernaum

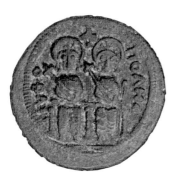 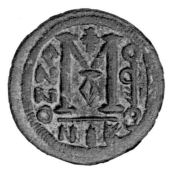

CAT. NO. 83.

(B) As previous, but in place of the date on the reverse, مقسم *miqsam* ("a part")

Amitai-Preiss, Berman, and Qedar 1999, A17

These very rare coins are usually well struck on large and heavy planchets.

(c) As type a, but with reverse type NIKO r., بيسن *baisan* in exergue

Walker 1956, 2 no. Bel. 2; Amitai-Preiss, Berman, and Qedar 1999, A18

The light weight of one of the published specimens and the fact that the other is overstruck on another coin of Scythopolis suggest that this is a late issue. It may belong to the beginning of the reign of Abd al-Malik (Oddy 2004a).

FINDS: Jerash

K denomination

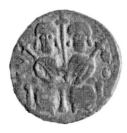 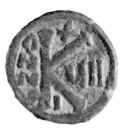

CAT. NO. 84.

(A) OBV.: Two enthroned figures with cruciform scepters pointing in opposite directions; long cross between, CKV/ΘO

REV.: K; l. ANNO, r. ЧII; X above, I below

Amitai-Preiss, Berman, and Qedar 1999, B1

FINDS: Scythopolis, Tiberias

(B) OBV.: Two enthroned figures, holding scepters pointing l., as on M, CKVΘO.

REV.: K with projecting bar; X above, Ω below; l. بيسن *baisan*

Amitai-Preiss, Berman, and Qedar 1999, B2

CAT. NO. 85.

(c) OBV.: Two enthroned figures, no crosses, no legend

REV.: K with projecting bar; crescent above, X below; l. بيسن *baisan*

Amitai-Preiss, Berman, and Qedar 1999, B3

Types b and c are smaller and lighter than type a.

This coinage, together with the related issues of Gerasa and "Abila" (see below), stands out in the entire Arab–Byzantine series by its size, weight, and prototype. While the vast majority of other issues imitate or derive from the small folles of Heraclius and Constans II, these copy the heavy issues of Justin II (565–578). Those coins have been found in disproportionate quantities in the excavations of Scythopolis and Gerasa, presumably brought there in association with the Persian war that afflicted Syria in Justin's reign. Why they were chosen as a prototype is uncertain, especially since they were at least seventy years old when the present coins were struck. Likewise, the date when this series began has not been determined: in theory, it could have been almost any time after the Arab conquest. Overstrikes provide some evidence. One M and a K (type a) were struck over three-figure types of Tiberias, and another M apparently on a Standing Caliph coin. That would indicate that these coins were being issued as late as the reign of Abd al-Malik. Aniconic types with the *shahada* (profession of the Islamic faith) struck over them suggest that they were still in circulation at the time of the great coinage reform that took place at the end of the seventh century. The large variation of weight and quality of design would be suitable for a coinage issued over a long period.

REF.: Amitai-Preiss, Berman, and Qedar 1999; cf. Goodwin 2001a, 100

Gerasa/Jerash

CAT. NO. 86.

OBV.: Two std. figures: l. holds globus cruciger, r. holds scepter, sometimes ✷ or + between heads, ΓΕΡΑCΟΝ

REV.: M, A, Є, or Γ below; l.: ANNO, r. ✷XII, ✷XIII or ✷XO; in ex., NIKO (usually retrograde)

These coins are scarcer than those of Scythopolis, but still employ some 17 obverse and 27 reverse dies (Oddy 2004b, 137).

Walker 1956, p. 44, nos. G1, A7; Amitai-Preiss, Berman, and Qedar 1999, C1–C10

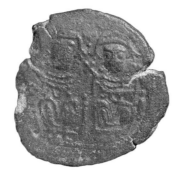

There are many varieties of these rare coins, most of them with blundered or careless legends. The present specimen, for example, has no obverse legend and ЧII as the "date" on the rev.; this "date" is more normally a type of Scythopolis, and here attests the close connection between the two series. These coins are often carefully countermarked on the bottom of the obverse with *tayyib,* "good." In size and weight, they conform to the coinage of nearby Scythopolis, with which they form a distinctive group. A die-link with a type issued at the beginning of the reign of Abd al-Malik (685–705) indicates that these coins were being struck at that time (Oddy 2004a).

Abila?

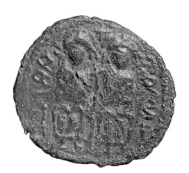

CAT. NO. 87.

OBV.: Two standing figures: l. holds globus cruciger, r. holds scepter, + between heads, inscribed l. (retrograde) ABI, r. EONH (?)

REV.: M, + above, AИO l., XI r., KYZ in ex

Closely related by style, size, and weight to the coins of Scythopolis and Gerasa is a large group with unreadable or seemingly meaningless legends that may be imitations, or the product of other mints in the region. Some of these read AB and some other letters that have been interpreted to represent ABIΛHNШN, for Abila, another city of the Decapolis. None, however, has a clear inscription, and one reads ABГΔЄ as if practicing the alphabet. The attribution must remain in question, especially since use of an ethnic (Abilēnōn rather than Abila or Abilas) would be unparalleled in this series. It is possible that all of them are imitations loosely derived from the coinage of Gerasa.

REF.: Oddy 2004c

FINDS: Jerash (6); Syria 1 hoard (4)

THE CIVIL WARS, 680–692

While he was still in power, in 679 or perhaps as early as 676, Muʻawiya called together the notables of the Arabs and obliged them to swear an oath of allegiance to his son Yazid, whom he intended as his successor. The notion of direct hereditary succession was a novelty in the Islamic state, and one which roused serious opposition. Among those who refused to accept the proposed succession were the Prophet's grandson al-Husayn and one of the most prominent members of the community, Abd Allah ibn al-Zubayr. Both of them remained in Medina, and both refused to recognize Yazid when he assumed the caliphate in 680. Yazid's forces soon defeated and killed al-Husayn and descended into Arabia to eliminate the threat from ibn Zubayr, who commanded a wide following in the holy cities of Mecca and Medina. During that campaign, which involved the destruction of the sacred shrine of the Kaaba, Yazid died in November 683. Since the chronicles focus entirely on these events, virtually nothing is known of Yazid's reign in Syria nor can any coins yet be attributed to it. The caliph's only recorded act in the region (which some sources attribute to his father Muʻawiya) was the creation of the jund of Qinnasrin, divided off from the large district of Homs.

The death of Yazid introduced a decade of serious internal strife, in which the caliphate was split and rival forces struggled for supremacy. Yazid had ensured the succession of his young son Muʻawiya II, who commanded only very limited support and probably controlled little territory outside Syria. In any case, he died after about forty days, leaving the field open to ibn Zubayr, who at first seemed to carry all before him, including Egypt. The governors of Qinnasrin, Homs, and Palestine openly took his side, but Jordan remained loyal to the Umayyads, actively making propaganda for

them. The situation in Damascus was complicated. Its governor, who had been the chief adviser of Muʿawiya II, came out openly for ibn Zubayr and moved against the Umayyads, now led by the elderly and very distinguished Marwan ibn al-Hakam, head of a collateral branch of the family.

The Umayyads, expelled from Arabia by ibn Zubayr, had gathered at Palmyra and given their oath to Marwan, on condition that he name Khalid, younger son of Yazid, as his heir, with Amr ibn Saʿid as next in the succession. With his support consolidated, Marwan marched toward Damascus and crushed his opponents in the battle of Marj Rahit in August 684. Ibn Zubayr's governors fled, leaving all Syria in Marwan's hands. Amr ibn Saʿid swiftly seized Egypt for Marwan, then defeated a force ibn Zubayr had sent against Palestine. During this turmoil (or perhaps in the civil war that followed), while ibn Zubayr controlled Palestine, the Byzantines took advantage of the confusion to descend on the coastlands, ravaging Tyre, Acre, Ascalon, and Caesarea. To compound the problems, Syria and Mesopotamia were struck by plague and famine.

Marwan made his headquarters in Damascus, where he reneged on his promise to Amr ibn Saʿid (the young Khalid had been sidelined already), and instead obliged the Syrian leaders to swear allegiance to his sons Abd al-Malik and Abd al-Aziz, who were to rule in succession after him. When Marwan died in April 685, Abd al-Malik was recognized in the territory his father had controlled.

Coinage of the Civil War

If the pseudo-Damascus coins with a falcon on the obverse really reflect a caliph's love of falconry, they might be issues of Yazid I (680–683), but such an identification is very problematic.

It is possible (though perhaps not very likely, considering the short time involved) that some small coins of Tiberias type but without mintmarks were struck in Jordan at the time when it was loyal to ibn Zubayr, and was advancing his cause. His regime, based in Mecca and Medina, was marked by its piety, and the coins struck in Iran by one of his governors in the years AH 66 and 67 (685/86 and 686/87) were the first to bear the *shahada,* or profession of the Islamic faith. If these coins could be associated with the civil war, they would be slightly earlier, and thus the first with Muslim inscriptions; but attribution to the early years of Abd al-Malik appears more probable (see below, "Transitional Coins").

CHAPTER 7

THE CALIPHATE OF ABD AL-MALIK,

685–705

Abd al-Malik easily succeeded to power in Syria and Egypt, but he faced many problems. Closest to home were the Mardaites, who took advantage of the confusion of the civil war to descend from the mountains and ravage the Lebanon in conjunction with Byzantine forces. Once again, the caliph agreed to a humiliating treaty with Byzantium to ward off the threat. After long negotiations, Abd al-Malik (in 686 or 688) promised to pay 1000 nomismata, a horse, and a slave every day. In return the new emperor Justinian II agreed to withdraw the Mardaites to Byzantine territory. Some 12,000 of them were moved to Asia Minor, a circumstance perhaps aided by a recurrence of famine, which also caused many people to seek refuge in the lands north of Syria. Nevertheless, a core of Mardaites remained behind until their stronghold of Jurjuma, in the rough mountains southwest of Antioch, was finally taken twenty years later.

The greatest danger, though, came from the rival caliph Abd Allah ibn al-Zubayr, who had established control over Iraq, Iran, and Arabia (though not without many internal enemies of his own). For a moment, the frontiers of Rome and Persia seemed reestablished, with hostile regimes facing each other across the Euphrates. Once Abd al-Malik was free of the threat from Byzantium, he started to move against ibn Zubayr. In 687 (probably; the chronology of these events is complicated and obscure), he began a series of annual campaigns, making his base at Butnan Habib, between Aleppo and the Euphrates. In 689, his forces had reached Rhesaena in upper Mesopotamia, when urgent news recalled the caliph to Damascus. There, he had put Amr ibn Sa'id

in charge as his deputy. As soon as the caliph was far away, however, ibn Saʿid, who had not forgotten how he had been passed over for the succession, revolted and seized the city. Abd al-Malik hastened back, and soon defeated and executed the rebel. His progress after that was rapid. The army led by his brother Muhammad took Edessa, the greatest city of Mesopotamia, without resistance and rapidly seized the rest of the region, probably in 690. The decisive battle took place the next year in northern Iraq, where Abd al-Malik crushed the forces of ibn Zubayr's brother, Musʿab, and gained control of Iraq and Iran. Finally, in 692, Abd al-Malik's ferocious commander al-Hajjaj stormed Mecca, where he defeated and killed ibn Zubayr. Unity was restored to the Islamic world.

The caliph was now free to direct his energies again toward Byzantium. Already in 690/91 he recaptured Caesarea, which had been ravaged (its mosque was destroyed) and apparently occupied by the Byzantines. Following the policy of Muʿawiya, Abd al-Malik directed his attention to the vulnerable Syrian coastlands. He rebuilt the damaged fortress cities of Tripolis, Sidon, and Tyre, and established the last as his main naval base. He also made a major administrative change by separating Mesopotamia (the strategic frontier region in the bend of the Euphrates) off from the large jund of Qinnasrin, thereby creating a new province.

The regional capitals of Homs and Qinnasrin continued to be the bases from which the annual expeditions against Byzantium were organized; they resumed in 692, with some interruptions, until the end of the reign. One of the interruptions was caused by a severe plague that struck the whole country in 699. Other than this, the internal history of Syria is as poorly known in this reign as in the previous. Christian sources add rather enigmatically only that the caliph ordered the slaughter of all the pigs in Syria in 693; some add that he also ordered the removal of crosses that had been on public display.

The greatest changes that Abd al-Malik brought to the life of his subjects—not only in Syria—involved a complete transformation of the administration and the monetary system. It seems to have begun toward the end of the civil war, in 692, when the caliph ordered a general census in Syria that obliged everyone to be registered, together with families, livestock, and land. This enabled the state to increase the tax rate substantially. Four years later, around 696 (the date is variously given), he made a fundamental and permanent reform by issuing a new aniconic coinage that bore only inscriptions in place of the customary images. This affected the gold, silver, and copper coins over a period of time. Finally, in 700, he established Arabic as the official language of the administration, replacing the Greek that had been customary in Syria.

These reforms were no doubt connected with the ostentatious proclamation of the Islamic religion that characterized this regime. In Muʻawiya's reign and before, Islamic slogans did not appear on the coinage or in public documents—in fact, the status and even the nature of the new religion is very unclear before Abd al-Malik. In 685, ibn al-Zubayr was actually the first to put on his coinage the proclamation that Muhammad was the Prophet of God (unless some undatable Arab–Byzantine issues are earlier). Abd al-Malik soon responded to the implicit religious challenge, and by 692 completed one of the great monuments of Islam, the Dome of the Rock in Jerusalem, which bears long inscriptions about Islam, many of them derived from the Koran. From that time on, Islam was visibly dominant throughout the vast Umayyad realm. Abd al-Malik had inherited a kind of sub-Roman society, with many elements of continuity. When he died in 705, he left behind a completely transformed and distinctive Islamic Arabic state.

The coinage of Abd al-Malik falls into three main divisions: transitional or experimental issues which employ or transform traditional Arab–Byzantine (or Arab–Sassanian) types; a regular issue with the figure, name, and titles of the caliph (the Standing Caliph coinage); and a vast aniconic series, the product of the reform that removed all images from the coins.

Transitional Coins

An Accession Issue (Gerasa/Jerash Probable Mint)

(A) OBV.: Two figures standing, facing, wearing long robes and Arab headdress adorned with six-pointed stars, r. hands on their swords. Between them, on three steps, a pointed staff with a globe. No inscription.

REV.: large M, six-pointed star above, A below; بسم الله عبدألله عبد ألملك أمير أامؤمنين
bism allah ʻabd allah ʻabd al-malik amīr al-muʼminīn, "In the name of God. Abd Allah (or "the Slave of God") Abd al-Malik, Commander of the Faithful."

Walker 1956, A5, A6; Amitai-Preiss, Berman, and Qedar 1999, D12

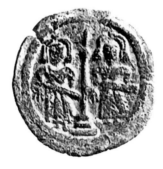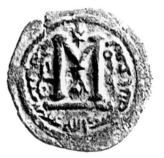

(B) **OBV.:** As previous, struck from the same die

REV.: M, A below; l.: ANN; r.: OK; ONK in ex.

Oddy 2004a; Amitai-Preiss, Berman, and Qedar 1999, D11a

The reverse inscription is a garbled version of ANNO NIKO.

This coin bears no mintmark, but its inscription leaves no doubt that it is an official issue of the Umayyad caliph. Its size and weight inevitably associate it with the region of Scythopolis, where this aberrant heavy standard was consistently used. The type apparently represents the caliph Abd al-Malik and his brother Abd al-Aziz, who were jointly proclaimed as successors to their father Marwan in 684/85. It is probably an accession issue of Abd al-Malik, who assumed supreme power, with his brother recognized as his successor, in April 685. A variety of type B is die-linked with an issue attributable to Gerasa, establishing that as the mint for these coins. That suits the discovery of two of them in the Jerash excavations (Bellinger 1938, 551). These coins were quite likely struck in 685. Dating them, incidentally, shows that the heavy coins of Jerash (and by implication Scythopolis) were being issued at this time.

REF.: Foss 2003b; Oddy 2004a

Issues of the First Years of the Reign, ca. 685–688

Tiberias/Tabariya

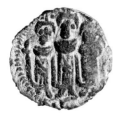

CAT. NO. 88.

OBV.: Three standing figures, no legend

REV.: M; ☦ above, A below; on l., THC; r. طبرية *ṭabariya*; in exergue قطرى *qṭrī*

SICA 592; *SNAPalästina* 286

This type has been de-Christianized: the figures no longer carry the globus cruciger, and the crosses on their crowns have been replaced by staffs flanked by dots.

The reverse inscription has provoked some discussion. Originally read as "Qatari," it was taken to refer to the famous Kharijite rebel, whose activities affected Iraq and Iran, but never Syria. Most probably, the legend is to be read as *quṭrī*, "regional," to indicate that this is part of a new coinage designed to introduce a uniform standard

throughout the region that included Baisan. Since the legend would have been am-
biguous after the rise of Qatari in AH 69 (688–89), the type was probably issued be-
fore that date, in the first years of Abd al-Malik. Since there are Bilingual coins of Ti-
berias with obverses of the same distinctive style as these, it would appear that the two
types were in production at the same time. This type is to be seen in connection with
the following:

Baisan

OBV.: Three standing figures holding globus cruciger,
crosses on crowns, no legend

REV.: M, ☩ above, A below; legend in Arabic only: فلس *fals*
(r.), الحق *al-ḥaqq* (ex.), بيسن *bi-baisan* (r.)

Amitai-Preiss, Berman, and Qedar 1999, A19

FINDS: Scythopolis

This rare type, of which one example was excavated at Scythopolis itself, anoma-
lously resembles issues of Tiberias rather than Baisan. Its size and weight are typical
of the small coins of Tiberias, having nothing in common with the heavy standard of
Scythopolis. The reverse inscription has been interpreted to mean "the true *fals* [mint-
ed/issued] in Baisan." If that is correct, it would indicate a serious reform, labeling this
as a valid issue, for an area where coins of a very different standard had been employed.
Taken with the previous type, it may be considered as an effort to produce a standard-
ized coinage for a district, replacing previous anomalies.

REF.: Foss 2002b

Without Mintmarks or Caliph's Name

Tabariya (Probable Mint)

CAT. NO. 89.

(A) OBV.: Three standing figures holding globus cruciger, crosses on crowns, no legend

REV.: M, ✠ above, A below; legend in Arabic only: محمد رسول الله *muḥammad rasūl allah*, "Muhammad is the prophet of God"

Walker 1956, 52, 53; *SNAPalästina* 283

(B) As previous, but legend لا اله الا الله وحده لا شريك له *lā ilaha illā allah waḥdahu lā sharīk lahu*, "There is no God but God alone; he has no associate"

Walker 1956, 17 no. J.1; *SICA* 593; *SNAPalästina* 284

(C) As previous, but legend الله احد الصمد لم يلد *allahu aḥad al-ṣamad lam yalid*, "God is one, eternal; he did not give birth" [Quran 112:2–4]

SNAPalästina 285

These small, lightweight coins correspond in style with the issues of Tiberias. Type A is notably lighter than the others, while B and C are struck on small, thick flans. Types B and C have a further peculiarity: instead of the letter A beneath the M, they have a star, bird, or bull's head. The religious slogans suggest association with the Standing Caliph types, which were not issued in this region; they may be contemporary with them. In any case, an important overstrike (Hirschfeld et al. 1997, 311 no. 103), where type C is struck over a Bilingual coin of Tiberias, suggests that these "religious" types were issued later than the normal Tiberias coins.

These coins present a further anomaly: the combination of Christian symbols on the obverse with the Islamic inscription of the reverse, and the use of a monogram above the M that is derived from, if it does not actually represent, the Christogram.

If these are not the product of the civil wars (see above), they are probably to be associated with the previous types by their style and format. The Islamic legends that they bear appear on Abd al-Malik's dated silver issues in AH 72 (691–92), where they have been taken as a reaction to ibn Zubayr's open profession of Islam. Whether these coins are earlier or later than that cannot be ascertained.

REF.: Phillips 2005

With Name of Abd al-Malik, No Mintmark

Amman (Probable Mint)

CAT. NO. 90.

OBV.: Standing caliph (defined below, p. 66), لعبد الله عبد الملك امير االمؤمنين *li-ʿabd allah ʿabd al-malik amīr al muʾminīn*, "for the servant of God, Abd al-Malik, Commander of the Faithful"

REV.: M, A below; لا اله الا الله محمد رسول الله *lā ilaha illā allah muḥammad rasūl allah*, "There is no god but God; Muhammad is the prophet of God"

Walker 1956, 104; *SICA* 716

FINDS: Amman, Jerash, Jericho

This type is usually very neatly struck on small flans. It has been assigned to Amman by its stylistic resemblance to the Standing Caliph issues of that mint. Except for the M of the reverse, it shares the characteristics of the Standing Caliph coinage. It may represent an intermediate stage before that uniform, large series was introduced.

Experimental Types

The following coins are notable for their religious legends and striking innovations: the transformation of the cross on the gold and copper, and the issue of Sassanian types on the silver, which had never before been struck in Syria. In this, Abd al-Malik accomplished what Muʿawiya had attempted. The silver is dated AH 72–74 (691–94), showing that this period of experimentation continued into the middle years of Abd al-Malik's reign. It forms part of a larger movement that also produced novel types and legends on the Arab–Sassanian coinage of these years.

Gold

Damascus (Probable Mint)

Dinar with Arabic Inscription, Anonymous and Undated

OBV.: Three standing imperial figures as previous; no inscription

REV.: Staff ending in globe on steps, بسم الله لا اله الا الله وحده محمد رسول الله *bism allah lā ilaha illā allah waḥdahu muḥammad rasūl allah,* "In the name of God. There is no god but God alone; Muhammad is the prophet of God," Ɓ I in field.

Walker 1956, p. 18 B2, Miles 1967, nos. 6–13; *SICA* 607 (scale here 1:1)

On this type, the last vestiges of crosses have been removed and the reverse has taken on a distinctive appearance, with much neater striking than the previous. The type survives in at least eight examples struck from two obverse and three reverse dies. It may be the first to use the full *shahada,* the profession of the Muslim faith.

REF.: Miles 1967, *SICA* p. 91

Silver

Damascus

Dirhams of Sassanian style, anonymous but dated AH 72, 73, and 74 (691–94)

OBV.: Sassanian bust, Pahlavi legends; in margin: بسم الله *bism allah* "in the name of God" (الا الله لا *lā ilaha illā allah waḥdahu,* "there is no god but God alone" on yrs. 73 and 74) وحده الله *muḥammad rasūl allah,* "Muhammad is the prophet of God"

REV.: Fire altar with attendants; r.: ثنين *thanain,* "two" (for other years ثلث *thalatha,* "three" or اربعة *arba'a,* "four") و سبعين *wa sab'īn* "and seventy"; l.: دمشق *dimashq*

Walker 1941, 23 (AH 73, 74), *SICA* 278, 279 (AH 72, 73)

Homs

Dirham of AH 72 (691/92)

OBV.: Sassanian bust, Pahlavi legends; in margin: بسم الله محمد رسول الله *bism allah muḥammad rasūl allah,* "in the name of God; Muhammad is the prophet of God"

REV.: Fire altar with attendants; l.: اثنين و سبعين *ithain wa sabʿīn* "seventy-two"; r.: حمص سنة *ḥimṣ sana,* "Homs; year"

SICA 305 (unique; scale here 1:1)

REF.: *SICA* pp. 27f.

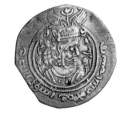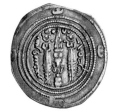

Copper

Anonymous and undated

OBV.: Two standing figures, each holding scepter; between them محمد رسول الله *muḥammad rasūl allah* "Muhammad is the prophet of God"; around, لا اله الا الله وحده لا شريك له *lā ilaha illā allah waḥdahu lā sharīk lahu,* "there is no god but God alone; he has no associate"

REV.: Staff ending in globe on steps, flanked by two stars, same legend as obverse.

Walker 1956, p. 14 Kh. 1

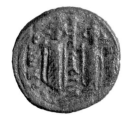

Extremely rare (2 specimens reported). Note that this coin has the same reverse type as the dinar with Arabic inscriptions above.

The Standing Caliph Coinage

The issues of this coinage are united by a common type: the image of a standing bearded figure, wearing an Arab headdress that flows down beside his head, and a long robe, and girt with a sword. His right hand rests on the sword that projects diagonally to his left. This figure appears on the obverse of the gold and copper and the reverse of the silver. The precious metal coins are extremely rare and bear no mintmark (though they

were presumably struck in the capital, Damascus), but are an extremely valuable source because they are dated. They were issued in the years between Abd al-Malik's reunification of the empire in 692 and the introduction of the reformed aniconic coinage, which starts in 697. Identity of type between these and most of the copper issues suggests that they were contemporary, though which were struck first is debated. In any case, this series may be considered as issued at the height of Abd al-Malik's power and as being the last regular Syrian Umayyad coins to depict a human image.

Neither gold nor silver bears the name of the ruler, though the silver issue at least identifies the figure as the caliph, giving his title as "Caliph of God, Commander of the Faithful"; the dates show that Abd al-Malik is intended.

The large and common copper issue falls into two main divisions, characterized by differences in type and legend. The largest series, struck at eleven mints of Syria (in the junds of Damascus, Homs, and Qinnasrin), normally has the name and title of Abd al-Malik on the obverse and the *shahada* around an object on steps that looks like the Greek letter Φ (see pp. 73–74). The mints of Damascus and Amman struck the identical type, but with the *shahada* on both sides; these are strictly speaking anonymous (like the gold and silver), but whether the absence of the caliph's name has any significance is uncertain. The suggestion has been made that they are the earliest issues of the series. Two mints in the jund of Qinnasrin struck types with the caliph's title *khalīfat allah*, "Caliph of God" (a formulation often used in this period), but without his name. Again, the significance of this title on these coins has not been established.

The other variety, struck only in the jund of Palestine, is substantially different. Its obverse figure has a large head, prominent beard, and raised rounded shoulders. His robe is hatched in a herringbone pattern. He wears a heavy headdress that flares out from the head and sometimes seems detached from it; the scabbard of his sword is short, about the same length as the three fillets that hang down from his girdle. The legend is *muḥammad rasūl allah*. These types do not employ the transformed cross on steps, but continue to use the large cursive ₥ familiar from Arab–Byzantine issues. The retention of the denomination mark, along with the absence of the caliph's name, has suggested that the Palestine coins may be earlier than the other Standing Caliph issues, and belong to the first part of the reign of Abd al-Malik.

The coins issued in Mesopotamia at al-Ruha (Edessa) and Harran (ancient Carrhae) form a linking subgroup. They have the same obverse image and inscription as the Palestinian coins, but feature on the reverse the Φ of the standard series. One variety, though, bears the staff ending in a globe that appears on the experimental coins discussed above (pp. 65–66).

Taken as a whole, this coherent series, struck in many more mints than any other Arab–Byzantine type, reflects a growing assertion of a central authority, with a standard type issued all over Syria and the north, and the "Muhammad" coins struck in Palestine and Mesopotamia. The province of Jordan, however, is absent from this picture. There, the large coins of Baisan and Jerash apparently continued in use, with the anonymous religious types of Tabariya possibly providing the supply for that part of the province.

Anonymous Types

Gold

Dinar, AH 74–77 (693–97): (Damascus Probable Mint)

OBV.: Stg. caliph, بسم الله لا اله الا الله وحده محمد رسول الله *bism allah lā ilaha illā allah waḥdahu muḥammad rasūl allah,* "In the name of God. There is no god but God alone; Muhammad is the prophet of God"

REV.: Globe on staff on steps, بسم الله ضرب هذا الدينار سنت اربعة (خمسة، سنة، سبعة) و سبعين *bism allah ḍuriba hadhā al-dīnār sanati arbaʿa (khamsa, sitta, sabʿa) wa sabʿīn,* "In the name of God. This dinar was struck in the year 74 (or 75, 76, 77)"

Walker 1956, p. 42f.; *SICA* 705; Miles 1967, nos. 14–19

Extremely rare: yr. 74: 1 known; 75: 1; 76: 2, 77: 3 (scale here 1:1)

Silver

Dirham of Sassanian Type, AH 75 (694/95): (Damascus Probable Mint)

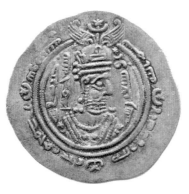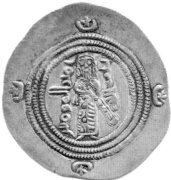

OBV.: Sassanian bust ضرب في سنت خمسة و سبعين *ḍuriba fī sanati khamsa wa sabʿīn,* "struck in the year 75"; in margin: بسم الله لا اله الا الله وحده محمد رسول الله *bism allah lā ilaha illā allah waḥdahu muḥammad rasūl allah,* "In the name of God. There is no god but God alone; Muhammad is the prophet of God"

REV.: Stg. caliph, خلفة الله امير المؤمنين *khal[ī]fat allah, amīr al-muʾminīn,* "Caliph of God, Commander of the Faithful."

Walker 1941, 25

Extremely rare: 2 known. This type has been associated with the experimental Arab–Sassanian silver noted above.

Muhammad Type

The obverse of these coins struck in Palestine and Mesopotamia differs from the normal type and raises an unexpected question: whom does this figure represent? It has usually been identified as the caliph, but there is a real problem, for the inscription names not the caliph, or no one at all, but it names the prophet Muhammad. Coinage bearing portraits of people (basically of rulers) began in the Hellenistic period and has continued to the present day. Whenever an inscription with a name accompanies the image, it identifies the portrait. Image and superscription correspond, as they consistently did on the Roman and Byzantine coinage. There are of course cases of coins with images and no inscription—these occur frequently in seventh-century Byzantine issues—or with an image accompanied by a religious invocation, but I know of no case where the inscription names someone other than the figure accompanying it. That suggests—heretical as it may sound—that these coins actually depict the Prophet of Islam. The imagery would suit a contemporary source, the *Doctrina Jacobi,* written probably in 634, which sees Muhammad as a false prophet because "prophets do not come armed with a sword" (Hoyland 1997, 57, drawn to my attention by Prof. Cyril Mango). In the present state of our knowledge of early Islam and its iconography this possibility can hardly be excluded. These coins, then, would have been struck before the strict iconoclasm and proscription of the image of Muhammad were in effect. The fact that the largest series was from Jerusalem may lend some support to this identification, for that city was closely associated with the Prophet, being the place to which he supposedly made a miraculous journey from Mecca and where Abd al-Malik himself built the Dome of the Rock, a great monument that many associate with veneration of the Prophet.

Appearance of this type in Mesopotamia may also have a certain logic, for that was precisely the area recaptured from ibn al-Zubayr, whose regime, based in Mecca, was noted for its piety. Use of the image there may have been religious propaganda, perhaps showing that the Umayyads could be just as holy as their rivals. Note also the new interpretation that would identify all the "Standing Caliph" figures as representations of the Prophet: Hoyland 2007.

REF.: Foss 2001, 9, Goodwin 2005a, 85–102

Jund of Palestine

Jerusalem (Iliya)

CAT. NO. 92.

OBV.: Standing figure in Arab dress, محمد رسول الله *muḥammad rasūl allah,* "Muhammad is the prophet of God."

REV.: m flanked by فلسطين الييه *ilīya filasṭīn*

Walker 1956, 73–82; *SICA* 730, 731; *SNAPalästina* 1–3; Goodwin 2005a, 95–102

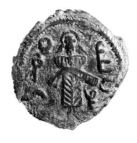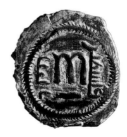

FINDS: Caesarea (?), Jerusalem

A large issue whose major type, consisting of some 75 percent of the coinage, bears the unusual image described above, and a less common type with a thinner, taller, more realistic image. Minor varieties involve the arrangement of the reverse legend, some with a crescent above the m. All these issues are usually very neatly struck on round flans.

Yubna

(A) OBV.: Standing imperial figure holding long cross and globus cruciger; no visible legend

REV.: m flanked by يبني فلسطين *yubnā filasṭīn*

Goodwin 2005a, 119, type 1; cf. 142 type 9, which seems derived from this.

FINDS: (all types): Bethlehem (3?)

CAT. NO. 93.

(B) OBV.: Standing figure in Arab dress, resembling that of the Jerusalem issue, but variously portrayed, محمد رسول الله, *muḥammad rasūl allah,* "Muhammad is the prophet of God."

REV.: m flanked by يبني فلسطين *yubnā filasṭīn,* variously arranged, often incomplete or blundered.

Goodwin 2005a, 120–24, 139–45, types 2, 6, 7, and 8

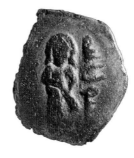

CAT. NO. 96.

(c) As previous, but rays or flames radiating from head, headdress or robe

Goodwin 2005a, 124–39, types 3, 4, and 5

(D) OBV.: Arab figure as (B) but usually with two large globes representing shoulders or chest

REV.: As previous, but legend فلوس يبني *fulūs yubnā*, "money of Yubna"

Goodwin 2005a, 119–45 nos. 91, 138, 139, 140, 143, and 146

These coins are usually struck on very irregular flans of highly varying weight, many of them cut down from old Byzantine folles. They tend to be poorly preserved, often with only the tail of the *ya* of the mint name surviving. This is a copious issue, with 47 obverse and 42 reverse dies identified. The obverses feature a great variety of images: eight distinct types range from a standing imperial figure to a conventional Standing Caliph, but most resemble badly drawn versions of the "Muhammad" type of Jerusalem. The variety and poor execution have suggested that this was an emergency military issue. If so, it could be associated with the efforts of Abd al-Malik to regain control of the coastlands of Palestine that were ravaged by the Byzantines during the civil war and perhaps early in his reign. On the other hand, the bewildering variety and inconsistent treatment of types and legends might suggest that the original series was accompanied by an exceptionally large number of imitations, some of which typically combined incongruous obverses and reverses.

REF.: Goodwin 2005a, 103–45

Ludd

CAT. NO. 101.

OBV.: Standing figure with Arab headdress and hand on sword, as on the coins of Jerusalem or Yubna; crescent above head; محمد رسول الله *muḥammad rasūl allah*.

REV.: ᛗ flanked by لد فلسطين *ludd filasṭīn*

Goodwin 2005a, 155f.

All reported specimens of this very rare issue are struck from the same pair of dies. They are of much neater execution than most of the Yubna issues with which they are connected by the fact that the *Ludd* of the reverse has been recut from an original *Yubna*. This indicates that the mint was of secondary origin and not of sufficient importance to have its own coinage. Alternatively, Ludd could have replaced Yubna as the local mint, but the rarity of these coins compared with the relative abundance of those of Yubna works against such a notion.

REF.: Goodwin 2005a, 153–56

Uncertain Mint

CAT. NO. 102.

OBV.: Standing figure, بسم الله *bism allah*, "in the name of God"

REV.: m, uninterpreted Arabic inscription, possibly reading فلس *filas* (written backward) l., طين *ṭīn* r. or بسم الله *bism allah*

FINDS: Tiberias (variety with *filasṭīn* both sides of m)

OBV.: Standing figure, inscription on l. that may read *lillah*, "for God"

REV.: m, Arabic inscription l. and r. that may read *lillah*, or *ṭayyib*, "good," or both.

One specimen of this type anomalously has a standing imperial figure obverse.

Goodwin 2004b

Like the Yubna issues, these coins are usually badly struck on irregular flans. They pose problems that have not been resolved. They may represent a new mint or mints, or be some sort of imitations.

The first coin would appear to name only the province, not a particular mint. For that, there is a parallel in the post-reform Umayyad coinage: an undated issue (Walker 1956, 911–13) that may have been produced around AH 100–15 (718–33) bears only the name *filasṭin* (another undated series has only the name of the province al-Urdunn: Walker 1956, 743–45). It is generally assumed that these were produced in the provincial capital, Ramla (*SNAPalästina* p. 10 attributes them to Jerusalem). Ramla, however, was founded only around 705, after the introduction of the reformed coin-

age without images. In that case, there seem to be two possibilities; either this coin (presuming it has been read correctly) was struck later than the introduction of the new type—something few would admit—or the name *filasṭīn* refers to the previous provincial capital, Ludd, whose coinage is otherwise exceptionally rare. Alternatively, it may be an issue of Yubna, where the legend *bism allah* occasionally occurs on the obverse: Goodwin 2005a, 124 nos. 32–34. Cat. no. 102 is of the same type, and perhaps from the same dies as Goodwin no. 34, classed with the issues of Yubna. But if it is indeed inscribed *bism allah* on both obverse and reverse, it is strictly speaking a coin without a mintmark.

Jazira province

The coins below have "Muhammad" on the obverse; Φ on steps reverse.

Harran

OBV.: Standing figure, as above; l.: محمد *muḥammad*; r.: حران *ḥarrān*

REV.: Φ on steps, ⋈ l., محمد *muḥammad* r.; I S below

Walker 1956, p. 25f.; cf. 98 which seems to lack mint name; *SICA* 687

Al-Ruha

(A) OBV.: Standing figure, محمد رسول الله *muḥammad rasūl allah*, "Muhammad is the prophet of God"

REV.: Staff ending in globe on steps, بسم الله لا اله الا الله وحده *bism allah lā ilaha illā allah waḥdahu*, "In the name of God. There is no god but God alone"; الرها *al-ruhā* in field

Walker 1956, 93

 FINDS: Dehes

CAT. NO. 103.

(B) OBV.: Stg. figure, محمد رسول الله *muḥammad rasūl allah*, "Muhammad is the prophet of God"

REV.: Φ on steps, بسم الله لا اله الا الله وحده *bism allah lā ilaha illā allah waḥdahu*, "In the name of God. There is no god but God alone"; الرها *al-ruhā* in field

Walker 1956, 92; *SICA* 688

Note that variety (a) of al-Ruhā has the same reverse design as the gold and copper experimental types above. These types, which share the *muḥammad* obverse with the issues of Palestine, but mostly have the Φ on steps of the normal Standing Caliph issue, were struck in territory reconquered from ibn Zubayr, and were therefore not issued before 687 or more probably 690. For the significance of the Φ, see below on the standard type.

Uncertain Mint

OBV.: Standing figure, محمد رسول الله *muḥammad rasūl allah,* "Muhammad is the prophet of God"

REV.: Φ on steps, بسم الله لا اله الا الله وحده *bism allah lā ilaha illā allah waḥdahu,* "In the name of God. There is no god but God alone"; I S (and possibly محمد *muḥammad)* in field.

Walker 1956, 98

This type has no mintmark; its type resembles the issue of al-Ruha, but the I S would seem to associate it with Harran.

Standard Type

All regular Standing Caliph types have a standing figure with hand on sword on the obverse and a Φ on steps on the reverse.

The meaning of the curious symbol on the reverse has given rise to much discussion. It obviously was intended to replace the cross of Golgotha, which was normally portrayed as standing on steps, forming the characteristic type of the Byzantine gold. But whether it was simply designed as a replacement for the cross, or had a specifically Islamic meaning is uncertain. The most recent (and plausible) theory identifies it as the *quṭb*, or pole, symbolizing the caliph as center of the community.

REF.: General: Bone 2000, 71–127, 344–64 (by far the most detailed treatment, with useful tables, but still unpublished), *SICA* 91–98 (comprehensive description and analysis); Φ: Jamil 1999; *SICA* p. 93

Anonymous Issues with Religious Legends Both Sides

All the following are from the jund Damascus.

Damascus

CAT. NO. 104.

OBV.: لا اله الا الله وحده محمد رسول الله (بسم الله) *(bism allah) lā ilaha illā allah waḥdahu muḥammad rasūl allah,* "(In the name of God.) There is no god but God alone; Muhammad is the prophet of God."

REV.: same legend (without *bism allah*); دمشق *dimashq* in field

Walker 1956, 86–90 (legends often defective); *SICA* 706–14

FINDS: Antioch (2), Jerash; Neve Ur (2), Shiloh

Amman

OBV.: لا اله الا الله وحده محمد رسول الله, *lā ilaha illā allah waḥdahu muḥammad rasūl allah,* "There is no god but God alone; Muhammad is the prophet of God"

REV.: same legend; عمان، *ammān* in field

Walker 1956, 96

FINDS: Amman (4)

Standing Caliph Obverse with Title, No Name; Φ on Steps Reverse

All the following are from the jund Qinnasrin.

Maʿarrat Misrin

OBV.: خلافة الله امير المؤمنين *khal<ī>fat allah āmīr al-mu'minīn,* "Caliph of God, Commander of the Faithful."

REV.: لا اله الا الله وحده محمد رسول الله, *lā ilaha illā allah waḥdahu muḥammad rasūl allah,* "There is no god but God alone; Muhammad is the prophet of God"; معرة .l، مصرين r., *maʿarat miṣrīn* flanking Φ

Walker 1956, 99–101; *SICA* 674–78; mint name always blundered

FINDS: Antioch, Çatal Hüyük, Qalat Siman?

Manbij

CAT. NO. 127.

OBV. AND REV. as previous; واف *wāfin*, "full weight"; منبج *manbij* in field

Walker 1956, 102–3, B4; *SICA* 679–82; legends often blundered

Sarmin

Obv. and Rev. as previous; سرمين *sarmīn* written on either side of Φ

Walker 1956, 94–95; *SICA* 649–55

FINDS: Dehes

The legends on these coins are usually blundered; they appear to have an additional, unparalleled obverse legend امير الله *amīr allah,* "commander of God." Note that on all these the *ya* of the word *khalīfa* is omitted; types with this inscription were struck only in these outlying mints of the jund Qinnasrin. Manbij and Sarmin also issued the normal type (below). This peculiar spelling also appears on the experimental silver of AH 75.

Standing Caliph Obverse with Name and Titles; Φ on Steps Reverse

OBV.: (ل)عبدالله عبد الملك امير امؤمنين (*li*) *ʿabd allah ʿabd al-malik amīr al-muʾminīn* "(for) the Servant of God, Abd al-Malik, Commander of the Faithful"; the word in parens appears on some of the coins

REV.: لا اله الا الله وحده محمد رسول الله, *lā ilaha illā allah waḥdahu muḥammad rasūl allah,* "There is no god but God alone; Muhammad is the prophet of God"

SICA 608–729, p. 95 with full description of varieties of size, style, and legends.

These coins have distinctive varieties: the northern mints (jund Qinnasrin) have a tall thin Φ, the material that hangs down from the figure's waistband is portrayed as a loop, and the quality of design, lettering, and production tends to be poor. Damascus and Amman, on the other hand, have a short round Φ, three fillets hanging from the waistband, and neat manufacture. The coinage of Homs is intermediate between these. Coins of the Qinnasrin jund (except for those of Sarmin) normally have the validating word واف *wāfin* "full weight" in the reverse field, in addition to the mintmark.

The poor quality of the Qinnasrin coins suggests rapid production, which is pos-

sibly to be associated with military activity. Otherwise, it is not obvious why coins would be struck in some of these mints at all: they are far in the north, remote from the centers of an empire that stretched from the Atlantic to the Indus, and even eccentric in terms of location within Syria. They were, on the other hand, of great strategic importance for guarding the northern frontier against the caliphate's greatest enemy, Byzantium, as well as for communications between Syria and Mesopotamia. Since this area was the base for the annual expeditions against the Byzantines, it is natural to suppose that these mints existed to serve the military. These Standing Caliph coins were presumably issued in the first decade or so of Abd al-Malik's reign, but that was a time without active conflict between the Umayyads and Byzantines. More probably, then, their issue might be associated with another series of campaigns that took place just in this area, the long struggle against ibn Zubayr, who controlled Iraq and the East. For that, Abd al-Malik established his base at Butnan Habib, east of Aleppo in the district of Qinnasrin, camping there every winter from AH 68 (687/88) until he finally gained supremacy in Iraq in 71 (690/91). On this occasion, a large army was assembled and kept operational over a period of several years in precisely the area where these coins were struck. Although the association between coins and history cannot be proved, the civil war provides a plausible occasion for striking coins in this area.

REF.: Foss 2001, 10

Since the following coins are all of the same type, only the mint name and significant variations will be noted.

Damascus Jund

Damascus

(A) REV.: دمشق *dimashq* in field

Walker 1956, 121

(B) Obverse and reverse legends reversed

Walker 1956, 122; *SICA* 715

Amman

CAT. NO. 107.

REV.: عمان ʿammān in r. field; ✳ in l.

Walker 1956, 126–31; *SICA* 718–29

Very neatly struck on small flans; large Ⲫ

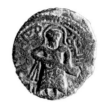

FINDS: Amman (13), Mount Nebo

Baalbek

OBV.: legend preceded by بسم الله *bism allah*

REV.: بعلبك *baʿlabakk* in field

Walker 1956, p. 32; *SICA* 701–4; Goodwin 2005a, 53f.

These uncommon coins (only 3 or 4 obverse and reverse dies known), closer in style to the issues of Homs than those of Damascus, employ uniquely florid lettering.

Homs Jund

Homs

CAT. NO. 111.

REV.: بحمص *bi-ḥimṣ* in r. field; often with ✳ in l. field

Walker 1956, 118, Th. 1; *SICA* 689–96

Usually well struck on large flans; a variety has the additional word ضرب *ḍuriba* "struck" in the l. reverse field: *SICA* 697–700

FINDS: Antioch (2), Apamea

Qinnasrin Jund

Qinnasrin

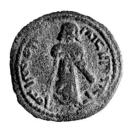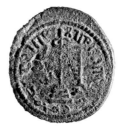

CAT. NO. 112.

REV.: واف بقنسرين *wāfin bi-qinnasrīn,* "full weight, in Qinnasrin" in field

Walker 1956, 132–35; *SICA* 657–65

Usually struck on broad flans; tall thin Φ; there are varieties in the arrangement of the legend

FINDS: Antioch (2), Çatal Hüyük, Dehes (2)

Halab

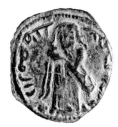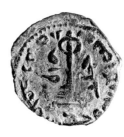

CAT. NO. 118.

REV.: (واف) (ب)حلب *(wāfin) (bi)-ḥalab,* "(full weight) (in) Halab" in field

Walker 1956, 106–17; *SICA* 608–38

A large issue with many varieties of style, size, and legend, sometimes poorly designed. Some have ✳ in l. field

FINDS: Antioch (4), Çatal Hüyük, Qalat Siman (2), Balis

Jibrin

REV.: واف (ب)جبرين *wāfin (bi-)jibrīn,* "full weight, (in) Jibrin" in field

Walker 1956, 105, I2

Manbij

REV.: واف منبج *wāfin manbij,* "full weight, Manbij" in field

Walker 1956, P9, 136, J3; *SICA* 679–82

Qurus

REV.: واف بقورس *wāfin bi-qurus,* "full weight, in Qurus" in field

Walker 1956, p. 40, J2; *SICA* 672–73

Sarmin

REV.: سرمين *sarmīn* in field l. and r.

Walker 1956, 123–24; *SICA* 639–48

A rare variety adds the name عبد الرحمان *ʿabd al-raḥmān*, perhaps that of a governor, on both sides of the figure: see Goodwin 1997, cf. Foss 2001, 7

Tanukh

CAT. NO. 129.

REV.: واف بتنوخ *wāfin bi-tanūkh* "full weight, in Tanukh" in field l. and r.

Walker 1956, p. 41 P10 (not identified); *SICA* 656

FINDS: Antioch

The name of this mint has been variously identified; Tanukh seems the most probable reading. The tall and narrow reverse Φ would associate it with the jund of Qinnasrin, but no place of that name appears in the sources. On the other hand, the name Tanukh is well known in northern Syria as that of a famous Christian tribe that had settled in Hadir or ("Camp") Qinnasrin, outside the city. Some converted to Islam after the Arab conquest and fought as allies of the Umayyads, on the side of Muʿawiya in the first civil war and of Marwan in the second. It would seem natural to associate them with this coinage. Yet all the other known Arab–Byzantine mints are places (whether towns or districts), not people. One possible solution is that some place, no longer attested, took the name of the tribe settled there, and was the site of the mint.

REF.: Foss 2001, 9

Uncertain Mints

CAT. NO. 130.

REV.: واف *wāfin* in field l., سر *sar* r.

At first sight, this would appear to be a coin of Sarmin, but those invariably split the full name of the mint, writing it on either side of the Φ, and do not employ the term *wāfin*. The present coin may instead bear the blundered mint name منبج *manbij*, though in that series the initial letter *mim* is usually clearly written.

Several coins of this type have been published with mint names that seem not to correspond with any known place. Some of these may simply be blundered forms, a common phenomenon on this coinage (for example, Stephen Album, *Price List No. 139,* September 1997, no. 60 attributed to Bosra may simply bear the badly written name of Halab, as on no. 117 here); others may represent mints not previously attested.

REF.: Walker 1956, p. 41, *SICA* 683–86, Goodwin 2003a

Conspectus of Syrian Coinage by Mints

This table is a synopsis of the Syrian coinage, arranging the coins by mints within the junds, to show which types and which series were struck at each mint. Note that the names of mints in parentheses do not actually appear on the coins, but are their probable place of issue.

	Type and Features			
Mint	Imitative and Derivative Coins	First Bilingual series (with standing figure)	Main Bilingual series	Standing Caliph
Jund of Damascus				
Damascus	AR dirham, Arab–Sassanian type	ΔAMACKOC/ Arabic	ΛЄO/Greek, stg. figure	Anonymous
			ΛЄO/Greek, std. fig.	Standard type
			ΛЄO/Arabic, stg. figure	
(Damascus)	AV solidus, Greek (Muʿawiya)			AV dinar, AH 74–77
	AV solidus, Greek, transformed cross			AR dirham, AH 75
	AV dinar, Arabic			

(table continues)

(Conspectus of Syrian Coinage by Mints continued)

Mint	Type and Features			
	Imitative and Derivative Coins	First Bilingual series (with standing figure)	Main Bilingual series	Standing Caliph
"Pseudo-Damascus"			Great variety	
Heliopolis/ Baalbek			Two figs., Bilingual	Standard type
Amman			Two figs., Arabic	Anonymous Standard type
(Amman)				M reverse
Jund of Jordan				
Tiberias/ Tabariya		Greek	Three figs., Bilingual	
			Three figs., Arabic: *quṭrī*	
(Tabariya)			Three figs., Arabic: religious inscriptions	
Scythopolis/Baisan			Two std. figs.; "M" Greek and Bilingual	
			"K" Greek and Bilingual	
			Three figs. (Tiberias type), Arabic: *fils al-ḥaqq*	
Gerasa			Two std. figs. Greek	
(Gerasa)				Two stg. figs. Arabic
Abila?			Two std. figs. Greek	
Jund of Palestine				
Jerusalem/Iliya		Greek		Muhammad; M
Yubna				Muhammad; M
Diospolis/ Ludd	countermark only	Greek		Muhammad; M, recut from Yubna

(Conspectus of Syrian Coinage by Mints continued)

	Type and Features			
Mint	Imitative and Derivative Coins	First Bilingual series (with standing figure)	Main Bilingual series	Standing Caliph
Jerusalem?	"De-Christianized" type			
Unknown	"Muhammad" type, square			
Jund of Homs				
Emesa/Homs	AR dirham, Arab–Sassanian type	Bilingual	Bust; Bilingual	Standard type
(Homs)	ΛITOIЄ type			
Antaradus/ Tartus			Bust; Bilingual	
Jund of Qinnasrin				
Qinnasrin				Standard type
Halab				Standard type
Jibrin				Standard type
Ma'arrat Misrin				*Khalīfat Allah*
Manbij				*Khalīfat Allah* Standard type
Qurus				Standard type
Sarmin				*Khalīfat Allah* Standard type
Tanukh				Standard type
al-Jazira				
al-Ruha				Muhammad, Φ
Harran				Muhammad, Φ

Note: Mint names in parentheses do not actually appear on the coin

EGYPT

CHAPTER 8

BYZANTINE EGYPT, 602–621

The coinage of seventh-century Egypt shares many features with that of Syria: it progresses from purely Byzantine issues (which, unlike three of Syria, include gold), through coins struck by the Persian occupiers, then back to the Byzantine. It includes a series that can be called Arab–Byzantine, and ends with a uniform anonymous coinage without images. It differs though in its denominations, which were expressed on a duodecimal standard. Although Justinian uniquely struck a 33-nummus piece, the most common denomination was the 12-nummus (IB in Greek numerals), sometimes accompanied by fractions. Egypt also differs in that its official Byzantine coinage continues through the first issues of Constans II, for Egypt remained in imperial hands for several years after the loss of Syria. The coinage of Egypt struck after the Arab conquest derives its imagery from the Byzantine, in some cases as imitations, in others devising new types. But nowhere is the exuberant variety of Syria apparent. Instead, the Egyptian coinage is all in copper, virtually all of it of a characteristic thick, dumpy fabric, with poorly engraved images and clumsily written inscriptions. However limited its types, it poses similar problems of date and attribution, and leaves major questions to be answered.

Egypt was economically the most important province of the later Roman Empire. Its large population, rich soil, and vast agricultural production meant that it not only contributed some thirty percent of the empire's taxes, but supplied the vast quantities of grain that fed the population of Constantinople. Its capital, Alexandria, the second city of the empire, was the seat of the Augustal Prefect and of the ecclesiastical patriarch. The prefect, whose powers had been extreme until the administrative

reorganization of Justinian, still commanded Alexandria and the western Delta and exercised primacy over the other four provinces into which the diocese of Egypt was divided. He had military and civil power as well as prime responsibility for supervising the collection and shipment of grain to the capital. He was directly responsible to the praetorian prefect of the East in Constantinople. The governor's subordinates were the *duces* in each province and under them the local *pagarchs,* who had jurisdiction over the major towns and the villages around them. The whole administration was organized primarily to collect the vast and complicated array of taxes imposed on the population. These were paid in kind and in gold, reflecting Egypt's overwhelmingly monetary economy, with taxes regularly calculated in gold nomismata and their fractions. An abundant documentation preserved on papyrus attests to the extent and complexity of the Egyptian bureaucracy and the taxes it collected. It also reveals the growing power of the great landowners, whose authority often conflicted with that of the civil administration.

The Egyptian church, famed for its wealth and the number and influence of its monasteries, was deeply divided. Since the mid-fifth century, the vast majority of the population followed a different interpretation of Christian doctrine from the orthodox church of Constantinople. There were often two rival patriarchs, one installed in Alexandria by the central government, the other making his headquarters outside the city. These divisions were another source of stress for the administration of the country, but the basic work of mobilizing and exploiting the resources of Egypt continued throughout despite revolts, civil war, and foreign occupation.

The seventh century in Egypt opened with serious trouble, as Alexandria and its surroundings were plagued by revolts in the final years of Maurice (598–601). The central government regained control, however, and maintained the country in peace along traditional lines until the major civil war that started in Carthage in 608. The rebel governor of Africa, Heraclius the elder, sent his nephew Nicetas overland; he took Alexandria that same year. The emperor Focas, whose hands were tied by Persian invasion in the east and revolts in Syria, ordered in his ferocious general Bonosus, who defeated Nicetas in 608/9, enabling the government to maintain control in Upper Egypt till early 610. By that time, though, Nicetas had won a signal victory outside Alexandria. Bonosus withdrew and by the end of 610 all Egypt was in the hands of Heraclius. He appointed Nicetas, his cousin, to govern the country. Egypt prospered under the restored regime, but it had only been established for half a dozen years when the Persians appeared on the scene.

REF.: Borkowski 1981, Palme 2002, Olster 1993

There are no copper coins of Alexandria bearing the name of Focas; only one unique gold solidus *MIB* 30 (cf. Bendall 2003, 314), of the usual facing bust/angel type, with reverse legend ending in IП, may possibly be attributed to that mint by analogy with the issues of Heraclius with similar inscription (see below). An abundant series of small copper coins of the IB denomination, however, have been assigned to his reign. Their crudely designed obverses bear blundered inscriptions that seem to name Justin, Justinian, and later emperors (but not Focas himself). They are common in excavations and finds at Alexandria, Upper Egypt, and Caesarea in Palestine. They appear to have filled the need for small change in Egypt and regions associated with it. Many of them are apparently unofficial issues, for a clay mold for making cast coins of this type was discovered at the great White Monastery of Sohag in Upper Egypt. Coins of Heraclius (of the smaller S or 6-nummus denomination) overstruck on this type, as well as the evidence of hoards, show that these anonymous coins were in circulation by the early years of Heraclius. For the moment, they may be considered as products of the early seventh century, but major questions remain.

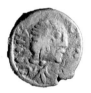 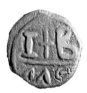

OBV.: Head r., illegible blundered inscription

REV.: I + B, ΛΛЄ in ex.

DOC 106 (Focas); *MIB* 90

REF.: DOC 2.1:150; hoards: Noeske 2000, 2:130f., 254, 364 (= Milne 1947), 400; overstrikes: Bendall 1980, Evans 2006, 200f.; Caesarea: Bijovsky (forthcoming); mold: Noeske (forthcoming)

In 608–10, the rebels struck three types of solidi at Alexandria, with obverses portraying the exarch Heraclius and his son the future emperor, and reverse inscriptions celebrating the (potential) victory of the Augusti or, more discreetly, consuls:

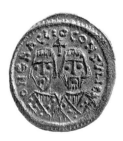 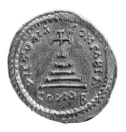

OBV.: Facing busts of the two Heraclii wearing consular robes, cross above, ƆN ЄRACLIO CONSVLI, blundered BA at end

REV.: Cross on steps, VICTORIA CONSΛB, IΛ at end. COИOB in exergue

DOC 11 (here); the other types are *DOC* 10 and 12; *MIB* 2–3

The rebels also issued an extremely rare copper coinage; only one example has been published. It has the two busts on the obverse, with the typical Alexandrian I + B reverse: Braunlin and Nesbitt 1999. The heavy weight of this coin, almost twice the average of the "Focas" types, corresponds to the early issues of Heraclius.

When he was in control of Alexandria (610–19), Heraclius struck gold and copper at Alexandria. The solidi are of two main types: an early issue of 610 with a bust resembling that of Focas, and an angel holding a long cross on the reverse (*DOC* 186, *MIB* 76); and a more common type, struck 610–13:

OBV.: Crowned facing busts of Heraclius and a smaller Heraclius Constantine, cross above, ddNN hERACLIꙊS ET hERA CONST P; exergual line beneath busts

REV.: Cross on steps, VICTORIA AVGꙊ; I, IΠ, or IX added at end

DOC 187 (187b4 illustrated here), *MIB* 77–78

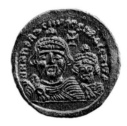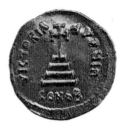

This type has also been attributed to Jerusalem (Bendall 2003, 315f.), but none has ever been found there, while they have been discovered in Egypt; see the discussion in *DOC* 2.1:232f.

Heraclius struck minor coins at Alexandria in three denominations. The types of the larger, IB coins often derive from those of the gold issues, rather than being parallel with the copper of Constantinople.

REF.: Domaszewicz and Bates 2002, to be used with the essential corrections of Metlich and Schindel 2004

12 Nummi

(Type 1 [following *DOC* classification]) Heraclius alone, struck 610–13

OBV.: Facing bust in consular robes, no inscription.

REV.: Cross on steps between I B

DOC Focas 105, reattributed by Hahn 1978: *MIB* 199

(2) Heraclius and Heraclius Constantine, struck 613–18

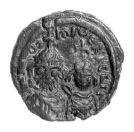 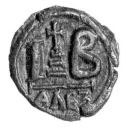

OBV.: Crowned facing busts of Heraclius and a smaller Heraclius Constantine, ΔOMIႮ ჩERACLIS, usually blundered

REV.: Cross on steps between I B; ᲐᲚEჳ in ex.

DOC 189 (189.12 illustrated here); *MIB* 200; Domasze-wicz and Bates 2002, type B1. In a rare variety, *DOC* 190/*MIB* 201, the cross rests on a letter N.

REF.: Goodwin 2003b

6 Nummi

OBV.: Two robed stg. figures.

REV.: Large S

DOC 199, *MIB* 212; probably struck 613 or 628/29 (*DOC* 2.1:342 note)

Large cross replaces imperial images. Struck 613–18.

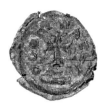

OBV.: Cross on steps, blundered ΔOMIႮ ჩERACLS

REV.: large S

DOC 198 (198.13 illustrated here), *MIB* 210.

REF.: Bendall 1980

3 Nummi

OBV.: eagle with curved wings, no legend

REV.: large Γ

MIB 213; very rare

THE PERSIAN OCCUPATION, 618–630

While the Persians were conquering Syria, refugees poured into what seemed safe and prosperous Egypt, where the enormously wealthy church, highly centralized in Alexandria, took care of them. Once the Persians had consolidated their power in Syria, though, they moved on Egypt under the leadership of their greatest general, Shahrbaraz, in 616 or 617. By June 619, they had conquered Alexandria and by 621 were in control of the entire country. As elsewhere, the initial phase of the occupation was marked by massacre and destruction (monasteries around Alexandria especially suffered), but the Persians soon took over the elaborate administrative machinery. They employed the same people to collect the same taxes, and left the local aristocracy in control of the countryside. They kept the traditionally detailed records of an elaborate bureaucracy in Greek and their native Pahlavi. Their main innovations involved establishing a governor in Alexandria to rule all Egypt through a network of Persian military subordinates. The regime controlled transport by land and the Nile, and maintained a postal system. It requisitioned men and goods, as all previous regimes had done. The Persians ran an orderly administration along traditional Egyptian lines with few innovations; they allowed social, economic and ecclesiastical life to continue with relatively little disruption.

Events outside Egypt cut short the Persian occupation. At first, the end of the war in 628, after the deposition and murder of Chosroes, did not affect Egypt, where Shahrbaraz had broken with the Persian government and remained in control, even though peace negotiations were under way. Finally, in July 629, Shahrbaraz met the victorious Heraclius in eastern Asia Minor and agreed to withdraw from the con-

quered territories in exchange for help in securing the Persian throne. The Persians left Egypt late in 629 or early in 630. The exact date is unknown, but papyrus documents that once again name Heraclius and Heraclius Constantine show that the Byzantines were back in control by May 630, if not before.

The Persian administration evidently carried out a major currency reform, issuing a complete series of denominations on a heavy standard:

12 Nummi

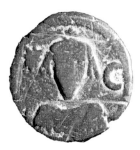 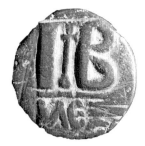

OBV.: Facing bust, with cross on crescent on crown, flanked by star and crescent, no inscription

REV.: Cross on globe between I B; ΛΛЄẐ in exergue

DOC 192, *MIB* 202a

BZC.2004.1.73

There has been much debate about the attribution of these coins; in the most recent discussion, Metlich and Schindel 2004 (refuting Domaszewicz and Bates 2002) argue convincingly that they are indeed a product of the Persian occupation. For the organization of the coins into a heavy and light series, see Hahn 1978 and *MIB* 3 p. 113, but note that Metlich and Schindel 2004, 12 suggest that the light coins preceded the heavy.

6 Nummi

OBV.: Palm tree

REV.: large S

DOC 200, *MIB* 211

3 Nummi

OBV.: Palm tree

REV.: Γ

DOC 201, MIB 214

Nummus

OBV.: Large ✳

REV.: A, cross above

DOC (Justinian) 375, MIB 215

In a second reform, perhaps in the 620s, only the IB denomination was issued, at about half the weight (around 8 g instead of 16) of the previous series. The facing figure has a simple cross on his crown.

DOC 191, MIB 202b

CHAPTER 10

THE BYZANTINE RESTORATION, 630–646

The restored regime of Heraclius took over Egypt without any recorded problems, and ruled it by the normal means, but had hardly been established when the Arabs began their astonishingly successful incursions into Syria. After the Arab commander Amr ibn al-ʿAs took Gaza, the key city on the frontier, in 637 Egypt gained a respite from attack. During these years, the dominant figure, in Byzantine Egypt was the patriarch Cyrus, who had been appointed governor by Heraclius in 630. Although regarded by much of the population as a heretic (he espoused a new doctrine promulgated by the emperor), his power in Alexandria was such that he entered into negotiations with Amr, who agreed to accept a generous tribute as the price of leaving Egypt alone. In 639, though, when Syria had been effectively lost, Heraclius deposed Cyrus, blaming his extravagance, and put a new prefect, the Armenian Manuel, in charge. When Manuel refused to continue paying the tribute, Amr led his army into Egypt in December 639, defeated the Byzantine forces, and lay siege to the crucial fortress of Babylon at the head of the Delta, which controlled the routes into Upper Egypt. Its fall in April 641 doomed imperial rule. Arab forces besieged Alexandria in June and also moved into Upper Egypt. By this time, the Byzantine government was in turmoil; the death of Heraclius in January or February 641, followed by rapidly changing emperors, left the way open for competing factions and differing views of how to deal with the crisis in Egypt. The new government of Constans II restored Cyrus, who began negotiations. In November 641, a treaty was agreed by which the Byzantine forces would withdraw peacefully; they evacuated Alexandria in September or October 642. Byzantine rule seemed at an end, but Constantinople did not give up hope. Late in 645,

when there was a serious dispute within the highest ranks of the new Arab regime, Manuel returned with the Byzantine fleet and with the help of the local population managed to reoccupy Alexandria. When the imperial forces moved out into the Delta, however, they met defeat. The city was besieged a second time and taken by force in the summer of 646. Byzantine rule came to a permanent end.

The years 641 to 646, when four emperors ruled as Augusti, were a time of great confusion, reflected in varying attributions of the coins.

Heraclius and Heraclius Constantine, 613–January or February 641

Heraclius Constantine with Heraclius II, January or February–April or May 641

Heraclius II (Heraclonas), April or May–October 641

Heraclius II with Constans II, October 641–November 641 or January 642

Constans II alone, November 641 or January 642–September 642; 645–summer 646

REF.: *DOC* 2.1:385, 389, 402; Mitthof 2002, 222–29

The restored regime of Heraclius (and his successors) struck only the **IB** denomination. Abundant finds, particularly in the excavations of Abu Mina near Alexandria, indicate that the government was determined to replenish the supply of coinage, which seemed to have ebbed during the Persian occupation.

REF.: Noeske 2000, 1:172f.

Heraclius

(*DOC* TYPE **3**) OBV.: Cross on steps between two facing crowned busts, no inscription.

REV.: Cross on globe above pyramid or letter delta between I B; ⲀⲖⲈⲌ in exergue. Apparently struck in 629.

DOC 193, 194, *MIB* 203, 204; Domaszewicz and Bates 2002, type B 2a, 2b (*DOC* 193.2 illustrated here)

This type had been assigned to the early years of Heraclius but Philip Grierson opted for 628/29 (necessarily 629 or later; in 628 the Persians still occupied Egypt) because of a mule between it and the following type; see *DOC* 2.1:234. On the other hand, the "mule" may, as in so many cases of the Syrian coinage, be an imitation, drawing its types from two different coins. A late date is supported by the relatively large head of Heraclius Constantine, which invites comparison with the solidi of

ca. 626–29. Furthermore, the prominence of the cross on steps on the obverse raises the possibility that the type reflects the triumph of Heraclius and the restoration of the True Cross to Jerusalem.

(4) **OBV.:** Long cross between facing busts of Heraclius with long beard and beardless Heraclius Constantine; no legend

REV.: Cross on Δ between I B. ΑΛΕჽ in exergue.

Issued 629–31.

DOC 195, *MIB* 205; Domaszewicz and Bates 2002, type B2c

(5) **OBV.:** Robed standing figures of Heraclius, Heraclius Constantine, and Heraclonas; no legend.

REV.: As previous

Issued 632–41.

DOC 196, *MIB* 206; Domaszewicz and Bates 2002, type B3a

(6) As previous but rev. cross on line above M between I B. Issued 632–41

DOC 197, *MIB* 209; Domaszewicz and Bates 2002, type B3b

The M of the reverse may indicate that these 12-nummus coins had the same value as the 40-nummus (M) pieces issued in Constantinople and Syria and struck at this time on a reduced standard.

Constans II

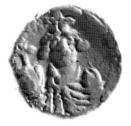

(1) **OBV.:** Beardless facing bust, holding globus cruciger

REV.: As Heraclius type 6

DOC Heraclonas 7, *MIB* 188; Domaszewicz and Bates 2002, type B4 (*DOC* 7.1 illustrated here)

This type, tied by its reverse to the last issue of Heraclius, could have been produced by any of his immediate successors, Heraclius Constantine, Heraclius II, or Constans II. Opinion favors Constans, if only because he was in control of Alexandria

longer than his immediate predecessors. In any case, an overstrike (in the Goodwin collection) shows that it was earlier than type 2.

(2) OBV.: Robed emperor stg. facing, holding long cross and globus cruciger

REV.: As Heraclius type 6

Awad 1972, 116, type 4(d)

The one reported example of this type looks authentic enough, in which case it would be intermediary between types 1 and 3, but it could also be a mule or an imitation.

(3) OBV.: Robed emperor stg. facing, holding long cross (sometimes ending in ₽) and globus cruciger

REV.: Cross on globe between I B flanked by pellets in field l. and r.; ᴧᴧᴇᴢ in exergue

DOC 105, *MIB* 189; Domaszewicz and Bates 2002, type B5 (*DOC* 105.3 illustrated here)

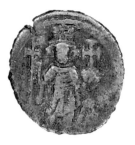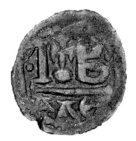

A variety (*DOC* 106, *MIB* 190) has no pellets flanking the I B of the reverse, and the cross resting on a globe. It is usually smaller and less well designed. This type, which forms the basis for much of the Arab–Byzantine coinage of Egypt, seems to consist of two issues, with the large and small being quite distinct. Tony Goodwin suggests that the larger coins may have been issued in 641–642, with the smaller perhaps representing the reoccupation of 645–46. The standing image corresponds to the early issues of Constans of Constantinople, imitated in Syria, though without the religious legend.

FINDS: Fustat

CHAPTER 11

EGYPT UNDER THE ARABS, 642–705

The new rulers, who formed a military elite, and constituted only a tiny minority of the Egyptian population, made their headquarters in a camp outside Babylon, which by 643 had become a city, Fustat, and capital of Egypt. Here resided the Arab fighters (who did not settle in the countryside); their number grew from about 15,000 soon after the conquest to 40,000 by the time of Muʿawiya. The caliph in Medina (later in Damascus) appointed the governor *(wali* or *symboulos),* who headed the entire regime—often with a great deal of independence—aided by his military commander, the *sahib al-shurta,* and the chief religious judge, the *qadi.* The governor presided over Egypt's traditionally elaborate administration, somewhat simplified by dividing the country into only two provinces, headed by *amir*s or *duces.* Below them, and essential for the smooth functioning of the regime, were the sixty or so pagarchs who transmitted the governor's orders to the population of town and village. These were local worthies, but no longer the great landowners whose wealth and influence diminished rapidly after the conquest.

After the governor Abd Allah ibn Saʿid (645–656) established a central financial bureau, the regime was more efficient—and more concerned with paperwork—than the Byzantine. Its main function was to ensure tranquility and to extract as much as possible from the country. The same vast array of taxes, collected by the same kind of officials, persisted, now supplemented by a poll tax on the Christian population and increasingly exacerbating requisitions of men and material, much of it directed to building fleets and equipping the naval expeditions that set out against Byzantium—notably the massive armada of 654—and soon established Arab domination

of the eastern Mediterranean. The exactions stirred resistance, which at first took the form of flight by individuals from their native jurisdictions (people in the countryside were especially reluctant to be sent to sea), then to serious revolts in the early eighth century.

Because of its wealth, Egypt played a important role in the Arab civil wars, for possession of the country conferred a great material advantage. Conflicts over the centralizing policies of the caliph Uthman, who wanted to extract a greater proportion of Egypt's revenue for the central government, led to a serious revolt in 656. Mu'awiya, governor of Syria, suppressed it after a year, but then Egypt was caught up with his struggle against the caliph Ali. Finally, in 658, Mu'awiya sent in the conqueror Amr, who held the country till his death in 664; his successors continued to control the country in the caliph's name. During these years, Egypt's resources were constantly mobilized for naval expeditions against Constantinople, culminating in the operations of 674–77, when the Arab fleet attacked from a base in the Sea of Marmara. This period of stability lasted until the next civil war, which broke out on the death of Yazid I in 683. Marwan I sent an army that besieged Fustat and conquered Egypt by the beginning of 685. He appointed as governor his son Abd al-Aziz (685–705), whose long regime brought stability, increased efficiency, and the first steps to Arabization: he ordered a thorough land survey and named the first Arab pagarch. His successor and cousin, Abd Allah ibn Abd al-Malik, made even greater change: in 706, he ordered that official records should be kept in Arabic, rather than Greek or the native Coptic. From this time bilingual documents become dominant, eventually to yield to those entirely in Arabic.

Imitative coins

The documentary evidence of the papyri, confirmed by that of hoards, makes it abundantly clear that Byzantine gold coins continued to circulate in Egypt for decades after the Arab conquest. Taxes were calculated in nomismata, and large transactions employed them. These were evidently the vast stock of gold already in the country at the time of the conquest, supplemented by issues of Constans II, but rarely those of his successors. The largest hoard, consisting of fractional gold of Constans II, comes from Sohag in Upper Egypt; others are much smaller. Their evidence may be supplemented by that of the Bajocchi collection, apparently formed from coins found in the Fayyum. This contained sixty-two Byzantine gold coins, including twenty-one of

Heraclius, four of Constans II, and one of Constantine IV (Noeske 2006, 427–33). Likewise, as in Syria, later copper coins of Constans, issued 653–68, continued to reach Egypt, though in relatively small quantities.

The copper coins of the last Byzantine period were widely imitated, especially Heraclius types 4, 5, and 6 and Constans type 2. Examples are abundant in private collections, and have been reported in hoards and excavations from Alexandria, Fustat, and Upper and Lower Egypt. Curiously, though, neither real nor imitation Byzantine bronzes of the seventh century are found in the Fayyum (Noeske 2006, 13). The Imitative coins vary considerably in size and weight, but are distinct in style and fabric from the regular Byzantine issues. By analogy with Syria, it would appear that imitations represent the first wave of coinage produced after the Arab conquest. Some, of course, that copy early types of Heraclius (e.g., *DOC* 189.13 and 14) or those of the Persian period (*MIB* Heraclius X49) could have been made decades earlier, perhaps during the Persian occupation. In any case, neither the date nor place of production of these imitations has been determined.

The present two examples, both imitated from Constans II type 3, illustrate the great variation in size, weight, and design of these pieces.

obv.: Crudely drawn stg. imperial figure

rev.: Cross on globe between I B, blundered ꝺΛЄⱫ in ex.

obv.: As previous, even cruder

rev.: Cross on large globe between I B, ΛΛΛ in ex.

MIB Heraclius X47, Constans II X37, X38; Domaszewicz and Bates 2002, type AI

ref.: Awad 1972

finds: Abu Mina (4), Fustat (100+), Jebel al-Tarif; Nessana; Pella (light weight; facing bust obv., no cross on rev.)

MACP coins

The first distinctive post-conquest type bears the mint signature MACP, i.e., Fustat, the Arab encampment, then military headquarters and capital of Egypt, now a suburb of Cairo. Fustat was also known in Arabic as Misr or Masr.

CAT. NO. 131.

OBV.: Crudely drawn stg. imperial figure, wearing crown and chlamys and holding long cross and globus cruciger, ✳ in r. field

REV.: Cross on globe between I B, MACP (often resembling MACⱭ) in ex.

MIB Constans II X36; *SICA* 732–34; Domaszewicz and Bates 2002, type AIII

REF.: Metlich and Schindel 2004, 13

FINDS: Abu Mina (9), Fustat (12+)

The mintmark indicates that these were the official product of an Arab government, issued from the new Egyptian capital. These coins could have been produced any time after the original type, whose date has not been determined. They may be products of the 640s or a decade or two later. They probably indicate that the mint was moved from Alexandria to Fustat, but the possibility remains that both mints produced concurrently. In any case, their abundance and variety suggest that this was a large issue, struck over several years. On well-preserved specimens, the drapery of the imperial robe displays a herringbone pattern of a type notable on the "Muhammad" coins of Jerusalem/Iliya. They may perhaps be contemporary. The use of a mintmark combined with the imperial figure certainly suggests a parallel with the Syrian Bilingual series, particularly its earliest issues. Like the issues of Constans II, they were widely imitated:

CAT. NO. 139.

OBV.: As previous

REV.: As previous, but cross upside down

Cf. catalogue no. 138, a cast imitation with reverse backward.

ABAZ coins

A third series derives from Constans II type 1 (facing bust, M between I B), but with a striking difference: not only is the bust drawn in a distinctive style, but all Christian symbolism has been removed:

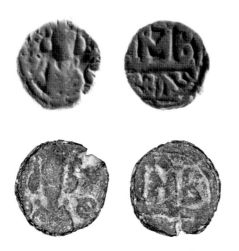

CAT. NO. 140.

OBV.: Facing bust with abundant locks of hair; palm branch on l., ✳ with Є, N, or P below on r.

REV.: M between I B, ABAZ, variously written, in ex.

CAT. NO. 141.

As previous, but Φ below star on obverse and mintmark missing from reverse

MIB Constans II X35; *SICA* 735; Domaszewicz and Bates 2002, type AII

FINDS: Alexandria (?), Fustat (25), Saqqara (9)

This type, which was probably struck in Fustat, offers some real novelties: the long cross and globus cruciger have disappeared from the obverse, as has the cross surmounting the M of the reverse. The style of the bust, with its projecting locks, bears some resemblance to the exceptional "falconer" of the pseudo-Damascus series; the palm branch also is characteristic of Damascus. On cat. no. 141 the letter to the right of the head looks rather like the large *phi* on the reverse of the Standing Caliph coinage. Most enigmatic is the reverse inscription, for which no place name can be found to correspond. Quite possibly, following the ingenious solution of N. C. Schindel, it could be a contraction for the name of the governor Abd al-Aziz ibn Marwan, who was brother of the caliph Abd al-Malik and who presided over Egypt from 685 to 705. Since his name appears on papyrus documents as Αβδελαζιζ, this could be a plausible abbreviation. A late source may offer some unexpected confirmation. Ibn Taghriberdi (d. 1470) reported that Abd al-Aziz wrote to his brother the caliph urging him to strike Islamic coins. If so, this coin could be considered a first step in that direction. In any case, it may be classed as contemporary with and parallel to the Standing Ca-

liph coinage of Syria. Another late source, al-Jahshiyari, writing in the tenth century, reports that when Abd al-Malik sent a new secretary to Egypt on the death of his brother in 705, he found the treasury full of "copper made in the land of Rome"—i.e., of the Byzantine type. If this account merits any credence, it suggests that the old-style coins (presumably including this type) still formed the bulk of the circulating medium at the beginning of the eighth century, a decade after the anepigraphic reformed coins were issued in Syria.

REF.: Metlich and Schindel 2004, 13ff., Bacharach and Awad 1981, 52 (ibn Taghriberdi), Domaszewicz and Bates 2002, 99 (al-Jahshiyari)

ΠΑΝ coins

The obverse of these curious coins reflects type 3 of Heraclius, issued in 629, but the reverse has no parallel in the series:

CAT. NO. 142.

OBV.: Two facing busts; long cross between

REV.: A Ѡ flanking cross; ΠΑΝ in ex.

MIB Heraclius X48

These pieces exceptionally have no indication of denomination, but instead distinctively religious symbolism. Most of them are cast, but one struck example (*MIB* 188) has been published. This has suggested that they form an emergency issue, or perhaps are not coins at all, but some kind of pilgrim tokens. The letters in the reverse exergue have logically been taken to be a mintmark, perhaps of Panopolis in Upper Egypt, which was near major centers of monasticism. On the other hand, these coins have been reported from the region of Alexandria and Cairo, not from Upper Egypt. They have also been proposed as issues of the monophysite patriarch Benjamin (622–661), expelled from Alexandria by Heraclius and his orthodox bishop Cyrus. Benjamin, who had the loyalty of most of the Egyptian population, took refuge first near Alexandria, then moved to Upper Egypt. If this were possible, it would explain the religious symbolism and perhaps, being unofficial issues, the lack of a denomination. The enigma remains.

REF.: Metlich and Schindel 2004, 12; *SICA* p. 108; Noeske 2000, 1:177f. (Benjamin)

FINDS: Abu Mina, Fustat (5), Saqqara

Two anomalous types seem to be related to this coinage:

OBV.: Long cross and four globular shapes, perhaps a deformed copy of this type

REV.: IB flanking indeterminate objects.

Goodwin 2003a

OBV.: O ‰ flanking cross

REV.: Indeterminate design, perhaps two figures; perhaps ⲁⲗⲉⲍ in ex.

FINDS: Alexandria

Conclusions

CHAPTER 12

THE END OF THE
ARAB–BYZANTINE COINAGE

Gold dinar

CAT. NO. 144.

OBV.: in field: لا اله الا الله وحده لا شريك له *lā ilaha illā al-lah waḥdahu lā sharīk lahu* "There is no god but God alone; he has no associate"; in margin: محمد رسول ألله *muḥammad rasūl allah arsalahu bi-al-hudā wa dīn al-ḥaqq li-yaẓhi-rahu ʿala al-dīn kullihi,* "Muhammad is the prophet of God; He sent him with guidance and the true religion to make it victorious over every religion" [Quran 9:33]

REV.: in field: الله احد الله الصمد لم يلد و لم يولد *allah aḥad allah al-ṣamad lam yalid wa lam yūlad* "God is one, God is eternal; He did not give birth and He was not born"; in margin: بسم الله ضرب هدا الدينار في سنة تسع و سبعين *bism allah ḍuriba hadhā al-dīnār fī sanati tisʿa wa sabʿīn,* "In the name of God; this dinar was struck in the year 79" [698–99 for this specimen; dates range from 77/696–97 to 132/749–50]

Walker 1956, 186–252

The gold coins have no mintmark; they were presumably struck in Damascus.

Silver Dirham

CAT. NO. 145.

OBV.: in field: لا اله الا الله وحده لا شريك له *lā ilaha illā al-lah waḥdahu lā sharīk lahu,* "There is no god but God alone; He has no associate"; in margin: بسم الله ضرب بسم الله ضرب هذا الدرهم بدمشق في سنة ثمنين *bism allah ḍuriba hadhā al-dirham bi dimashq fī sanati thamanīn,* "In the name of God; this dirham was struck in Damascus in the year 80" [699/700 this specimen; these coins were issued at many mints from 79/698–99 through 132/751–52]

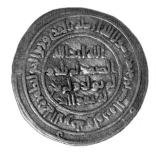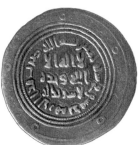

REV.: in field: الله احد الله الصمد لم يلد و لم يولد و لم يكن له كفوا احد *allah aḥad allah al-ṣamad lam yalid wa lam yūlad wa lam yakun lahu kufuan aḥad,* "God is one, God is eternal; He did not give birth and He was not born, and He has no equal"; in margin: محمد رسول ألله ارسله بالهدا و دين الحق ليظهره على الدين كله و لو كره المشركون *muḥammad rasūl allah arsalahu bi-al-hudā wa dīn al-ḥaqq li-yaẓhirahu ·ala al-dīn kullihi wa law kariha al-mushrikūn,* "Muhammad is the prophet of God; He sent him with guidance and the true religion to make it victorious over every religion, even if the associators [i.e., Christians] hate it."

Walker 1956, pp. 104–201

Copper

CAT. NO. 146.

OBV.: لا اله الا الله وحده *lā ilaha illā allah waḥdahu,* "There is no god but God alone"

REV.: محمد رسول ألله *muḥammad rasūl allah,* "Muhammad is the prophet of God"

Walker 1956, pp. 201–27

Abd al-Malik introduced the fundamental reforms that gave the Islamic state its definitive form and imagery. He proclaimed Islam as the state religion, he reformed the administrative system, making the universal use of Arabic compulsory, and he abolished images from the coinage, introducing aniconic issues that became characteristic of virtually all future Islamic states. The removal of images, which brought the

Arab–Byzantine coinage to an end, appears on the gold coinage in AH 77 (696/97), which is also the date of the last gold with the figure of the caliph. From then on, there is a continuous series bearing inscriptions alone, though without mintmarks. Similarly, the series of epigraphic silver dirhams begins in 79 (698/99). In Egypt, however, neither gold nor silver was issued until 170 (786–87), well into the Abbasid period, with the exception of a rare issue of silver dirhams struck in 91–93 (709–12) at Hulwan south of Cairo (Walker 1956, 138), the place where Abd al-Aziz had built a palace.

It would be natural to assume that the issue of the Standing Caliph copper came to an end at about the same time. The first dated epigraphic types, however, are only of AH 87 (705/6), the first year of Abd al-Malik's successor, al-Walid. They evidently form a second series, following types that bear only the *shahada* spread over both sides; these are undated, but were probably issued about AH 78–85 (698–705). An important hoard of this anonymous type found in Gaza included numerous pieces that had been overstruck on Arab–Byzantine coins, among them an example of the "Muhammad" type of Yubna. This suggests that the older coins were called in and restruck with the appropriate slogan, bringing the whole series to an abrupt end. Likewise in Egypt, images disappeared and anonymous thick coins—of typically Egyptian fabric—with the *shahada* alone were struck in great quantities. This series may have begun a few years later than the Syrian. The situation was different in North Africa and Iran. In the former, images continue until AH 80 or even possibly 85 (704). The Arab–Sassanian coinage is far more complex: there, silver with traditional images lingered on till AH 83 (702), though aniconic types had begun four years earlier. On the copper, however, pictorial types appear frequently until AH 95 (713/14) and intermittently as late as AH 137 (754/55), beyond the end of the Umayyad period.

It seems therefore that the main series of Arab–Byzantine coins came to an end around 700, with many being recalled and overstruck, but that imitations of various kinds might have continued well beyond that time.

REF.: Walker 1956, liii–civ, with useful tables of mints and dates, corrected by Album 1998, 21f.; Grierson 1960; Gaza hoard: Qedar 1985; Egypt: Miles 1958a, Bates 1991

CHAPTER 13

CONCLUSIONS

This series of coins, though it has by no means yielded up all its secrets, reveals some intriguing information of real value for understanding the whole period of transition from Byzantine to Arab rule. To consider what the coins tell, the discussion may return to the four questions asked before: who? where? when? why?

For the Standing Caliph coins, the first two questions are easily answered; they were struck by Abd al-Malik in the places they name. Likewise, the mints of the Bilingual coins are known, and there is a good probability that they were issued by Muʻawiya. Most of the Pseudo-Byzantine coins, though, whether Imitative or Derivative, produce no direct answers. Continuing research might allow more of them to be associated with individual places or districts (so far, one Imitative series has been plausibly assigned to Homs; one or two of the Derivative appear to be issues of Palestine, perhaps Jerusalem). But the "who" remains a mystery. Their great variety and lack of any recognizable indications suggest only that they were not the production of a central authority, but whether they were struck by local towns, bishops, armies, or tribes cannot yet be determined. Whoever they were, as Henri Pottier writes, "they were not producing forgeries but local currency in the Byzantine style" (Pottier and Schulze 2008).

Why were they struck? In general terms, evidently, to provide small change. Large numbers of them, especially the Imitative types, are found all over the region, and have appeared in excavations of cities and villages (Foss 1999). Very limited evidence can give rise to some suggestions. Overstrikes indicate that the Bilingual and Standing Caliph coins continued to circulate side-by-side down to the time of the reform,

even though one was issued before the other (Goodwin 2001a, 101). Excavated finds hint that the Standing Caliph (and possibly even the Bilingual) coins were issued for or used by the military (and perhaps the urban population), while civilians or villagers remained content with Byzantine issues or their imitations. Distribution of mints, especially of the Standing Caliph types from the jund of Qinnasrin, also suggests that these were struck for the military, for many of the places where they were issued were insignificant, but lay near the main base for operations beyond the frontier (Foss 2001, 10). Beyond that, all is speculation.

The question of when these coins were issued has given rise to much discussion, but now seems on the way to resolution, thanks to the work of Henri Pottier and his colleagues. The Standing Caliph coins are the least problematic, for they can be assigned without any doubt to the reign of Abd al-Malik (685–705), even if the date of their introduction has not been determined. In one case—the type of Baisan with two figures—an exact date of 685 is probable, and a few other types may belong to the first years of the reign. Likewise, the Bilingual series was probably issued in the reign of Mu'awiya, and one or two rare Imitative gold types may belong to the very beginning of his rule as caliph (660–680). The curious large coins of Scythopolis and Gerasa appear to have been produced over a long period, some of them contemporary with the Standing Caliph coinage. The Imitative and Derivative (Pseudo-Byzantine) types have posed the greatest problem: were they produced continuously from the time of the invasion, or compressed into a few years before the Standing Caliph issues? Obviously, the vast majority postdate the Arab conquest, for they imitate early issues of Constans II, who took power only in 641. A few of them with much later prototypes were issued in the 660s or (in the case of the imitation of Constantine IV) as late as 670. Metrology is now offering a solution, with the discovery that the weights of these imitations correspond to those of the regular Byzantine coinage. By this analysis, the earliest issues can be seen as beginning in about 638, when the conquest was far advanced, while the series continued until about 670, the presumed time of the introduction of the Bilingual series. Here, as elsewhere, much progress is being made, but there is still a great deal to learn.

The Arab–Byzantine coins were presumably issued to supply small change to Syria and Egypt. Hoards and site finds reveal the extent of their circulation, but the information they offer, however objective and precise it may seem, comes with important caveats. Very few large excavations have published their coins: when, for example, the myriads of coins uncovered at Scythopolis are ever published, the picture may change substantially. A more serious problem is the uneven distribution of sites: there have

been numerous excavations in Israel/Palestine, with an abundance of published coins, especially from Galilee. Evidence from Jordan is substantial, that of Syria much less so, but information from Egypt is almost entirely lacking. Hoards show a similar distribution. Generalizations, therefore, tend to be based on a region on both sides of the Jordan River, with supplementary information from Syria, the seat of the Arab government and its major military base.

One generalization, however, seems inescapable. Even though the Arab–Byzantine coins circulated widely, they are never as abundant as the sixth-century Byzantine issues or the first series of Umayyad coppers. In large sites like Antioch or Jerash the sixth- and eighth-century coins are overwhelmingly more common than those of the seventh, while smaller sites present a similar phenomenon, though not so consistently or to such a large degree (Foss 1999, 121). It is not yet clear whether that reflects a lower level of economic activity, political or social disturbances, or the limited attention traditionally paid by archaeologists to this series.

The coins discussed here formed two distinct zones of circulation, the Syrian and the Egyptian. Coins struck in Syria are virtually never found in Egypt (one was reported but not described from Fustat) while Egyptian coins rarely entered Syria, except apparently southern Palestine (three in the Lachish hoard, two found at Nessana). The pattern may have been different during the Persian occupation, when coins struck in Egypt occasionally turn up in Syria and when—since a vast area was united under one administration—silver from the East also entered circulation, if only on a small scale. This seems a precedent for the attempt of Mu'awiya to issue a bimetallic coinage in Syria, and for Abd al-Malik's successful achievement. The tiny cast IB coins of Alexandria, on the other hand, are common at Caesarea in Palestine, where they seem to have formed the bulk of small change, at least in the early seventh century; they may have been produced over a relatively long period, though perhaps not much after the Arab conquest, when the coin sequence there comes to an end. They also appear in other Palestinian sites. Since reported finds from Egypt are too limited to support conclusions, the following remarks will deal with greater Syria alone. They will necessarily be confined to coins that have been reported in some quantity, not just an occasional excavated piece or two.

The excavations of Antioch, Apamea, Dehes, Jerash, and perhaps Epiphania confirm the evidence of the Hama and Aleppo hoards, that regular Byzantine coppers of Constans II entered Syria and circulated extensively there. They may have been more common in the northern part of the area, closer to Byzantium, but are found virtually everywhere. Surprisingly, three of them were uncovered at Assur, far away in Assyria.

Most common are the issues of the first years of the reign, but there were still substantial imports through about 658, with a notable decline thereafter. Coins of Constantine IV (668–685) are rarely found: only four reported, three of them issues of Sicily, perhaps reflecting Arab raids there. Equally common, and widely distributed throughout the whole region, are the imitations of Constans II, most of them derived from his early issues. Taken together, the real and imitation coins of Constans are overwhelmingly the most abundant of this whole period, and presumably served as small change over a wide area and perhaps a long period.

They may have been supplemented by cut-down and reused earlier coppers if the tantalizing summary of a hoard discovered fifty years ago at Zemach south of the Sea of Galilee and never published is accurate (Kadman 1967). It supposedly consisted of 200 halved and quartered coins of Heraclius. Such a fabric is common in Palestine, but coins of this type, as in the Lachish hoard, are usually overstruck with Imitative types of Constans II. They are discussed in Goodwin 2005, 161–63. The Zemach hoard probably consisted of such Imitative coins, but the details remain to be determined.

Of the "Pseudo-Byzantine" types, the Cyprus imitations appear to constitute the largest issue, and appear more commonly in sites (about 48 reported, 30 in one Syrian hoard). They evidently circulated not in Cyprus, but in northern and central Syria, as far away as the Euphrates; they are rare in Palestine and other southern regions. Limited evidence for the other types suggest that they were local coinages, some of them produced in very small quantities. The de-Christianized coins, usually square, appear to have been a Palestinian issue, perhaps from Jerusalem, though they have been found (not excavated) in quantity in Jordan. The *al-wafā lillah* coins are found in a wide area of Palestine, especially Galilee; there were 40 in the Irbid hoard, but they do not appear in Syria.

There is not enough evidence to discuss the early Bilingual issues, but the standard Damascus coins circulated widely. Although the type inscribed in Greek is found mostly in Galilee and the Irbid hoard, the Greek/Arabic coins are found over a wide area from northern Syria to Galilee and Jordan. The pseudo-Damascus coins, on the other hand, seem to have circulated in Galilee and neighboring parts of Jordan (63 in the Irbid hoard), rather like the related *al-wafā lillah* type. Coins of Baalbek, Emesa, and especially Tiberias (for which the evidence is most abundant) seem to have enjoyed wide circulation, while those of Scythopolis appear only in the Decapolis and Galilee. The coins of Gerasa appear to have had a purely local circulation.

There is less evidence for the Standing Caliph coins. Damascus issues have been

found in Antioch, Jerusalem, and Judea, while coins of Amman seem to have circulated primarily in Transjordan. Very limited information for issues of northern mints would suggest that their use was primarily local. For all this, further excavation or accurate reporting of less formal finds is needed. In any case, one conclusion is certain: that the whole region (including Egypt) was on a monetary economy and that coins circulated even in small and remote sites.

These coins have an importance that is not always recognized: they are a prime source for the extremely obscure period of transition from Byzantium to Islam. The obscurity results from the lack of reliable historical sources: although the Arab chronicles (Tabari being the most important) present a wealth of detail for most of the seventh century, they were compiled more than a hundred years later and show every sign of having gone through a period of oral transmission, a method that invites distortion, fabrication, or suppression. Even worse, they were written under the Abbasids, and virtually obliterate the memory of their enemies, the Umayyads, at least as far as events in Syria and Egypt are concerned. Most of their lengthy detailed accounts deal with Iraq or Iran. Other sources in Greek or Syriac offer some useful information, but not enough to support a continuous narrative, nor do they reveal much about the internal conditions of this region. Inscriptions of the early Umayyad period are extremely rare and archaeological evidence scattered and very hard to date. Consequently, the coins have the potential of being an extremely valuable and undoubtedly contemporary source.

The coins supplement the historical record, even if ambiguously. The presence of large quantities of Byzantine coin in the region after the conquest, both in gold and silver, indicates a higher level of economic contact between the two hostile powers than would have been imagined from the written sources. The details of this would be much clearer if the mechanism by which these coins (especially the copper) reached Arab-controlled Syria could be explained. If, as has been suggested, it was the result of deliberate Byzantine activity, then relations between the two powers would be seen in a different light. The main potential contribution of these coins to history, though, comes from the Imitative and Derivative series. Their vast (and so far incoherent) variety suggests a period of breakdown of central control. It seems to coincide with the decades when Muʿawiya was governor. Some sources give the impression that the years after the conquest were a time when the Arab tribes exercised considerable power and enjoyed a great deal of autonomy (Crone 1980, 18–33). That would be a suitable scene for production of these coins, which were probably not made by the tribes themselves, who came from a region where coinage was not in current use, but by the local

Christian population—always the vast majority in this period—whether under the leadership of civil or ecclesiastical authorities. If the attribution of the Bilingual series to Muʿawiya is correct, it would indicate an extension of central control, in accord with other types of scattered evidence (Foss 2002a). The Standing Caliph coinage certainly shows that a major development in this direction had taken place by the time of Abd al-Malik, with a standard coinage being issued over the whole region.

More striking, perhaps, is the contribution the coins make to understanding the imagery and iconography of early Islam. Most obvious is the use of images. Whatever later Islamic practice condemned, these coins—even indubitably official issues—abound in images. On the Standing Caliph coins, it is Abd al-Malik who appears, in the same form as the statue taken to represent the caliph in the Umayyad palace of Khirbet al-Mafjar at Jericho. The issues of Palestine, however, seem to represent the Prophet himself, a drastic divergence from accepted ideas of Islamic practice. The vast majority of coins, though, whether Imitative, Derivative, or Bilingual, portray some-one remarkably like the Byzantine emperor, with all his regalia, whether as a single standing figure (the most frequent), or as a bust or in some other guise. One variant with a falcon on the figure's wrist has been taken as representing the caliph. Appearance of the "emperor" (who is never identified as such) is not hard to understand: these coins were issued by or for an overwhelmingly Christian population, who wanted to use and were willing to accept the kind of coins to which they had long been accustomed. The figure of an emperor here need be no more surprising than the Christian empress on the Maria Theresa thalers that circulated widely in Arabia and East Africa for two centuries after the death (in 1780) of the figure portrayed.

The image of the caliph with his falcon (if that is what it is: see p. 47f.) brings up one of the most surprising aspects of this coinage, the representation of the cross. On purely "Christian" types this might be nothing unusual; after all, a chronicler recorded that Muʿawiya's initial attempt to issue a new coinage failed because the people would not accept it since it had no cross. Yet, all the sources—Greek, Syriac, and Arabic—that deal with the seventh century agree that the new regime was extremely hostile to the cross from the very beginning (Griffith 1992, 126). Since the cross implied the divinity of Christ (the Crucifixion followed by the Resurrection), it was anathema to the Muslims, who recognized Jesus as only a prophet, not the son of God. There are numerous reports of crosses being defaced or removed from public places. That makes these coins extremely anomalous, especially the official Bilingual issues, which feature the cross (and the Christogram) as much as any other. Even more surprising is the combination of the cross with openly Islamic proclamations, as on the curious small

coins probably issued in Tiberias. If such a combination were possible, why not show the caliph with a cross in one hand and his falcon on the other? If that were admitted, it might be tempting even to see the figure on the curious square Derivative coins labeled *muḥammad* (cat. no. 31) as the Prophet, flanked by a long cross.

That may seem to be entering the realms of fantasy, but there is one relevant piece of indubitably contemporary evidence that contradicts the written sources. The baths of Hammat Gader southeast of the Sea of Galilee were rebuilt in 662. The work was ordered by the local governor in the time of "Abd Allah Muʿawiya Commander of the Faithful." The inscription, preceded by a cross, was written in Greek and displayed in the main hall of the baths (Hirschfeld et al. 1997, 238–40). This was an official document visible to all who entered, and by no means hidden from Muslims. Numerous graffiti in the same room show that the baths were frequented by Muslim Arabs. Furthermore, Muʿawiya himself liked to spend the winter at a resort on Lake Tiberias (the Sea of Galilee), only about ten kilometers from this site, which he is likely to have visited. In other words, public display of the cross was not incompatible with the official life of the Umayyad state. The further implications of this phenomenon remain to be explored.

Beside the general questions and the problems of history and iconography, this coinage offers special puzzles for the numismatist. Why were no Standing Caliph coins struck in Jordan? Why does Palestine (and Mesopotamia) use the "Muhammad" type rather than the normal Standing Caliph? Why did the mints so far identified strike coins, when other equally important cities (notably those on the coast like Caesarea or Ascalon) did not? Why are the coins of Ludd, the capital of a jund, so rare? What is the significance of the small Tiberias types with Islamic legends? And so on. In this coinage, more than most, there are more questions than answers, but the progress that has been made in recent decades brings reason for optimism and suggests that answers may be forthcoming. Meanwhile, this catalogue of the Dumbarton Oaks collection of Arab–Byzantine coins will hopefully prove of use both to collectors and to those working to resolve the remaining mysteries of this complex but rewarding coinage.

CATALOGUE

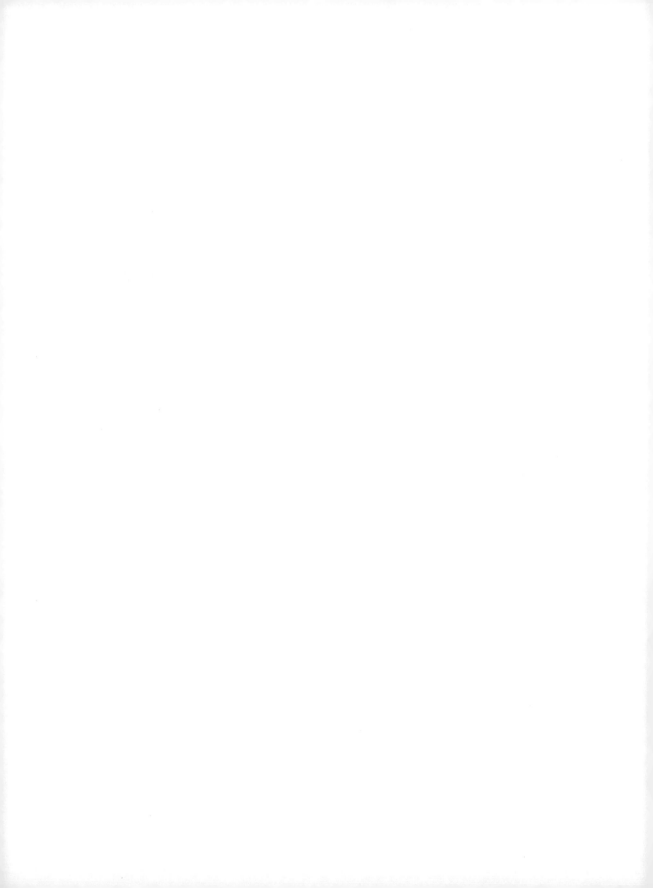

CATALOGUE OF ARAB–BYZANTINE COINS IN THE DUMBARTON OAKS COLLECTION

This catalogue describes and illustrates every Arab–Byzantine coin in the Dumbarton Oaks Collection, beginning, for the sake of completeness, with the Persian occupation and continuing through the first issues of the reformed coinage without images. The coins are arranged chronologically as far as possible, according to the categories discussed in the introduction, with the Egyptian issues following the Syrian.

The catalogue presents the physical characteristics of each coin, describes its types and legends, and, where appropriate, gives a cross-reference to the introduction. "Dia." is the diameter of the coin in millimeters. "Wt." is the weight in grams. "Axis" denotes the relation between the two dies from which the coin was struck, with numbers corresponding to the face of a clock. "12" means the reverse die is oriented the same as the obverse—that is, if the coin is held upright and spun on its axis, the reverse will be upright; "6" means the reverse would be upside-down, and so on. The die axis can be a useful indication of mint practice and help to assign unattributed coins to a mint.

Coinage of Syria

The Persian Occupation

No.	Dia.	Wt.	Axis	Obverse	Reverse
1	27	9.21	10	Two emperors l. stg., ON l., ΓΑΛΙΝϹΤΟ r.	M, + above, ANN +l., XIII r., B below, OCNKO in ex.

The Byzantine Restoration

2	25 × 21	6.42	7	On l., Heraclius stg. in military dress holding long cross; on r., Heraclius Constantine wearing chlamys and holding globus cruciger; +between heads; no inscription	K, + above, X X r., Γ below; on lower l., countermark of class 3

The Early Caliphate

Cyprus Imitations: 638–43

3	19 × 27	4.84	6	Three stg. imperial figures; crosses on crowns, long crosses on their r.	M, + above, ANNO l., Γ below, CON in exergue
4	15 × 24	6.33	6	Three crudely drawn imperial figures; long staffs between them	M, + above, Γ below

Two-Figure Obverse: 642–46

5	17 × 25	3.73	6	Two stg. figures, cross between heads; l. figure with beard, in military dress, holds long cross; r. figure holds globus cruciger; monogram (?) or blundered Arabic inscription in r. field.	M, + above, Γ below; ΛИИΟ l., monogram, apparently a reversed Christogram, r., ИVK in ex.
6	25	4.07	6	As previous	As previous

1. Pottier 2004, 52.6. See above, p. 11.
5. Goodwin 1993a fig. 1 (this coin). See above, p. 24.

2. See above, p. 16.
6. Same dies as no. 5

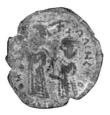

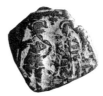

1

2

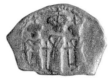

3

4

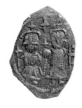
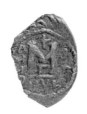

5

6

No.	Dia.	Wt.	Axis	Obverse	Reverse
Bust Type: 645–47					
7	25	2.47	11	Facing bust flanked by ✳ and crescent, holding tall cross in r. hand	**M**, + above, A below; ANA l., AX r., CON in ex.

Imitative Coins

"Standing imperial figure" in the Imitative, Derivative, and Bilingual series denotes the characteristic type of a standing facing figure wearing a long robe, holding in his right hand a long cross, in his left a globus cruciger, and wearing a crown adorned with a cross; significant variations are noted.

No.	Dia.	Wt.	Axis	Obverse	Reverse
8	19	2.31	12	Stg. imperial figure, [ЄN] TȢTO NIKA	**m**, ✳ above, AΦA l., ONΔ r., unclear letters in ex.
9	17 × 23	4.15	6	As previous, TȢTO l., NIK r.	**m**, + above, ANA l., NЄO r.
10	23	4.16	1	As previous, TȢT l., NTO r.	**m**, + above, NAN l., ONЄ r., C below
11	20	3.66	7	As previous, inscription fragmentary and garbled	**m**, ✳ above, ANO l. and r., III in ex.
12	20	3.29	4	As previous, inscription missing	**m**, + above, NT l., K r., Γ and unclear letters in ex.
13	21	4.41	2	As previous; crudely drawn figure	**m**, XЄ r.
14	18	3.20	2	As previous, fragmentary garbled inscription; ✳ r. of cross	**m**, traces of illegible letters
15	21 × 25	4.74	12	As previous, O above globus cruciger; no other inscription	**m**, + above, AИ l.

7. Overstruck; undertype unclear. See above, p. 25. 8. See above, p. 27.
10. See above, p. 27.

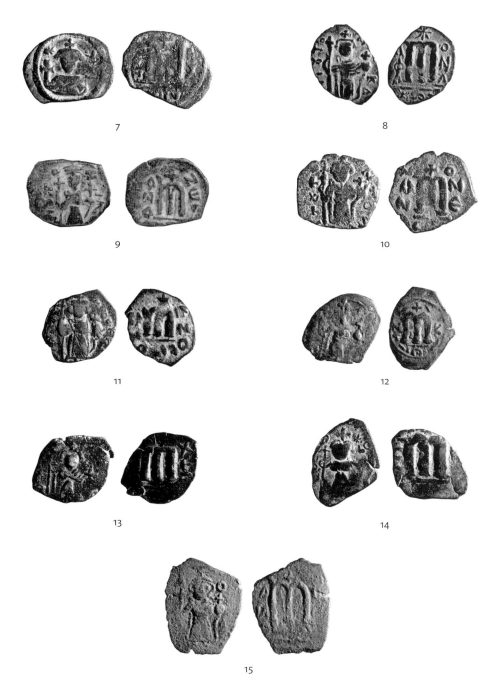

7

8

9

10

11

12

13

14

15

No.	Dia.	Wt.	Axis	Obverse	Reverse
16	17 × 21	3.54	4	As previous, good style, striped robe	Ⅲ, и и I I., X∈ r.
17	21	2.64	5	As previous, striped robe, no legend	Ⅲ, + above, AN r.
18	23	4.03	6	Imperial figure, l. arm around long cross; globus cruciger in r. hand (?); no inscription	Ⅲ, I I.
19	20 × 23	3.15	5	Very crude figure, with arm curling around staff, holding globe with long cross in r. hand. No legend.	Ⅲ, + above, A l., AN r.
20	21 × 21	3.39	5	Very crude figure with large triangular head; traces of garbled legend including HIKO r.	Ⅲ, + above, T V l., HΛ∈O r.
21	19 × 18	3.71	4	As previous, more regular figure, no inscription	Ⅲ, illegible inscription, perhaps derived from Arabic, in ex.
22	20	1.79	7	Stg. imperial figure, small neat execution	Ⅲ, + above, N∈A (?) r., uncertain countermark (bird?) and N in ex.
23	20 × 14	5	6	Two stg. imperial figures holding long crosses; l. has long beard; r. smaller	M, + above, N N l., B below
24	18 × 25	4.35		Facing crowned bust, HΔ∈ r., probably from undertype	M, B below, AИA l.
25	21	2.78	9	Facing bust with plumed helmet, holding globus cruciger; unread inscription possibly in Pahlavi or Arabic	M flanked by two standing imperial figures, ⅁ above, SCL in ex.

19. Struck on a quartered follis, typical of Palestine. See above, pp. 27, 114.

20. Foss 2001, no. 4. See above, p. 28.　　　　24. Cyprus imitation, overstruck; undertype obscure

25. Prototype: Constantine IV. See above, pp. 40–41.

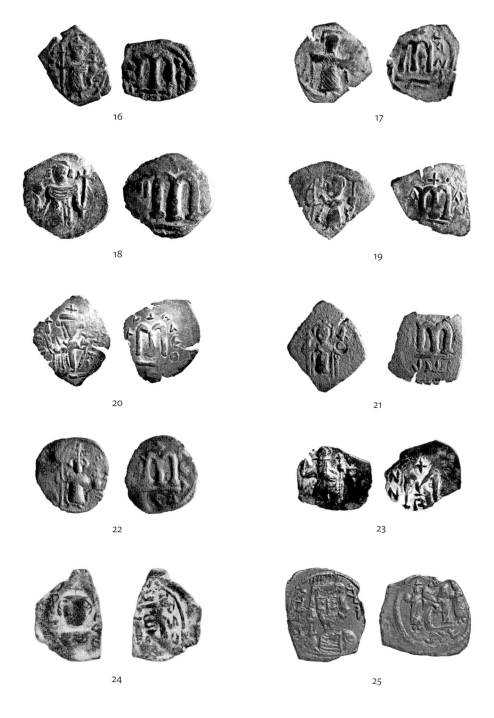

16

17

18

19

20

21

22

23

24

25

No.	Dia.	Wt.	Axis	Obverse	Reverse
26	20 × 23	4.88	3	Facing bust, traces of garbled inscription	Қ, + above, T below, ΛNN l., I r.

Derivative Coins

No.	Dia.	Wt.	Axis	Obverse	Reverse
27	20	2.96	4	Stg. Imperial figure, staff ends in trident, ИA l., ЄN r.	m, pellets within; AИA l., ΔHЄ r., 0⌣0 in ex.
28	21	3.46	2	Stg. imperial figure, ӘO l.	m, + above, pellets within; AXHЄ r., 0⌣0 in ex.
29	18	4.05	10	Stg. robed figure with large detached crown; uncertain object l., orb on staff and cross on longer staff r., no legend	m, Ѵ above., H l., AѴ r.
30	17 × 17	3.64	11	As previous	As previous
31	14 × 17	3.38	5	Crude standing figure with detached crown, flanked by long cross r., [مد]مح *muḥ[ammad]* l.	m, + above, بعض *baʿḍ* in ex.
32	17	3.70	6	Stg. Imperial figure, الوفا لله *al-wafā lillah* l.	m, AN l., \HЄ r., in ex.: الوفا لله *al-wafā lillah*
33	20	3.92	6	Three crowned stg. figures; details obscure; no inscription	M, + above, ∩ below; ƆƆO l., XXЧ r., CON in ex.

Countermarks

No.	Dia.	Wt.	Axis	Obverse	Reverse
34	20	3.60	8	Stg. figure holding long cross, ЄNTႣ l.	M, details obscured by two round countermarks reading بلد *bld*

26. Foss 2001, no. 2.

27. See above, p. 31.

29. See above, p. 33.

30. Same dies as no. 29.

31. See above, p. 34.

32. See above, p. 35.

33. See above, p. 37.

34. See above, p. 35.

26

27

28

29

30

31

32

33

34

No.	Dia.	Wt.	Axis	Obverse	Reverse

First Bilingual Series

(Standing Imperial Figure)

Damascus

No.	Dia.	Wt.	Axis	Obverse	Reverse
35	20	5.43	4	Imperial figure, bird on T l., in l. field Ⱶ, r. ΛИ and traces of other letters	M, ♈ above, ✳ below; دمشق *dimashq wafiya jāza hadhā* وفيه جازهاذا beginning on r.
36	21	3.96	9	Imperial figure wearing short belted garment, ΔMΔ∀ l., ✳ below r. arm; CKO r.	As previous
37	21	4.69	1	As previous	As previous; parts of inscription illegible
38	20	4.05	7	Imperial figure, traces of Greek inscription, KOC r.	As previous; very prominent ✳
39	22	4.34	10	Imperial figure, ΛOT+	As previous, but وفيه *wafiya* retrograde

Emesa

No.	Dia.	Wt.	Axis	Obverse	Reverse
40	20	4.13	7	Obv.: Standing imperial figure, r. (reading upward) KΛΛON, l. بسم ألله *bism allah*	M, ⚓ above flanked by stars, Δ below; l. and r. ЄMH/CIC; in ex., طيب *ṭayyib*
41	19	3.79	9	As previous	As previous, but + flanked by crescent and star above M, pellet below Δ; MH l., طيب *ṭayyib* in ex.
42	19	5.08	6	As previous; Greek insc. off flan	M, ⚓ above, Δ below; ЄMH/CIC
43	22	4.11	10	Imperial figure, ✳ and O in r. field	As previous, with طيب *ṭayyib* in ex.

35. See above, p. 42.
40. See above, p. 43.
43. Mule or imitation.

37. Same obverse die as no. 36.
41. Same obverse die as no. 40.

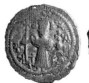 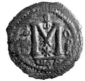

35

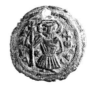

36

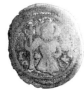 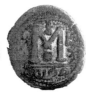

37

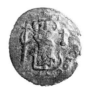

38

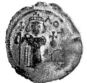 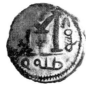

39

40

41

42

43

No.	Dia.	Wt.	Axis	Obverse	Reverse

Tiberias

| 44 | 20 | 6.04 | 2 | Imperial figure, inscription missing | **ℼ**, + above; XAΛЄ r., AΛΛA l. |

Jerusalem

| 45 | 16 × 24 | 3.39 | 6 | Imperial figure, details obscure | **ℼ**, O l., POЄ r., MON (?) in ex. |

Main Bilingual Series

Damascus (Standing Imperial Figure/M)

46	18	3.06	12	Stg. imperial figure, ΛЄO r.	**M**, ⅏ above, ᴖ below, AN l., XЧII r., ΔAM in ex.
47	19	3.85	12	As previous, palm branch in l. field	As previous
48	19	3.93	1	As previous, palm branch on T l.	As previous
49	18	5.23	7	As previous, bird on T l.	As previous, but A N O l.
50	21	3.41	4	As previous	As previous
51	17	2.72	6	As previous	As previous
52	20	5.06	7	Imperial figure, ΛЄO r., star and crescent above T in l. field	**M**, crudely drawn ⅏ above, ᴖ below, legend beginning on r. ضرب دمشق جائز *ḍuriba* (or *ḍarb*) *dimashq jāʾiz*
53	19	4.38	7	Imperial figure, ΛЄO r.	As previous
54	17	4.70	7	As previous, crescent above T in l. field	As previous
55	20	5.43	10	As previous, fragmentary garbled inscription	As previous

44. Foss 2001, 7f. See above, p. 45.
46. See above, pp. 45–46.

45. See above, p. 44.
52. See above, p. 46.

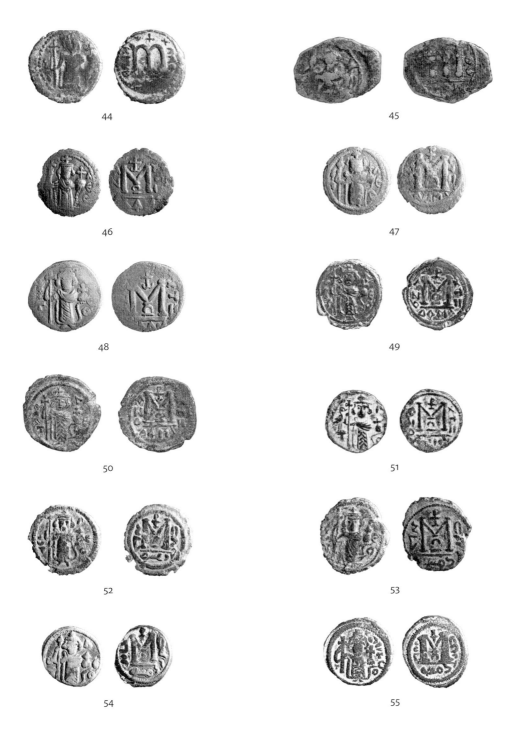

44

45

46

47

48

49

50

51

52

53

54

55

No.	Dia.	Wt.	Axis	Obverse	Reverse

Pseudo-Damascus

No.	Dia.	Wt.	Axis	Obverse	Reverse
56	18	2.62	11	Stg. figure with long hair, beard and mustache, wearing elaborate headdress and holding spear in r. hand, cross ending in crescent and ✳ in r. field	ɰ, ✳ + ✳ and two pellets above, pellets within and below; traces of letters r.
57	18	4.22	8	Figure wearing elaborate headdress std. cross-legged, holding scepter in r. hand, globus cruciger in l.; bird on T l.	ɰ, + above, pellets and wavy lines within; tall cross l., AX r., ΔΘM below
58	20	3.42	12	Stg. imperial figure; o above globe.	ɰ, pellets within; AИ l., O r. in very small letters; ∾ in ex.
59	16	3.62	7	Imperial figure	ɰ, + above, pellets within

Baalbek/Heliopolis (Two Standing Figures/M)

No.	Dia.	Wt.	Axis	Obverse	Reverse
60	18	3.61	10	Two stg. figures holding scepters in r. hands, globus cruciger in l.; + between heads	M, + above, ◠ below, l. HΛI४, r. ИOΛЄ; in ex. بعلبك baʿlabakk
61	19	4.38	5	As previous	As previous
62	18	4.21	3	As previous	As previous
63	19	3.06	7	Crudely drawn imperial figure; palm branch and pellet in l. field, O in r.	As previous

Homs/Emesa (Bust/ɰ)

No.	Dia.	Wt.	Axis	Obverse	Reverse
64	21	3.39	5	Draped bust facing, wearing crown with cross and holding globus cruciger in r. hand. KA /ΛON ; ✳ r. of cross on crown.	ɰ, ◡ ✳ ◡ above, ЄMI l., CH r., طيب ṭayyib in ex.

56. See above, p. 47.
59. Pellets suggest connection with previous.
63. Mule or imitation. See above, p. 49.

57. See above, p. 48.
60. See above, p. 49.
64. See above, p. 50.

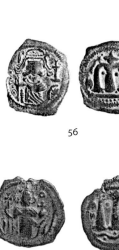

56

57

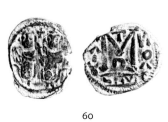

58

59

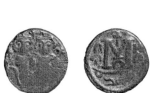

60

61

62

63

64

No.	Dia.	Wt.	Axis	Obverse	Reverse
65	21	3.93	7	As previous; K Λ Λ Ο N downward l., بحمص *bi-ḥimṣ* r., ✳ below	ꟿ, o ✳ o above, ЄMI l., CHC r., طيب *ṭayyib* in ex.
66	21	4.54	5	As previous	As previous
67	21	4.51	6	As previous, with ◡ above بحمص	As previous
68	19	3.89	6	As previous	As previous
69	20	4.15	6	As no. 65	As previous, but with ☉ ✳ ☉ above ꟿ
70	20	4.09	2	As previous	As previous
71	21	4.18	6	As previous	As previous
72	20	2.02	6	As previous	Reverse details obscure
73	22	3.91	6	As previous, but pellet instead of ✳	As previous, o ✳ o above ꟿ
74	22	3.62	6	As previous	As previous; ◡ ✳ ◡ above ꟿ
75	19	4.07	6	As previous, but no star or pellet	As previous; o ✳ o above ꟿ
76	20	2.49	11	As previous	As previous
77	18	3.48	7	As previous	As previous; ◡ o ◡ above ꟿ
78	19	2.78	6	As no. 64, but globus cruciger ends in crescent; star l. of crown. Greek inscription almost entirely missing, though Arabic clear	ꟿ, ✳ above, garbled Greek letters resembling SSH l., OM r.

Tartus/Antaradus (Bust/M)

No.	Dia.	Wt.	Axis	Obverse	Reverse
79	23	3.18	1	Facing bust, as on 57; بطردوس *bi-ṭardus* l., K Λ Λ Ω N r.	M, + above flanked by star and crescent, Δ below; ANT l., AP r., طيب *ṭayyib* in ex.

68. Same dies as 67.

78. Evidently an imitation.

75. See above, p. 50.

79. See above, p. 51.

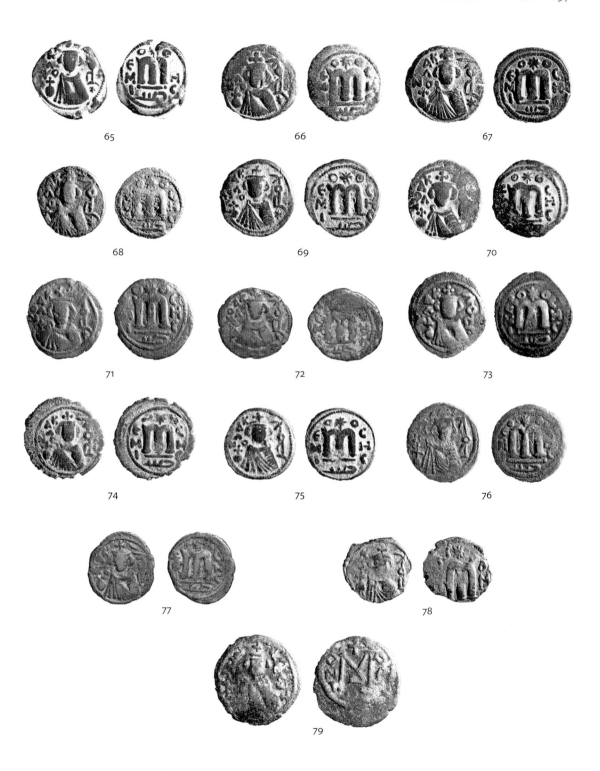

65

66

67

68

69

70

71

72

73

74

75

76

77

78

79

No.	Dia.	Wt.	Axis	Obverse	Reverse
80	21	4.58	7	As previous, but l. KAΛN, r. طيب *ṭayyib*	**M** as central element of monogram of ANTAPAΔOY; star r., طيب *ṭayyib* in ex.

Tabariya/Tiberias (Three standing figures/M)

81	21	3.75	2	Three standing figures, each holding a globus cruciger, crosses on crowns, no legend	**M**, ⅃ above, A below, TIBEPIAΔO l. and in ex., طبرية *ṭabariya* r.

Baisan/Scythopolis (Two enthroned figures/M or K)

82	27	10.11	6	Two enthroned crowned figures, each holding cruciform scepter in r. hand; cross between heads; CKYΘO l., ΠOΛHC r.	**M**, + above, A below; ANNO l., uncertain letters (perhaps intended as Arabic) r., NIKO in ex.
83	29	12.36	6	As previous	**M**, + above, A below; ANNO l., مقسم *miqsam* r., NIK in ex.
84	20	5.82	12	Two enthroned crowned figures holding scepters; long cross between them; CKV l., ΘO r.	**K**, X above, I below; ANNO l., ЧII r.
85	18	2.91	9	Two enthroned figures holding scepters; no crosses or inscription	**K**, crescent above, X below; بيسن *baisan* l., — r.

Jerash/Gerasa (Two Enthroned Figures/M)

86	29	9.75	1	As previous, but r. figure holds cruciform scepter, l. holds globus cruciger; no inscription. Crudely drawn	**M**, + above, A below; AN [NO] l., [X] ЧII r., NIK in ex.

80. See above, p. 51.
81. See above, p. 52.
82. Amitai-Preiss, Berman, Qedar 1999, A14. See above, p. 52.
83. Amitai-Preiss, Berman, Qedar 1999, A17. See above, p. 53.
84. Amitai-Preiss, Berman, Qedar 1999, B1. See above, p. 53.
85. Amitai-Preiss, Berman, Qedar 1999, B3. See above, p. 54.
86. Unpublished die; cf. Amitai-Preiss, Berman, Qedar 1999, C1–C10. See above, pp. 54–55.

80

81

82

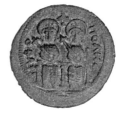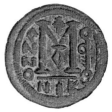

83

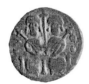

84

85

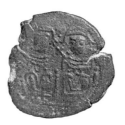

86

No.	Dia.	Wt.	Axis	Obverse	Reverse

Abila? (Two enthroned figures/M)

No.	Dia.	Wt.	Axis	Obverse	Reverse
87	29	7.25	1	As previous, but inscribed l. (retrograde) ABI, r. ЄONH (?)	M, + above, A below; AИO l., XI r., KYZ in ex.

Early issues of Abd al-Malik

Tabariya/Tiberias

No.	Dia.	Wt.	Axis	Obverse	Reverse
88	18	3.41	7	Three standing figures with staff flanked by pellets replacing crosses on heads; no legend	M, Ϯ above, A below, ΤΗϹ l., طبرية ṭabariya r., قطرى quṭrī below

No mintmark

No.	Dia.	Wt.	Axis	Obverse	Reverse
89	17	2.58	7	Three standing figures with crosses on crowns holding globus crucigers; no legend	M, Ϯ above, A below, محمد muḥammad r., رسول rasūl in ex., الله allah l.
90	17	3.44	11	Stg. caliph, عبدألله عبد ألملك abd allah ʿabd al-malik أمير ٱلمؤمنين amīr al-muʾminīn	M, Ā below, لا إله إلا ألله محمد رسول ألله lā ilaha illā allah muḥammad rasūl allah
91	15	3.58	8	As previous	As previous

Standing Caliph Coinage

"Muhammad" type

Iliya (Jerusalem)

No.	Dia.	Wt.	Axis	Obverse	Reverse
92	21	3.06	5	Stg. figure with prominent headdress, robe with herringbone pattern and short sword; محمد muḥammad l., رسول ألله rasūl allah r.	ɯ, إليبه ilīya l., فلسطين filasṭīn r.

87. See above, p. 55. 88. See above, pp. 61–62.
89. See above, pp. 57, 63. 90. See above, p. 64.
91. Same dies as 90. 92. See above, pp. 69–70.

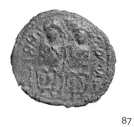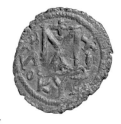

87

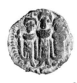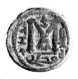

88

89

90

91

92

No.	Dia.	Wt.	Axis	Obverse	Reverse

Yubna

No.	Dia.	Wt.	Axis	Obverse	Reverse
93	20	3.73	2	Stg. figure with Arab headdress, hand on sword; [محمد *muḥammad*] رسول ألله *rasūl allah* r.	**ⵕⵕ**, يبني *yubnā* r., فلسطين *filasṭīn* l.
94	19	3.18	1	As previous, legend complete	As previous
95	18 × 22	3.44	1	Figure with radiate "halo"; l. inscription missing	As previous; يبني *yubnā* l., r. inscription missing
96	16 × 23	3.38	7	As previous	As previous; legends illegible
97	18	2.96	12	As previous	As previous; most of inscription missing
98	20	4.40	4	Similar to previous; legends complete	As 93; legends complete
99	19	2.73	3	As previous; legends illegible	As previous; فلسطين *filasṭīn* r.; l. legend missing
100	18 × 24	3.44	3	Figure with prominent headdress; most of legend missing	As 93

Ludd

No.	Dia.	Wt.	Axis	Obverse	Reverse
101	20	3.39	2	As 93, but crescent above head; محمد l.*muḥammad* l., r. inscription missing	**ⵕ**, star above; لد *ludd* r., فلسطين *filasṭīn*

Uncertain Mint

No.	Dia.	Wt.	Axis	Obverse	Reverse
102	15 × 21	2.77	8	As previous, بسم *bism* r., ألله *allah* l.	**ⵕ**, Arabic inscription of uncertain meaning

93. Goodwin 2005, type 2. See above, p. 70.
95. Goodwin 2005, type 3.
97. Goodwin 2005, type 3.
99. Goodwin 2005, type 4, obv. die 23.
101. See above, pp. 71–72.

94. Goodwin 2005, type 2.
96. Goodwin 2005, type 3. See above, p. 71.
98. Goodwin 2005, type 4, obv. die 33.
100. Goodwin 2005, type 5, obv. die 16.
102. See above, p. 72.

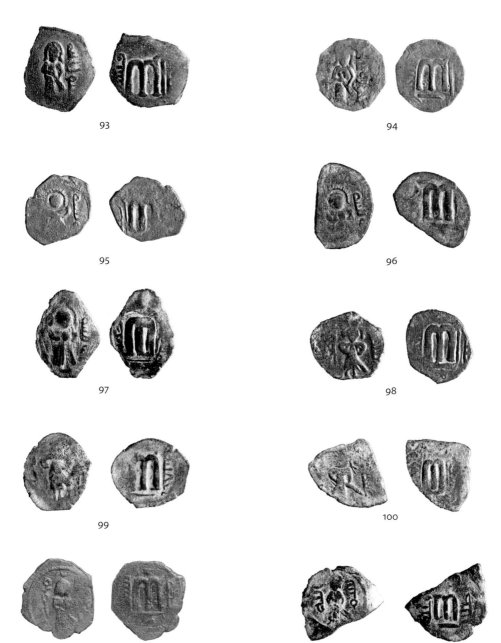

93

94

95

96

97

98

99

100

101

102

No.	Dia.	Wt.	Axis	Obverse	Reverse

Al-Ruha (Edessa)

No.	Dia.	Wt.	Axis	Obverse	Reverse
103	22	3.58	2	As no. 92	Φ on steps, بسم الله لا اله الا الله وحده *bism allah lā ilaha illā allah waḥdahu*, in field r. الرها *al-ruhā*

Standard Type

These coins all share a common type. The obverse has the standing bearded figure of the caliph, wearing an Arab headdress and long robe, his right hand on the hilt of his sword, which hangs diagonally to his left; folds of material, sometimes portrayed as three loops, hang from his right waistband. Unless otherwise specified, its inscription reads (ل) عبدالله عبد الملك امير المؤمنين *(li) ʿabd allah ʿabd al-malik amīr al-muʾminīn*, "(for) the servant of god, Abd al-Malik, Commander of the Faithful." The reverse has an object resembling the Greek letter Φ on four steps and the inscription لا اله الا الله وحده محمد رسول الله *lā ilaha illā allah waḥdahu muḥammad rasūl allah*, "There is no God but God alone; Muhammad is the prophet of God." Obverse and reverse legends are often incomplete and sometimes garbled. Variations and mintmarks will be noted.

Jund of Damascus

Damascus

No.	Dia.	Wt.	Axis	Obverse	Reverse
104	17	2.23	1	Legend لا اله الا الله وحده محمد رسول الله *lā ilaha illā allah waḥdahu muḥammad rasūl allah*	مشق *mshq* ("Damascus" with initial letter missing)
105	16	3.05	12	As previous, legend probably incomplete	As previous
106	17	2.89	2	As previous, but inscription blundered	As previous

Amman

No.	Dia.	Wt.	Axis	Obverse	Reverse
107	15	3.00	3	Standard legend; last word divided, with منين *minīn* in r. field	Large squat Φ; large star l., عمان *ʿammān* r.

103. See above, p. 73.
104. See above, p. 75.
107. See above, p. 78.

103

104

105

106

107

No.	Dia.	Wt.	Axis	Obverse	Reverse
Jund of Homs					
Homs					
108	22	3.76	1	Standard type, well engraved and struck; ل *li* before inscription	Tall thin Φ; star l., بحمص *bi-ḥimṣ* r.
109	22	3.70	10	As previous	As previous
110	22	4.72	1	As previous	As previous
111	23	4.83	12	As previous	No star in field
Jund of Qinnasrin					
Qinnasrin					
112	23	3.12	9	Standard legend preceded by ل *li*, neatly written; well engraved and struck	Tall thin Φ; بقنسرين *bi-qinnasrin* in field r., واف *wāfin* l.
113	21	1.86	6	As previous	As previous, but بقنسرين *bi-qinnasrin* l., واف *wāfin* r.
114	20	3.27	7	As previous	As previous
Halab (Aleppo)					
115	21	3.09	5	Standard legend preceded by ل *li*	Star l., حلب *ḥalab* r.
116	21	3.13	7	Legend blundered; may be the *shahada*	As previous
117	19	2.76	12	Clear legend starts with ل *li*	Star (?) l., حلب *ḥalab* r.
118	19	2.13	7	Poorly written legend preceded by ل *li*	واف *wāfin* l., حلب *ḥalab* r.
119	18	3.82	6	Blundered legend; letters or symbol in l. field	واف *wāfin* r., بحلب *bi-ḥalab* l.

109. Overstruck; undertype unclear. 111. See above, p. 78.
112. See above, p. 79. 118. See above, p. 79.

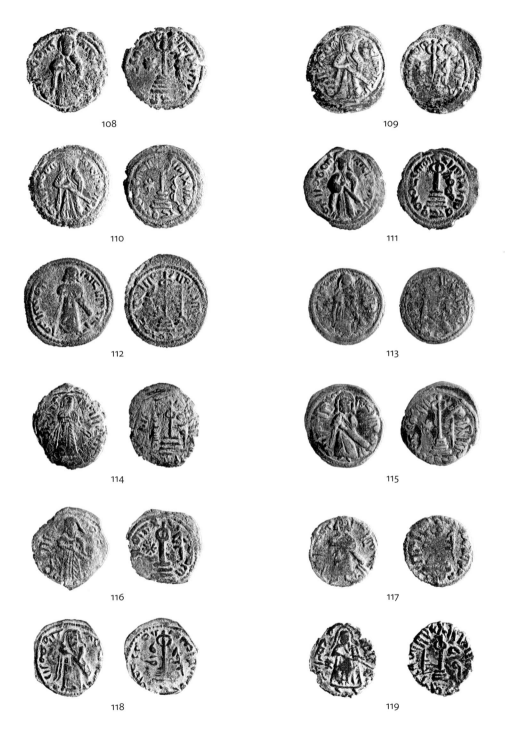

108

109

110

111

112

113

114

115

116

117

118

119

No.	Dia.	Wt.	Axis	Obverse	Reverse
120	16	3.21	10	As previous	As previous, but crudely written
121	15	3.03	5	First part of legend missing	واف *wāfin* l., حلب *ḥalab* r.
122	15	4.15	10	Most of legend missing	As previous
123	15	3.82	3	Most of legend missing; herringbone design in robe	وواف *wāfin* r., حلب *ḥalab* l.

Ma'arrat Misrin (Obv.: *Khalīfat Allah*)

No.	Dia.	Wt.	Axis	Obverse	Reverse
124	16	3.89	10	Blundered and incomplete inscription: خليفة الله [امير المؤمنين] *khalīfat allah [amīr al-mu'minīn]*; first word written خلفية *khalfia*	Blundered incomplete inscription; tall thin Φ; معرة *ma'arrat* r., مصرين *miṣrīn* l.
125	18	2.97	6	As previous, but much of legend missing	As previous, but very poorly engraved and written

Manbij (Obv.: *Khalīfat Allah*)

No.	Dia.	Wt.	Axis	Obverse	Reverse
126	18	2.27	6	First part of legend missing, probably *khalīfat allah*; traces of *amīr al-mu'minīn* r.	Incomplete inscription; واف *wāfin* l., منبج *manbij* r.
127	22	2.80	3	Badly blundered version of previous	As previous

Sarmin

No.	Dia.	Wt.	Axis	Obverse	Reverse
128	19	2.56	10	Legend obscure; probably *khalīfat allah*	سر *sar* r., مين *mīn* l.

Tanukh

No.	Dia.	Wt.	Axis	Obverse	Reverse
129	17	3.26	5	ل *li* before standard inscription; neatly engraved and well struck	Small, tall thin Φ; واف *wāfin* r., بتنوخ *bi-tanūkh* l.

Uncertain Mint

No.	Dia.	Wt.	Axis	Obverse	Reverse
130	18	1.53	1	Legend mostly missing	واف *wāfin* l., سر *sar* r.

120. Same obv. die as 107.
129. See above, p. 80.

127. See above, p. 76.
130. See above, pp. 80–81.

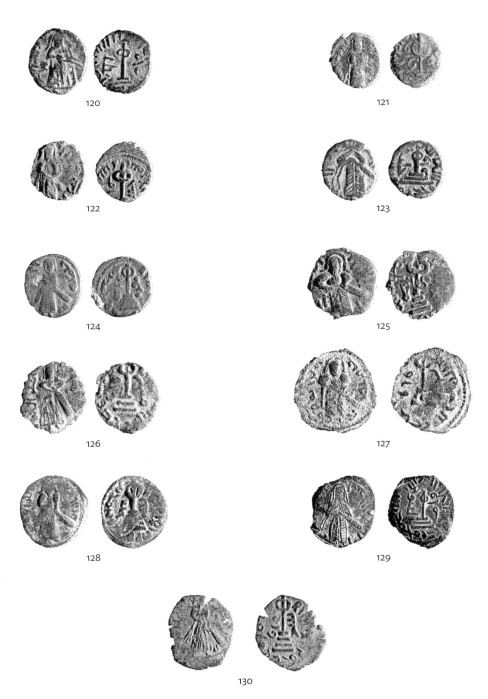

120

121

122

123

124

125

126

127

128

129

130

No.	Dia.	Wt.	Axis	Obverse	Reverse

Coinage of Egypt

Mint of Fustat

No.	Dia.	Wt.	Axis	Obverse	Reverse
131	19	7.39	6	Crudely drawn stg. imperial figure, wearing crown and chlamys and holding long cross and globus cruciger, ✳ in r. field	Cross on globe between I B , MACP in ex.
132	18	7.00	6	As previous	As previous, MACA in ex.
133	18	5.67	6	As previous	As previous
134	17	6.14	6	As previous; herringbone pattern on robe	As previous
135	17	3.42	3	As previous	As previous
136	18	3.49	6	As previous	As previous, [M]ACP in ex.
137	16	5.30	6	As 131	As previous, ҏMΛ in ex.
138	17	3.41	3	As 134	[Ꞵ]+I,IƆAM in ex.: whole design reversed
139	15	3.82	12	As 131	I B , upside-down cross between; no mintmark

ABAZ Coins

No.	Dia.	Wt.	Axis	Obverse	Reverse
140	17	6.55	10	Facing bust with abundant locks of hair; palm branch on l. ✳ and Є on r.	M, between I B , AB AZ in ex.
141	16	6.38	10	As previous, Ⲫ below star	As previous; exergue legend missing

Panopolis (?)

No.	Dia.	Wt.	Axis	Obverse	Reverse
142	15	5.10	12	Two facing busts; long cross between	A Ѡ, long cross between, ΠAN in ex.

131. See above, p. 102.
139. See above, p. 102.
141. See above, p. 103.

137. Cast imitation.
140. See above, p. 103.
142. See above, p. 104.

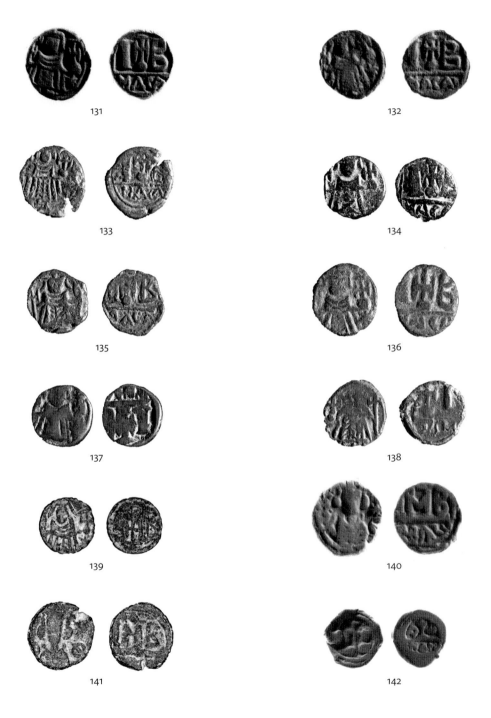

131

132

133

134

135

136

137

138

139

140

141

142

No.	Dia.	Wt.	Axis	Obverse	Reverse
143	13	1.43	12	As previous	As previous

Reformed Coinage

These coins bear inscriptions alone; no images.

Gold Dinar

| 144 | 20 | 4.20 | 6 | In field: لا اله الا الله وحده لا شريك له *lā ilaha illā allah waḥdahu lā sharīk lahu;* in margin: محمد رسول ألله أرسله بالهدا و دين الحق ليظهره علي الدين كله *muḥammad rasūl allah arsalahu bi-al-hudā wa dīn al-ḥaqq li-yaẓhirahu ʿala al-dīn kullihi* | In field: الله احد الله الصمد لم يلد و لم يولد *allah aḥad allah al-ṣamad lam yalid wa lam yūlad;* in margin: بسم الله ضرب هذا الدينار في سنة تسع و سبعين *bism allah ḍuriba hadhā al-dīnār fī sanati tisʿa wa sabʿin* |

Silver Dirham

| 145 | 26 | 2.74 | 6 | In field: لا اله الا الله وحده لا شريك له *lā ilaha illā allah waḥdahu lā sharīk lahu;* in margin: بسم الله ضرب هذا الدرهم بدمشق في سنة ثمنين *bism allah ḍuriba hadhā al-dirham bi dimashq fī sanati thamanīn* | In field: الله احد الله الصمد لم يلد و لم يولد و لم يكن له كفوا احد *allah aḥad allah al-ṣamad lam yalid wa lam yūlad wa lam yakun lahu kufūan aḥad;* in margin: محمد رسول ألله أرسله بالهدا و دين الحق ليظهره علي الدين كله و لو كره المشركون *muḥammad rasūl allah arsalahu bi-al-hudā wa dīn al-ḥaqq li-yaẓhirahu ʿalā al-dīn kullihi wa law kariha al-mushrikūn* |

Copper

| 146 | 22 | 3.0 | 10 | لا اله الا الله وحده *lā ilaha illā allah waḥdahu* | محمد رسول الله *muḥammad rasūl allah* |

144. See above, p. 109. 145. See above, p. 110.
146. See above, p. 110.

143

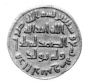

144

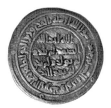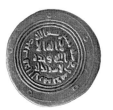

145

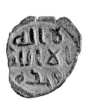

146

Cat. no.	DO Accession no.	Source
1	BZC.2000.4.1	Foss collection
2	BZC.2000.4.20	Foss collection
3	BZC.2006.8.3	Foss 9.v.2006
4	BZC.2006.8.4	Foss 9.v.2006
5	BZC.2004.29	Baldwin's Islamic Auction 9, 12.x.2004, ex-Pavlou 3021
6	BZC.2004.30	ibid., 3021
7	BZC.2000.4.33	Foss collection
8	BZC.2000.4.4	Foss collection
9	BZC.48.17.4220	Peirce, from Boston Le Blanc 1939
10	BZC.2000.4.6	Foss collection
11	BZC.2000.4.5	Foss collection
12	BZC.2000.4.13	Foss collection
13	BZC.2000.4.8	Foss collection
14	BZC.2000.4.14	Foss collection
15	BZC.2000.4.17	Foss collection
16	BZC.2000.4.15	Foss collection
17	BZC.2000.4.7	Foss collection
18	BZC.2000.4.16	Foss collection
19	BZC.2000.4.12	Foss collection
20	BZC.2000.4.22	Foss collection
21	BZC.2000.4.9	Foss collection
22	BZC.2000.4.19	Foss collection
23	BZC.2000.4.10	Foss collection
24	BZC.2002.22	Marcus Phillips gift
25	BZC.2004.27	Baldwin's Islamic Auction 9, 12.x.2004, ex-Pavlou 3017
26	BZC.2000.4.2	Foss collection
27	BZC.2000.4.23	Foss collection
28	BZC.2000.4.27	Foss collection
29	BZC.2000.4.24	Foss collection
30	BZC.2000.4.25	Foss collection
31	BZC.2000.4.110	Foss collection
32	BZC.2000.4.107	Foss collection
33	BZC.2000.4.50	Foss collection
34	BZC.2000.4.21	Foss collection
35	BZC.2000.4.41	Foss collection
36	BZC.2000.4.46	Foss collection
37	BZC.2000.4.31	Foss collection
38	BZC.2000.4.47	Foss collection
39	BZC.2000.4.30	Foss collection
40	BZC.2000.4.53	Foss collection
41	BZC.2000.4.54	Foss collection
42	BZC.2000.4.55	Foss collection
43	BZC.2000.4.56	Foss collection
44	BZC.2000.4.11	Foss collection
45	BZC.2004.36	ex-Pavlou 3142
46	BZC.2000.4.38	Foss collection
47	BZC.2000.4.39	Foss collection
48	BZC.2000.4.40	Foss collection
49	BZC.2004.31	ex-Pavlou 3059
50	BZC.2004.32	idem, 3059
51	BZC.2004.33	idem, 3059
52	BZC.2000.4.44	Foss collection
53	BZC.2000.4.45	Foss collection
54	BZC.2000.4.43	Foss collection
55	BZC.2000.4.42	Foss collection
56	BZC.2000.4.26	Foss collection
57	BZC.2000.4.29	Foss collection
58	BZC.48.17.4225	Peirce collection
59	BZC.2000.4.28	Foss collection
60	BZC.2000.4.36	Foss collection
61	BZC.2000.4.37	Foss collection
62	BZC.48.17.4224	Peirce collection
63	BZC.2000.4.35	Foss collection
64	Whittemore 1070	
65	BZC.2000.4.57	Foss collection
66	BZC.2000.4.61	Foss collection
67	BZC.2000.4.58	Foss collection
68	BZC.2000.4.63	Foss collection
69	BZC.2000.4.65	Foss collection
70	BZC.2000.4.60	Foss collection
71	BZC.2000.4.67	Foss collection
72	BZC.56.23.1263	Bertelè collection
73	BZC.2000.4.64	Foss collection
74	BZC.2000.4.66	Foss collection
75	BZC.2000.4.59	Foss collection
76	BZC.2000.4.62	Foss collection

Cat. no.	DO no.	Accession Source
77	Whittemore 1072	
78	BZC.2000.4.68	Foss collection
79	BZC.2000.4.32	Foss collection
80	BZC.2000.4.34	Foss collection
81	BZC.2000.4.51	Foss collection
82	BZC.2000.4.48	Foss collection
83	BZC.2004.21	Numismatica Ars Classica 27, 12.v.2004, 555 from Sternberg 25-26. xi.1976, 1072
84	BZC.2006.2	Baldwin
85	BZC.2006.8.2	Foss 9.v.2006
86	BZC.2004.34	ex-Pavlou 3137
87	BZC.2004.35	ex-Pavlou 3141
88	BZC.2000.4.49	Foss collection
89	BZC.2000.4.52	Foss collection
90	BZC.2000.4.76	Foss collection
91	BZC.2000.4.77	Foss collection
92	BZC.2000.4.69	Foss collection
93	BZC.2000.4.71	Foss collection
94	BZC.2006.7.1	Foss 9.v.2006
95	BZC.2006.7.4	Foss 9.v.2006
96	BZC.2006.7.3	Foss 9.v.2006
97	BZC.2000.4.70	Foss collection
98	BZC.2006.7.5	Foss 9.v.2006
99	BZC.2006.7.2	Foss 9.v.2006
100	BZC.2006.7.6	Foss 9.v.2006
101	BZC.2006.8.1	Foss 9.v.2006
102	BZC.2000.4.72	Foss collection
103	BZC.2000.4.102	Foss collection
104	BZC.2000.4.88	Foss collection
105	BZC.2000.4.89	Foss collection
106	BZC.2000.4.90	Foss collection
107	BZC.2000.4.78	Foss collection
108	BZC.2000.4.91	Foss collection
109	BZC.2000.4.92	Foss collection
110	BZC.2000.4.93	Foss collection
111	BZC.2000.4.94	Foss collection

Cat. no.	DO no.	Accession Source
112	BZC.2000.4.100	Foss collection
113	BZC.2000.4.99	Foss collection
114	BZC.2000.4.101	Foss collection
115	BZC.2000.4.79	Foss collection
116	BZC.2000.4.80	Foss collection
117	BZC.2000.4.82	Foss collection
118	BZC.2000.4.81	Foss collection
119	BZC.2000.4.86	Foss collection
120	BZC.2000.4.87	Foss collection
121	BZC.2000.4.84	Foss collection
122	BZC.2000.4.85	Foss collection
123	BZC.2000.4.83	Foss collection
124	BZC.2000.4.95	Foss collection
125	BZC.2000.4.96	Foss collection
126	BZC.2000.4.97	Foss collection
127	BZC.2000.4.98	Foss collection
128	BZC.2000.4.104	Foss collection
129	BZC.2000.4.105	Foss collection
130	BZC.2000.4.103	Foss collection
131	BZC.56.23.1025	Bertelè
132	BZC.60.125.14448	Schindler collection
133	BZC.1960.125.1449	Schindler collection
134	BZC.2000.4.74	Foss collection
135	BZC.1960.125.1444	Schindler from Trinks 1898
136	BZC.1960.125.1447	Schindler collection
137	BZC.1960.125.1446	Schindler collection
138	BZC.1960.125.1445	Schindler collection
139	BZC.56.23.1076	Bertelè
140	BZC.48.17.2121	Peirce
141	BZC.1960.125.1450	Schindler collection
142	BZC.1960.125.1443	Schindler collection
143	BZC.56.23.1076	Bertelè
144	BZC.2001.29	Baldwins Selection of Islamic Coins 3, Nov 2001, 7
145	BZC.2000.4.133	Foss collection
146	BZC.2005.30	Bought from Foss

Maps
Coins from Hoards and Excavations
Abbreviations
Glossary of Arabic Inscriptions
References
Photo Credits

MAP 1. **JUNDS AND MINTS.**

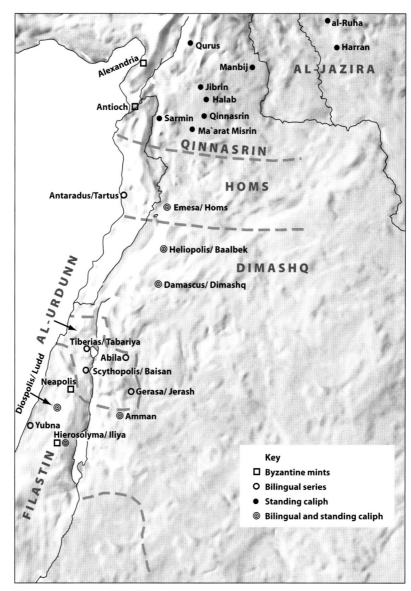

al-Ruha

Qurus

Harran

Manbij

AL-JAZIRA

Alexandria

Jibrin

Halab

Antioch

Sarmin

Qinnasrin

Ma`arat Misrin

QINNASRIN

Antaradus/Tartus

HOMS

Emesa/ Homs

Heliopolis/ Baalbek

DIMASHQ

Damascus/ Dimashq

AL-URDUNN

Tiberias/ Tabariya

Abila

Scythopolis/ Baisan

Diospolis/Ludd

Neapolis

Gerasa/ Jerash

Amman

Yubna

Hierosolyma/ Iliya

FILASTIN

Key
□ **Byzantine mints**
○ **Bilingual series**
● **Standing caliph**
◎ **Bilingual and standing caliph**

Map template courtesy of Digital Wisdom, Inc. Adapted by Kachergis Book Design.

MAP 2. **HOARDS AND EXCAVATIONS.**

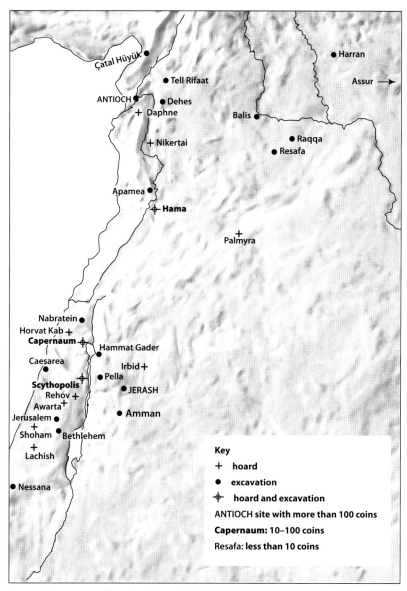

Map template courtesy of Digital Wisdom, Inc. Adapted by Kachergis Book Design.

MAP 3. **HOARDS AND EXCAVATIONS: FILASTIN AND AL-URDUNN.**

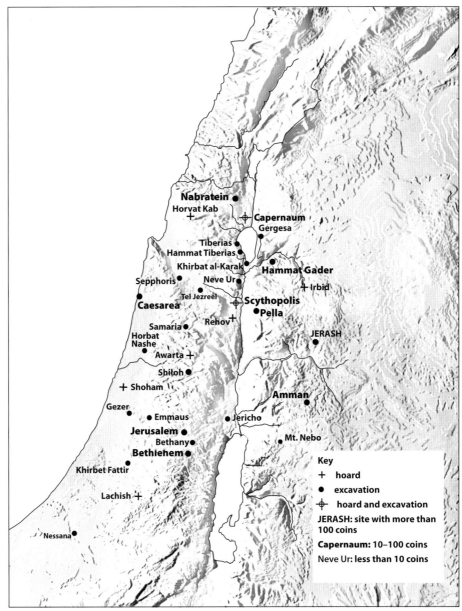

Nabratein •
Horvat Kab ✛
⊕ **Capernaum**
Gergesa •
Tiberias •
Hammat Tiberias •
Khirbat al-Karak •
Hammat Gader •
Sepphoris • Neve Ur •
✛ Irbid
Tel Jezreel • ⊕ **Scythopolis**
Caesarea • **Pella**
Rehov ✛
Samaria •
Horbat
Nashe
Awarta ✛
JERASH
Shiloh •
✛ Shoham
Amman •
Gezer •
• Emmaus • Jericho
Jerusalem •
Bethany •
Bethlehem •
• Mt. Nebo
Khirbet Fattir •
Lachish ✛
Nessana •

Key
✛ hoard
• excavation
⊕ hoard and excavation
JERASH: site with more than 100 coins
Capernaum: 10–100 coins
Neve Ur: less than 10 coins

Map template courtesy of Digital Wisdom, Inc. Adapted by Kachergis Book Design.

MAP 4. **EGYPT.**

Alexandria

Abu Mina

Fustat

Saqqara

Panopolis

Sohag

Jebel al-Tarif

Map template courtesy of Digital Wisdom, Inc. Adapted by Kachergis Book Design.

COINS FROM HOARDS AND EXCAVATIONS

The evidence of the archaeological record is potentially of great value for understanding the Arab–Byzantine coinage, since it puts the coins in context. Finds of coins in excavations or hoards enable them to be seen as part of a functioning economic system by showing where they were used and giving some indication of their relative scarcity or abundance. There is a great deal of information available, but necessarily incomplete and uneven, for some regions have far more excavated sites than others, while the level of detail and accuracy of publications can vary a great deal.

This list offers references for all the relevant coins I have been able to find in reports of hoards and excavations in Syria, Palestine, Egypt, and Cyprus. It tabulates all coins struck after the Arab conquest and before the reform of Abd al-Malik, including issues of Constans II. Hoard coins are given first, followed by examples from excavated sites. The list does not include stray (unexcavated) finds or coins in museum collections, since their exact provenance cannot be determined, but it does include coins known to be found on sites even if, strictly speaking, they were not excavated; this applies especially to the coins from Fustat in Egypt. The lists make no claim to completeness, for there are certainly many coins buried in excavation reports or inaccessible publications or not published at all. It leaves out sites that have produced only one relevant coin. It is intended to give an idea of the circulating media in the region and period, however incomplete. All coins listed are copper unless otherwise specified and of the M or IB denominations. All were issued in Constantinople or Alexandria unless another mint is indicated.

In many cases, descriptions of these coins in published reports are superficial or inadequate. Wherever possible, I have checked and sometimes changed attributions; those cases are indicated by an asterisk. A few coins whose description did not allow satisfactory identification have been omitted. The only coins I have examined personally are the Byzantine finds from Antioch, where I have made a few changes to the usually accurate attributions of Dorothy Waagé.

Hoards are listed by region (Syria/Palestine then Egypt), by metal (gold preceding copper), and by date of deposition. The tables show the total number of coins in a hoard ("quantity"), specifying those that are relevant to the period covered here ("contents"). "Source" refers to publications whose details may be found in the References.

Excavation coins are listed by region, usually corresponding to modern political boundaries: Syria (one site from Iraq included here), Israel/Palestine, Jordan, and Egypt; the sites within them are in alphabetical order. "Source" refers to items in the bibliography, while "Ref." specifies the number assigned each coin in the source.

The following abbreviations are used: "Constans II imit(s)," unless otherwise noted, refers to imitations of his early issues, with standing figure, struck 641–48; BI = Bilingual series (usually indicated by the Greek name of the mint); SC = Standing Caliph coins; ND ("no details") means inadequate description in the publication. Quotation marks around the name of a site indicate an approximate or unspecified location.

Hoards

Syria/Palestine

Gold

Date of deposition	Site	Source	Quantity	Contents
651+	Palmyra	Michalowski 1962, 226–36	27	17 Heraclius 1 Constans II (647–51)
663+	Capernaum	Callegher 1997	7	3 Heraclius 2 Constans II (641–44, 661–63) 2 Constans II semisses
ca. 668+	Shoham	Unpublished: Bijovsky 2002, 182f.	53	50 Heraclius (42 from 626–31) 2 Constans II semisses
668+	Hurvat Kab	Syon 2002	50	22 Heraclius (16 from 632–41) 22 Constans II (latest 663–68)
ca. 675	Awarta	Dajani 1951	29	13 Heraclius 13 Constans II 1 Constantine IV (668–73)
ca. 680	Daphne	Metcalf 1980	66	32 Heraclius 6 Constans II 2 Constantine IV (674–81) 1 Heraclius imit. with modified cross

Date of deposition	Site	Source	Quantity	Contents
680+	"south Jordan"	Unpublished: Bijovsky 2002, 182f.	230	90 Heraclius (27 from 616–25) 78 Constans II 27 Constantine IV (latest 674–81)
680+	Beth Shean (Scythopolis)	Bijovsky 2002	751	95 Focas 382 Heraclius, of which 120 from 616–25 219 Constans II 55 Constantine IV Latest: 30 Constantine IV class III (674–81)
ca. 681	"Nikertai"	Morrisson 1972	534	285 Heraclius, of which 76 from 616–25, 127 from 632–41 2 Heraclonas (?) 159 Constans II 27 Constantine IV (latest 674–81)
687+	Rehov	Bijovsky 2002, 183	27	16 Heraclius 7 Constans II 3 Constantine IV 1 Justinian II (685–87)
690+	near Damascus	Metcalf 1980	50	19 Heraclius 18 Constans II 7 Constantine IV 1 Justinian II (685–95)

Copper

Date of deposition	Site	Source	Quantity	Contents
613+	"Syria 1"	Bates and Kovacs 1996	53	45 Byzantine: Anastasius–Heraclius yr. 3 1 Scythopolis 3 Gerasa 4 Scythopolis related
ca. 658	"Hama"[1]	Phillips and Goodwin 1997	298	64 Byzantine (1 Maurice, 63 Heraclius) 113 Constans II 641–48 18 INPER CONST (including 1 SCL) 30 Constans II 651–58 73 Constans II imit., including: 6 Cyprus types 1 Single fig. in military dress 1 *tayyib* countermark

Date of deposition	Site	Source	Quantity	Contents
ca. 658	"Aleppo"	Schulze 2007	93	12 Heraclius 64 Constans II 641–48 1 INPER CONST 15 Constans II 651–58 1 Constans II imit.
660+	"Syria 2"	Goodwin 1994	60	30 Heraclius, Constans II and Constans II imit. (ND) 30 Cyprus imitations
670+?	"Lachish"[2]	Metcalf 1964	80	48 Byzantine Anastasius–Heraclius 3 Heraclius Alexandria IB (nos. 49, 50, 52) 1 Persian IB (51) 2 Constans II (53, 55) 23 Constans II imit., many on quartered flans of old Byzantine folles (nos. 54, 56, 60–80 including 6 on square flans) 1 Bl Heliopolis (59)
680+?	"Irbid"[3]	Milstein 1989	158	5 Constans II imit. (nos. 1, 4, 6, 10, 14) 6 "lazy S" (nos. 2, 3, 5, 7–9) 40 *al-wafā lillah* (nos. 11–13, 15–51) 6 Bl Damascus first series (nos. 52–57) 27 Bl Damascus Greek (nos. 58–65, 82–96, 102–5) 74 pseudo-Damascus (nos. 66–81, 97–101, 106–58)

1. "Said to have been found near Hama."

2. "It seems reasonable to conjecture that most of them came from the general vicinity of Lachish; and some certainly came from the site itself." (Metcalf, 1964, 36) Note that the numbers of catalogue and plate do not correspond. Two of the 80 coins catalogued could not be identified.

3. Apparently part of a much larger (unpublished) hoard bought in Irbid in Jordan; attributions, as far as possible, made according to the illustrations.

Egypt

Gold

Date of deposition	Site	Source	Quantity	Contents
661+	Abu Mina	Noeske 2000, 2:15f.	16	4 Heraclius 3 Constans II
668+	Saqqara	Noeske 2000, 2:250f.	14	3 Heraclius 1 Constans II
668+	Sohag monastery (Upper Egypt)	Unpublished: Noeske forthcoming	180	Constans II semisses

Excavation Coins

Syria and Mesopotamia

Site	Source	Ref.	Type	Quantity
Antioch	Miles 1948	3–6	BI Damascus, Arabic	4
		7–8	BI Emesa stg. fig.	2
		12–15	BI Emesa bust	4
		9	BI Heliopolis	1
		10–11	BI Tiberias	2
		17	SC Damascus anon.	1
		16, 20–23	SC Halab	5
		24	SC Homs	1
		25	SC Maʿarrat Misrin	1
		26	SC Tanukh	1
	Waagé 1952	2228, 2231*	Heraclius Cyprus (real)	3
		2217*, 2227*	Cyprus imit. (?)	2
		2243, 2245	Constans II early	48
		2244	INPER CONST restruck on Cyprus	1
		2246, 2247	Constans II 653–55	16
		2249, 2250	Constans II 660–68	5
		2245*, 2251, 2253–9	Constans II imit.	16
Apamea	Napoleone-Lemaire and Balty 1969, 136f.	2*, 23*, 24*	Cyprus imit. (ND)	3
		10*	INPER CONST	1

Site	Source	Ref.	Type	Quantity
		9	Constans II 644/45	1
		12*	BI Damascus Arabic	1
	Balty 1984 with		Constans II 641–48 (ND)	14
	Nègre 1984		Constans II 652–58 ND	7
			Constans II imit. ND	13
			BI Damascus Arabic	1
			SC Homs	1
Assur	Heidemann	9–10	Constans II early	2
	and Miglus	8	INPER CONST	1
	1996, 367			
Barbalissus/	Hennequin and	62	Constans II 642/43	1
Balis	al-Ush 1978	63, 134	Constans II imit.	2
		136	BI Emesa stg. fig.	1
		135	SC Halab	1
Çatal Hüyük	Vorderstrasse		Constans II imit.	4
	2001, 498f.		BI Emesa stg. fig. (?)	1
			SC Halab	1
			SC Maʿarrat Misrin	1
			SC Qinnasrin	1
Dehes	Morrisson 1980	40*	Cyprus imit.	1
		41–51	Constans II 641–48	11
		52–54	Constans II 652–56	3
		56, 58–61	Constans II imits.	5
		57*	INPER CONST imit. (Cyprus?)	1
		62	Constantine IV SCL	1
		55*	"Two Long Crosses" type	1
		63	SC Qinnasrin	1
	Morrisson	63, 66	Heraclius imits. (Cyprus?)	2
	(forthcoming)[1]	64, 65	Cyprus imit.	2
		67–74	Constans II 641–48	8
		75	Constans II 651/52	1
		76–77	Constans II 655–58	2
		78, 79, 82	Constans II imit.	3
		83	SC al-Ruha	1
		84	SC Sarmin	1
		85	SC Qinnasrin	1
Epiphania	Papanicolaou-	p. 63	Cyprus 626/27 (real? ND)	1
(Hama)[2]	Christensen 1986			
	Ploug et al. 1969	p. 165	Constans II 641–44 ND	30
			Constans II 655–57	3
			Constans II K 659/60	1

Site	Source	Ref.	Type	Quantity
			Constans II imit.	1
			Constantine IV SCL	1
Harran	Heidemann 2002, 279f.	1	Constans II 654/55	1
		2	Constans II imit.	1
Qalat Siman[1]	Morrisson (forthcoming)		Constans II 641–48	4
			Constans II 650–68	4
			Constans II imit.	1
			Bl Emesa bust	2
			SC Halab	2
			SC Maʿarat Misrin?	1
Raqqa	Heidemann and	28–34	Constans II early	7
	Becker 2003	35	Constans II 656–58	1
		36	Constans II imit.	1
Resafa	Mackensen 1984, 29	1–3	Constans II 642–48	3
	Ibid. 36	5	Heraclius Cyprus (imit?)	1
	Mackensen 1986, 220	6	INPER CONST	1
	Ibid. 225	3	Constans II early	1
	Korn 2004, 201	31	Cyprus imit.	1
Tell Rifaat	Clayton 1967	50–52	Constans II 641–48	3
		53	Bl Emesa bust	1

1. Provisional list provided by Cécile Morrisson
2. The coins of Constans II probably include imitations

Israel/Palestine

Site	Source	Ref.	Type	Quantity
Bethany	Saller 1957, 343	49–51	Constans II early	3
		52–53	Constans II imit.	2
		54	Constans II SCL 655/56	1
Bethlehem	Karukstis 2000b	1–2	Heraclius imit.	2
		3	(Cyprus?)	1
		4	Late Constans II imit.	1
		7–15	INPER CONST	9
		16	Constans II imit.	1
		17–19	square Derivative SC Yubna (? ND)	3

Site	Source	Ref.	Type	Quantity
Caesarea	Ariel 1986	136	SC Filastin ND	1
	Lampinen 1992	122–23	Constans II imit.	2
	Evans 2006, 202f.	2722	INPER CONST	1
		2723–24	Constans II 646–52	2
		2725	Constans II 655–57	1
		2726	Constans II 666–58	1
		2727, 2729	Constans II imit.	2
		2730–33	"Arab–Byzantine" ND	4
		2728	Constantine IV 674–81	1
Capernaum	Wilson 1989, 139–43	17	BI Damascus *wafiya*	1
		18	Scythopolis	1
		19	BI Tiberias	1
	Callegher 2007	1227–28	Constans II 641–48	2
		1225	Constans II 651/52	1
		1226	Constans II 655/56	1
		1231	BI Damascus Greek	1
		1232	BI Damascus *wafiya*	1
		1233–37	pseudo-Damascus	5
		1238–39	BI Tiberias	2
Emmaus	Bagatti 1947, 163	21	Constans II	1
		22	Constans II K	1
Gergesa	Tzaferis 1983, 40	9	square Derivative	1
		10	BI Tiberias	1
		11	*al-wafā lillah*	1
Gezer	Goodwin 2005b	16	Constans II imit.	1
		17	*al-wafā lillah*	1
Hammat Gader	Hirschfeld et al. 1997, 301–18	24, 25, 51	Constans II imit.	3
		23	Constans II (imit?)	1
		5*, 42(?)	*al-wafā lillah*	2
		40	BI Damascus Arabic	1
		148	BI Damascus Greek	1
		41	Square Derivative	1
		54, 86, 103, 122–25	BI Tiberias	7
		146, 147	pseudo-Damascus	2
Hammath Tiberias	Dothan 2000, 96	6	imit: 2 stg. figs (?)	1
		7–8	Constans II imit.	2
Horbat Nashe	Mettens 2004, 6	6	Constans II imit. with countermark A5	1
		7	*al-wafā lillah*	1
Jericho	Miles 1958b, 29f.	1	*Constans II imit.?	1
		2	SC (Amman) M rev.	1

Site	Source	Ref.	Type	Quantity
Jerusalem	Crowfoot 1929, 119	230, 232	Constans II (or imit.: ND)	4
		231	"Lazy S" (?)	1
	Hamilton 1944, 17ff.	12–13	Constans II imit.	2
		21, 24, 26	Constans II imit. (?)	3
		15	Constans II 666–68	1
		25	*BI Jerusalem	1
	Tushingham 1985, 170f.	305	Constans II (?)	1
		306–7	SC Iliya	2
	Wightman 1989, 94f.	21*	square Derivative	1
		27	Constans II early	1
		28	BI Emesa bust	1
	Foss 2001	7–8	square Derivative	2
	Avigad 2003, 467	438	Constans II early	1
		439–44	Constans II imit.	6
	Goodwin 2005b	25	Constans II 659/68	1
Khirbet Fattir	Strus 2003, 387f.	23	Constans II 654/55	1
		22, 25	Constans II imit.	2
		24*	*al-wafā lillah* (?)	1
		26	Constans II imit. (?)	1
Khirbet al-Karak	Delougaz and Haines 1960, 51	15	Constans II 641–51	1
		16	Constans II 655/56	1
		17	BI Damascus Greek	1
Nabratein[1]	Meyers and Meyers, forthcoming	92	Tiberias stg. fig.	1
		104	Damascus BI Arabic	1
		93, 95, 98–100, 102, 105, 122	pseudo-Damascus	8
		96, 101, 109, 111–13, 116, 121	*al-wafā lillah*	8
Nessana	Bellinger 1962, 74	129–30	Constans II IB	2
		131–35	Constans II 641–51	5
		136*	pseudo-Damascus (?)	1
		146	BI Damascus Greek	1
	Goodwin 2005b	7*	Cyprus imit.	1
		8–11	Constans II imit.	4
		12	*al-wafā lillah*	1
		13	Alexandria Constans II imit.	1
Neve Ur	Berman and Bijovsky 2002, 43	6, 8, 9	Constans II imit.	3
		7	Damascus BI Greek	1
		10–11	Damascus SC anon.	2

Site	Source	Ref.	Type	Quantity
Samaria-Sebaste	Crowfoot 1957	p. 63f.	Constans II	1
			Constans II imit. (?)	1
			Bl Tiberias	1
		p. 69, no. 26	Bl Tiberias	1
	Fulco and Zayadine 1981, 222	335*, 336–37	Constans II imit.	3
Scythopolis	Amitai-Preiss, Berman, and Qedar 1999	A2, A3, A6, A10	Scythopolis	4
		B2	Scythopolis K	1
		A19	*fals al-ḥaqq*	1
	Syon 2004[1]		Constans II	3
			Constans II imit.	7
			Bl Damascus Greek	1
			Bl Tiberias stg. fig.	1
			Bl Tiberias	1
			Bl Homs	1
			Scythopolis	2
			al-wafā lillah	1
	Amitai-Preiss 2006, 612–14	47	Constans II imit. (?) with countermark B2	1
		30	Tiberias Bl	1
Sepphoris	Waterman 1937, 77	387*	Damascus Bl Greek	1
		388	Tiberias Bl	1
		389*	*al-wafā lillah*	1
Shiloh	Andersen 1969, 106	453	INPER CONST	1
		454–55	Constans II imit.	2
		458	SC Damascus anon.	1
Tel Jezreel	Moorhead 1997, 103	111–12	Constans II early	2
		113–14	Constans II imit.	2
		119	Bl Tiberias	1
		117–18	"ArByz" ND	2
Tiberias	Hirschfeld 2004, 169–77	19	*al-wafā lillah*	1
		20	Bl Tiberias	1
	Stacey 2004, 221–45	40–41	Constans II imit.	2
		42	Scythopolis K	1
		43	SC Filastin	1
		44	Bl Tiberias	1

1. Detailed description from Gabriela Bijovsky

Jordan

Site	Source	Ref.	Type	Quantity
Amman	Hadidi 1970, 126–30	3	Constans II	1
		4*	(Amman) SC/M	1
		10	Tiberias BI	1
	Hadidi 1973, 53	3	Constans II early	1
		4	BI Damascus Arabic	1
		10	BI Tiberias	1
		8	SC Amman Abd al-Malik	1
	Hadidi 1975, 9–14	8, 15–17	SC Amman anon.	4
		1–7, 9–13	SC Amman Abd al-Malik	12
Gerasa/Jerash	Bellinger 1938	494	Constans II early	1
		495	Constans II 656/57	1
		497–506	Scythopolis	10
		514	Scythopolis K	1
		508–13	Scythopolis type	6
	Goicoechea 1986	66	BI Baalbek stg. fig.	1
		67–71	Scythopolis	5
		72	Scythopolis with Arabic	1
	Walmsley 1987	p. 149	Scythopolis	11
			Gerasa	3
	Naghawi 1989		Gerasa	3
	Marot 1998, 385–495	1389	INPER CONST	1
		1390–1415	Constans II before 648	26
		1427–32	Constans II 651–65	6
		1433–34	Constantine IV CON, SCL	2
		1416–25	Constans II imits.	10
		1426	Constans II K 641–48, countermarked	1
		1439–43	Gerasa	5
		1444–47	Scythopolis	4
		1448*	Constans II imit., ṭayyib countermark	1
		1449	BI Damascus	1
		1450	SC Damascus	1
		1451	SC (Amman)/M	1
		1452	BI Emesa stg. fig.	1
	Blanke et al. 2007, 190–96	92, 99	Constans II imit.	2
		354, 358, 1870	pseudo-Damascus	3
Mount Nebo	Gitler 1998, 563	102	Constans II K 655/56	1
		105	SC Amman Abd al-Malik	1

Site	Source	Ref.	Type	Quantity
Pella	Smith 1973	163ff.	Constans II ID	2
	Sheedy et al. 2001,	91, 92	Constans II 641–58	2
	142f.	93, 95	Constans II imit.	2
		94	Constans II K	1
		96	Constantine IV	1
	149f.	12	Tiberias stg. fig	1
		13	Scythopolis	1
		14*	Emesa stg. fig. *bld* countermark	1

Cyprus

Site	Source	Ref.	Type	Quantity
Salamis	Callot 2004	684, 684*bis*	Heraclius Cyprus (real)	2
		730–88	INPER CONST	59
		1070–81	Constans II imit.	12
		1082	Constans II 655/58 imit.	1
		1083	BI Damascus Greek	1
		1084	BI Heliopolis	1
		1085	BI Emesa bust	1
		1086	Cyprus imit. (?)	1

Egypt

Site	Source	Ref.	Type	Quantity
Abu Mina	Noeske 2000,	2656	Heraclius type 2 imit.	1
	2:138–40	2682	Panopolis	1
		2693–95	Heraclius type 5 imit.	3
		2687	Constans II 653/54	1
		2688	Constans II 655–58	1
		2689–92	Constans II 666–68	4
	2:196	779	Heraclius imit.	1
	2:199	848	Panopolis	1
		849–60*	Constans II early	12
		861–69	MACP	9
		870	BI Heliopolis	1
Alexandria	Rodziewicz 1984, 433	340*	ABAZ?	1
		341*	Panopolis related	1

Site	Source	Ref.	Type	Quantity
Fustat	Awad 1972, 114–16	Type III	Late Heraclius imits.	50
		Type IV (b, c, e)	Constans II imits.	10+
		Type IV (a)	MACP	12+
		Type II	ABAZ	25
		Type I	Panopolis	5
	Bianquis et al. 1974	169 n.11	Constans II imits. (? ND)	40+
	Scanlon 1981	p. 58	Constans II (? ND)	1
			Constans II imit. (? ND)	2
			"Syrian imitation" ND	1
	Bacharach 2002	p. 54	Constans II K	1
			Constans II (imits.? ND)	3
Jebel al-Tarif (Upper Egypt)	Goehring 1984, 34	75.53	Heraclius type 4 imit.	1
			Constans II	2
Saqqara	Noeske 2000, 2:254	224	Panopolis	1
		225–66	Constans II	42
		267–75	ABAZ	9

ABBREVIATIONS

ADAJ	*Annual of the Department of Antiquities of Jordan*
AH	anno Hegirae
AR	silver
AV	gold
DOC	Philip Grierson, *Catalogue of the Byzantine Coins in the Dumbarton Oaks Collection and in the Whittemore Collection*. Vol. 2, *Phocas to Theodosius III*. Washington 1968.
ex.	exergue
HA-ESI	*Hadashot Arkheologiyot: Excavations and Surveys in Israel*. Online journal, http://www.hadashot-esi.org.il/index_eng.asp.
imit.	imitation
INJ	*Israel Numismatic Journal*
insc.	inscription
MIB	W. R. Hahn, *Moneta Imperii Byzantini*. Vol. 2, *Von Justinus II. bis Phocas (565–610)*. Vol. 3, *Von Heraclius bis Leo III*. Vienna 1975, 1981.
NC	*Numismatic Chronicle*
NCirc	*Numismatic Circular*
NNM	*Numismatic Notes and Monographs*
ONS	*Oriental Numismatic Society*
RN	*Revue numismatique*
SICA	Album, S., and T. Goodwin. *Sylloge of Islamic Coins in the Ashmolean Museum*. Vol. 1, *The Pre-Reform Coinage of the Early Islamic Period*. Oxford 2002.
SNAPalästina	*Sylloge Nummorum Arabicorum Tübingen: Palästina*. Edited by L. Ilisch. Tübingen 1993.
std.	seated
stg.	standing

GLOSSARY OF ARABIC INSCRIPTIONS

allah aḥad allah al-ṣamad lam yalid wa lam yūlad wa lam yakun lahu kufuan aḥad: "God is one, God is eternal; He did not give birth and He was not born, and He has no equal"

amīr allah: commander of God

amīr al-mu'minīn: Commander of the Faithful *or* of the Believers

baʿḍ: a part

bism allah: in the name of God

ḍuriba: was struck

ḍarb: issue or minting

jāʾiz, jāza: current or legal

jayyid: good

khalīfat allah: caliph of God

lā ilaha illā allah waḥdahu: there is no god but God alone

lā ilaha illā allah muḥammad rasūl allah: there is no god but God; Muhammad is the prophet of God (The Islamic profession of faith, known as the *shahada*)

lā sharīk lahu: He has no associate

lillah: for God

miqsam: a part

muḥammad rasūl allah: Muhammad is the prophet of God

muḥammad rasūl allah arsalahu bi-al-hudā wa dīn al-ḥaqq li-yazhirahu ʿala al-dīn kullihi wa law kariha al-mushrikūn: Muhammad is the prophet of God; He sent him with guidance and the true religion to make it victorious over every religion [Quran 9:33], even if the associators [i.e., Christians] hate it

quṭrī: regional (?)

ṭayyib: good

al-wafā lillah: Good faith is with God

wāfin: full weight

wafiya jāza hadhā: full weight; this is legal (or current)

REFERENCES

Album, Stephen. 1998. *A Checklist of Islamic Coins.* Santa Rosa, CA.

Amitai-Preiss, Nitzan. 2006. "The Coins." In *Excavations at Tel Beth Shean 1989–1996.* Ed. Amihai Mazar. Jerusalem. 1:67–614.

Amitai-Preiss, N., A. Berman, and S. Qedar. 1999. "The Coinage of Scythopolis-Baysan and Gerasa-Jerash." *INJ* 13:133–51.

Andersen, Flemming. 1969. *Shiloh—The Remains from the Hellenistic to the Mamluk Period.* Copenhagen.

Ariel, Donald. 1986. "The Coins." In *Excavations at Caesarea Maritima, 1975, 1976, 1979—Final Report.* Ed. L.I. Levine and E. Netzer. *Qedem* 21:137–48.

Avigad, Nahman. 2003. *Jewish Quarter Excavations in the Old City of Jerusalem.* Vol. 2. Jerusalem.

Awad, Henry Amin. 1972. "Seventh Century Arab Imitations of Alexandrian Dodecanummia." *ANS Museum Notes* 18:113–17.

Bacharach, Jere. 2002. *Fustat Finds: Beads, Coins, Medical Instruments, Textiles, and Other Artifacts from the Awad Collection.* Cairo.

Bacharach, Jere, and Henry Amin Awad. 1981. "Rare Early Egyptian Islamic Coins and Coin Weights: The Awad Collection." *Journal of the American Research Center in Egypt* 18:51–56.

Bagatti, Bellarmino. 1947. *I monumenti di Emmaus el-Qubeibeh e dei dintorni.* Studium biblicum franciscanum 4. Jerusalem.

Baladhuri. 1916. *The Origins of the Islamic State: Being a Translation from the Arabic, Accompanied with Annotations, Geographic and Historic Notes of the Kitāb Fitūh al-Buldān of al-Imām abu-l Abbās Ahmad ibn-Jābir al-Balādhuri.* Trans. Philip Khûri Hitti. New York.

Balty, Jean. 1984. "Monnaies byzantines des maisons d'Apamée: étude comparative." In *Apamée de Syrie, bilan des recherches archéologiques 1973–1979: aspects de l'architecture domestique d'Apamée.* Ed. J. Balty. Fouilles d'Apamée, Miscellanea, Fasc. 13. Brussels. 239–48.

Bates, George. 1968. "A Byzantine Hoard from Coelesyria." *ANSMN* 16:80–81.

Bates, Michael. 1976. "The 'Arab–Byzantine' Bronze Coinage of Syria: An Innovation by ʿAbd al-Malik." In *A Colloquium in Memory of George Carpenter Miles (1904–1975).* New York. 16–27.

———. 1986: "History, Geography, and Numismatics in the First Century of Islamic Coinage." *Revue suisse de numismatique* 65:231–62.

———. 1989. "The Coinage of Syria Under the Umayyads, 692–750 A.D." In *The Fourth International Conference on the History of Bilād al-Shām.* English Section. Ed. M. Adnan Bakhit and Robert Schick. Amman. 2:195–228.

———. 1991. "Coins and Money in the Arabic Papyri." In *Documents de l'Islam médiéval.* Ed. Yusuf Ragib. Cairo. 43–64.

———. 1994. "Byzantine Coinage and Its Imitations, Arab Coinage and Its Imitations: Arab–Byzantine Coinage." *Aram* 6:381–403.

Bates, Michael, and Frank Kovacs. 1996. "A Hoard of Large Byzantine and Arab-Byzantine Coppers." *NC* 156:165–73.

Bellinger, Alfred. 1938. *Coins from Jerash 1928–1934.* NNM 81. New York.

———. 1962. "Coins." In *Excavations at Nessana.* Ed. H. D. Colt. London. 1:70–75.

Bendall, Simon. 1980. "A Hoard of Heraclian Six Nummi Coins of Alexandria." *NCirc* 88:441.

———. 2003. "The Byzantine Coinage of the Mint of Jerusalem." *RN* 159:307–22.

Berman, Ariel, and Gabriela Bijovsky. 2002. "The Coins from Neve Ur." *Atiqot* 43:172–84.

Bianquis, Th., G. T. Scanlon, and A. Watson. 1974. "Numismatics and the Dating of Early Islamic Pottery in Egypt." In *Studies in Honour of G. C. Miles.* Ed. Dikran Kouymjian. Beirut. 163–73.

Bijovsky, Gabriela. 2002. "A Hoard of Byzantine Solidi from Bet She'an in the Umayyad Period." *RN* 158:161–227.

———. Forthcoming. "The Coins from Insula W2S3 in Caesarea." In *The Insula W2S3: Roman Domus and Public Bath; The Israel Antiquities Authority Excavation Project at Caesarea 1992–1998.* Ed. Y. Porath and P. Gendelman. IAA Reports.

Blanke, L., K. Damgaard, I. Simpson, and A. Walmsley. 2007. "From Bathhouse to Congregational Mosque: Further Discoveries on the Urban History of Islamic Jarash." *ADAJ* 51:177–97.

Bone, Harry. 2000. *The Administration of Umayyad Syria: The Evidence of the Copper Coins.* PhD dissertation. Princeton.

Borkowski, Zbigniew. 1981. *Inscriptions des factions à Alexandrie.* Warsaw.

Braunlin, Michael, and John Nesbitt. 1999. "Thirteen Seals and an Unpublished Revolt Coin from an American Private Collection." *Byzantion* 69:187–205.

Butler, A. J. 1978. *The Arab Conquest of Egypt.* Ed. Peter Fraser. 2nd edition. Oxford.

Callegher, Bruno. 1997. "Un nipostiglio di monete d'oro bizantine dalla sinagoga di Cafarnao." *Liber annuus* 47:329–38.

———. 2007. *Cafarnao.* Vol. 9, *Monete dall'area urbana di Cafarnao (1968–2003).* Studium biblicum franciscanum, Collectio maior 47. Jerusalem.

Callot, Olivier. 2004. *Salamine de Chypre.* Vol. 16, *Les monnaies: fouilles de la ville 1964–1974.* Paris.

Clayton, Peter. 1967. "The Coins from Tell Rifaat." *Iraq* 29:143–54.

Crone, Patricia. 1980. *Slaves on Horses.* Cambridge.

Crowfoot, J. W., and G. M. Fitzgerald. 1929. *Excavations in the Tyropoeon Valley, Jerusalem, 1927.* London.

Crowfoot, J.W., et al. 1957. *The Objects from Samaria.* London.

Dajani, A. 1951. "A Hoard of Byzantine Gold Coins from Awarta, Nablus." *ADAJ* 1:41–43.

de Roever, W. P. 1991. "A Nea(polis) Follis of Heraclius' 26th Regnal Year." *NCirc* 99:146.

Delougaz, Pinhas, and Richard Haines. 1960. *A Byzantine Church at Khirbat al-Karak.* Chicago.

Domaszewicz, Lidia, and Michael Bates. 2002. "The Copper Coinage of Egypt in the Seventh Century." In Bacharach 2002, 88–111.

Donald, P. J. 1986. "The Neapolis Coins of Heraclius." *NCirc* 94:116.

———. 1987. "Neapolis Under Heraclius—A Further Find." *NCirc* 95:151.

Dothan, Moshe. 2000. *Hammath Tiberias*. Jerusalem.

Evans, Jane DeRose. 2006. *The Coins and the Hellenistic, Roman, and Byzantine Economy of Palestine.* The Joint Expedition to Caesarea Maritima Excavation Reports 6. Boston.

Foss, Clive. 1999. "The Coinage of Syria in the Seventh Century: The Evidence of Excavations." *INJ* 13:119–32.

———. 2001. "Anomalous Arab–Byzantine Coins: Some Problems and Suggestions." *ONS Newsletter* 166:5–12.

———. 2002a. "A Syrian Coinage of Muʿawiya?" *RN* 158:353–66.

———. 2002b. "The Kharijites and Their Coinage." *ONS Newsletter* 171:24–34.

———. 2003a. "The Coinage of the First Century of Islam." *Journal of Roman Archaeology* 16:748–60. Review of *SICA*.

———. 2003b. "The Two-Caliph Bronze of Abd al-Malik." *ONS Newsletter* 177:4–5.

———. 2003c. "The Persians in the Roman Near East (602–630 AD)." *Journal of the Royal Asiatic Society*, ser. 3, 13:149–70.

Fulco, W. J., and F. Zayadine. 1981. "Coins from Samaria-Sebaste." *ADAJ* 25:197–226.

Gil, Moshe. 1992. *A History of Palestine, 634–1099*. Cambridge.

Gitler, Haim. 1998. "The Coins." *Mount Nebo: New Archaeological Excavations, 1967–1997*. Ed. Michele Piccirillo and Eugenio Alliata. Jerusalem.

Goehring, J. E. 1984. "Byzantine Coins from Jabal al-Tarif in Upper Egypt." *Bulletin de la Société d'Archéologie Copte* 26:31–40.

Goicoechea, Emilio Olivarri. 1986. *Excavaciones en el Agora de Gerasa en 1983*. Madrid.

Goodwin, Tony. 1993a. "Imitations of the Folles of Constans II." *ONS Occasional Paper* 28.

———. 1993b. "Imitative 7th Century Byzantine Folles with a Single Figure in Military Dress." *NCirc* 101:112–13.

———. 1993c. "Miniature Punchmarks on the Arab–Byzantine coins of HIMS." *NCirc* 101:114.

———. 1994. "A Hoard of Imitative Byzantine Folles." *NCirc* 102:357–59.

———. 1995. "7th Century Arab Imitations of Byzantine Folles." *NCirc* 103:336–37.

———. 1997. "A Remarkable Standing Caliph Fals." *ONS Newsletter* 151:5.

———. 1998. "Walker's Full-Weight Dirhams—New Light on an Enigmatic Arab–Byzantine Coin of Damascus." *ONS Newsletter* 157:9.

———. 2001a. "Arab–Byzantine Coins—The Significance of Overstrikes." *NC* 161:91–109.

———. 2001b. "Anomalous Arab–Byzantine Coins—Some Further Observations." *ONS Newsletter* 168:11–12.

———. 2003a. "Some Interesting Arab–Byzantine Coins from the Barber Institute Collection." *NCirc* 111:196–98.

———. 2003b. "A Hoard of Seventh Century Byzantine Dodecanummia." *NC* 163: 355–57.

———. 2004a. "The Dating of a Series of Arab–Byzantine Coins." *ONS Newsletter* 181:5–9

———. 2004b. "A New Standing Caliph Mint in Jund Filastin?" *NCirc* 112:299–301.

———. 2005a. *Arab–Byzantine Coinage*. Studies in the Khalili Collection 4. London.

———. 2005b. "Seventh Century Coins in the Palestine Exploration Fund Collections." *Palestine Exploration Quarterly* 137:65–76.

Goussous, Nayef. 2004. *Rare and Inedited Umayyad Copper Coins*. Amman.

Grierson, Philip. 1960. "The Monetary Reforms of 'Abd al-Malik," *Journal of the Economic and Social History of the Orient* 3:241–64.

Griffith, Sidney. 1992. "Images, Islam and Christian Icons." In *La Syrie de Byzance à l'Islam.* Ed. Pierre Canivet and Jean-Paul Rey-Coquais. Damascus. 121–38.

Hadidi, Adnan. 1970. *The Roman Forum at Amman.* PhD dissertation. Univ. of Missouri.

———. 1973. "Some Bronze Coins from Amman." *Annual of the Department of Antiquities of Jordan* 18:51–53.

———. 1975. "Fulus nuhasiyya umawiyya min 'Amman." *Annual of the Department of Antiquities of Jordan* 20:9–14.

Hahn, Wolfgang. 1978. "Alexandrian 3-nummi and 1-nummus types under Heraclius." *NC* 138:181–83.

———. 1980. "A Sixth-Century Hoard of Byzantine Small Change from Egypt, and Its Contribution to the Classification of African Minimi." *NC,* ser. 7, 20:64–70.

Hamilton, R. W. 1944. "Excavations against the North Wall of Jerusalem, 1937–8." *Quarterly of the Department of Antiquities in Palestine* 10:1–54.

Heidemann, Stefan. 1997. "The Merger of Two Currency Zones in Early Islam." *Iran* 36: 95–112.

———. 2002. "Die Fundmünzen von Harran und ihr Verhältnis zur lokalen Geschichte." *Bulletin of the School of Oriental and African Studies, University of London* 65:265–99.

Heidemann, Stefan, and Andrea Becker. 2003. *Raqqa II, die Islamische Stadt.* Mainz.

Heidemann, Stefan, and Peter Miglus. 1996. "Fundmünzen aus Assur und Lokalgeschichte in islamischer Zeit." In *Das Wohngebiet von Assur.* Ed. Peter Miglus. Berlin. 351–76.

Heidemann, Stefan, and Claudia Sode. 2000. "Christlich-orientalische Bleisiegel im orientalischen Münzkabinett Jena." *Aram* 11–12:533–93.

Hennequin, G., and Abu-l Faraj al-Ush. 1978. *Les monnaies de Balis.* Damascus.

Hirschfeld, Yizhar. 2004. *Excavations at Tiberias, 1989–1994.* Jerusalem.

Hirschfeld, Yizhar, et al. 1997. *The Roman Baths of Hammat Gader.* Jerusalem.

Hitti, Philip. 1991. *History of Syria.* London.

Hoyland, Robert. 1997. *Seeing Islam as Others Saw It.* Princeton.

———. 2007. "Writing the Biography of the Prophet Muhammad: Problems and Solutions." *History Compass* 5:1–22.

Humphreys, Stephen. 2006. *Mu'awiya ibn abi Sufyan: From Arabia to Empire.* Oxford.

Jamil, Nadia. 1999. "Caliph and Qutb: Poetry as a Source for Interpreting the Transformation of the Byzantine Cross on Steps on Umayyad Coinage." In *Bait al-Midis: Jerusalem and Early Islam.* Ed. J. Johns. Oxford. 11–57.

Kadman, Leo. 1967. "The Monetary Development of Palestine in the Light of Coin Hoards." In *International Numismatic Convention Jerusalem 27–31 December 1963, Proceedings.* Ed. A. Kindler. Tel-Aviv. 311–24.

Karukstis, Charles. 1996. "The Underlying Die Types of Countermarked Arab–Byzantine and Related Coinage." Unpublished paper presented to the Arab–Byzantine Forum II, American Numismatic Society.

———. 1997. "Comments on the *al-wafā lillah* Coinage." Unpublished paper presented to the Arab–Byzantine Forum, American Numismatic Society.

———. 2000a. "A Note on the Localization of Pseudo-Byzantine Coinage in Syria." *NCirc* 108:158.

———. 2000b. "An Eighth-Century Hoard from Bethlehem?" Unpublished paper presented at Arab–Byzantine Forum VI (Washington DC).

Korn, Lorenz. 2004. "Resafa: Fundmünzen der Stadtgrabungen." *Damaszener Mitteilungen* 14:197–206.

Lampinen, Peter. 1992. "The Coins, Preliminary Report, 1990." In *Caesarea Papers*. Ed. Robert Lindley Vann. Journal of Roman Archaeology Supplement Series 5. Ann Arbor. 169–72.

Leuthold, Enrico. 1952. "Monete Bizantine ninvenute Siria." *Rivista italiana di numismatica* 54–55:31–49.

Mackensen, Michael. 1984. *Resafa I: Eine befestigte spätantike Anlage vor den Stadtmauern von Resafa.* Mainz.

———. 1986. "Die spätantiken Fundmünzen." In *Resafa II: die Basilika des heiligen Kreuzes.* Ed. Thilo Ulbert. Mainz.

Mansfield, S. J. 1992. "A Byzantine Irregular Issue of 'Year 20'." *NCirc* 100:81–82.

Marot, Teresa. 1998. *Las monedas del Macellum de Gerasa.* Madrid.

Metcalf, D. M. 1964. "Some Byzantine and Arab–Byzantine Coins from Palaestina Prima." *INJ* 2:32–46.

———. 2003. *Coinage as Evidence for the Changing Prosperity of Cyprus in Byzantine and Medieval Times.* Nicosia.

Metcalf, William. 1975. "A Heraclian Hoard from Syria." *ANSMN* 20:109–37.

———. 1980. "Three Seventh-Century Byzantine Gold Hoards." *ANSMN* 25:87–108

Metlich, Michael, and Nikolaus Schindel. 2004. "Egyptian Copper Coinage in the 7th Century AD: Some Critical Remarks." *ONS Newsletter* 179:11–15.

Mettens, Astrid. 2004. "Horbat Nashe." *HA-ESI* 116.

Meyers, Eric, and Carol Meyers. Forthcoming. *Excavations at Ancient Nabratein: Synagogue and Environs.* Winona Lake, IN.

Michalowski, Kazimierz. 1962. *Palmyre—Fouilles Polonaises 1960.* Warsaw.

Miles, George. 1948. "Islamic Coins." In *Antioch.* Vol. 4.1, *Ceramics and Islamic Coins.* Ed. F. Waagé. Princeton. 109–24.

———. 1958a. "The Earliest Islamic Bronze Coinage of Egypt." In *American Numismatic Society Centennial Publication.* Ed. Harald Ingholt. New York. 471–502.

———. 1958b. "Catalogue of Islamic Coins." In *The Excavations at Herodian Jericho 1951.* Ed. James Pritchard. New Haven. 29–41.

———. 1967. "The Earliest Arab Gold Coinage." *ANSMN* 13:205–29.

Milne, J. G. 1947. "Report on the Coins Found at Antinoe in 1914." *NC,* ser. 6, 7:108–14.

Milstein, Rachel. 1989. "A Hoard of Early Arab Figurative Coins." *INJ* 10:3–26.

Mitthof, Fritz. 2002. *Corpus papyrorum Raineri archiducis Austriae XXIII: Griechische Texte XVI: neue Dokumente aus dem römischen und spätantiken Ägypten zu Verwaltung und Reichsgeschichte.* Vienna.

Moorhead, T. S. N. 1997. "The Late Roman, Byzantine and Umayyad Periods at Tel Jezreel." *Tel Aviv* 24:129–66.

Morrisson, Cécile. 1972. "Le trésor byzantin de Nikertai." *Revue belge de numismatique* 118:29–91.

———. 1980. "Les monnaies." In "Déhès (Syrie du nord) campagnes I–III (1976–78): Recherches sur l'habitat rural." Ed. J. P. Sodini et al. *Syria* 57:267–87.

———. 1992: "Le monnayage omeyyade et l'histoire administrative et économique de la Syrie." In *La Syrie de Byzance à l'Islam.* Ed. Pierre Canivet and Jean-Paul Rey-Coquais. Damascus. 309–21.

———. Forthcoming. Contribution to *Le Proche-Orient de Byzance aux Abbassides: Peuplement, villes et territoires, sanctuaires chrétiens.* Ed. A. Borrut et al. Paris.

Naghawi, Aida. 1989. "Umayyad Filses Minted at Jerash." *Syria* 66:219–22.

Napoleone-Lemaire, Jacqueline, and Jean Balty. 1969. *L'église à atrium de la grande colonnade.* Fouilles d'Apamée de Syrie I.1. Brussels.

Nègre, Arlette. 1984. "Monnaies orientales des maisons d'Apamée: Étude comparative." In Balty 1984. 249–58.

Noeske, Hans-Christoph. 2000. *Münzfunde aus Ägypten.* Vol. 1, *Die Münzfunde des ägyptischen Pilgerzentrums Abu Mina und die Vergleichsfunde aus den Diocesen Aegyptus und Oriens vom 4.–8. Jh. n. Chr.* Berlin. In 3 parts (volumes).

———. 2006. *Münzfunde aus Ägypten.* Vol. 2, *Griechisch-römischen Münzfunde aus dem Fayum.* Berlin.

———. Forthcoming (2009). "Finds of Coins and Related Objects from the Monastery of Apa Shenute at Suhag." Part 3 of "Second Report on the Excavation of the Supreme Council of Antiquities in the Monastery of Shenute at Suhag in Upper Egypt." By P. Grossmann et al. *DOP* 63.

Oddy, Andrew (W. A.) 1987. "The 'Constans II' Bust Type of Arab–Byzantine Coins of Hims." *RN,* ser. 6, 29:192–97.

———. 1991. "Arab Imagery on Early Umayyad Coins in Syria and Palestine: Evidence for Falconry." *NC* 151:59–66.

———. 1995. "Imitations of Constans II Folles of Class 1 or 4 Struck in Syria." *NCirc* 103:142f.

———. 2003. "The Christian Coinage of Early Muslim Syria?" *Aram* 15:185–96.

———. 2004a. "The Twin Standing Caliph Fals." *ONS Newsletter* 179:10f.

———. 2004b. "Whither Arab–Byzantine Numismatics? A Review of Fifty Years' Research." *Byzantine and Modern Greek Studies* 28:121–52.

———. 2004c. "A New Proto-Umayyad Mint in Syria?" *NC* 164:236–40.

Olster, David. 1993. *The Politics of Usurpation in the Seventh Century.* Amsterdam.

O'Sullivan, Shaun. 2004. "Sebeos' Account of an Arab Attack on Constantinople in 654." *BMGS* 28:67–88.

Palme, Bernhard. 2002. *Corpus papyrorum Raineri archiducis Austriae.* Vol. 24, *Dokumente zu Verwaltung und Militär aus dem spätantiken Ägypten.* Vienna.

Palmer, Andrew. 1993. *The Seventh Century in the West-Syrian Chronicles.* Liverpool.

Papanicolaou-Christensen, A., et al. 1986. *Hama.* Vol. 3.3, *The Greco-Roman Objects of Clay, the Coins and the Acropolis.* Copenhagen.

Petry, Carl, ed. 1998. *The Cambridge History of Egypt.* Vol. 1, *Islamic Egypt 640–1517.* Cambridge.

Phillips, Marcus. 2005. "Islamic Legends on Pre-reform Coins of Ṭabariya." *XIII Congreso Internacional de Numismatica, Madrid 2003, Actas.* 1:1631–37.

Phillips, Marcus, and Tony Goodwin. 1997. "A Seventh-Century Syrian Hoard of Byzantine and Imitative Copper Coins." *NC* 157:61–87.

Ploug, G., et al. 1969. *Hama.* Vol. 4.3, *Les petits objets médiévaux sauf les verreries et poteries.* Copenhagen.

Pottier, Henri. 2004. *Le monnayage de la Syrie sous l'occupation perse.* Paris.

Pottier, Henri, and I. and W. Schulze. 2008. "Pseudo-Byzantine Coinage in Syria under Arab Rule (638–c. 670)." *Revue Belge de Numismatique.*

Qedar, Shraga. 1985. "A Hoard of Monetary Reform Fulus." *INJ* 8:65–75.

———. 1989. "Copper Coinage of Syria in the Seventh and Eighth Century A.D." *INJ* 10:27–39.

Robinson, Chase. 2005. *Abd al-Malik.* Oxford.

Rodziewicz, Mieczyslaw. 1984. *Les habitations romaines tardives d'Alexandrie: à la lumière des fouilles polonaises à Kôm el-Dikka.* Warsaw.

Saller, Sylvester. 1957. *Excavations at Bethany (1949–1953).* Jerusalem.

Scanlon, George. 1981. "Fustat Expedition, Preliminary Report, 1972 Part I." *JARCE* 18:57–84.

Schindel, Nicolas. 2005. "A New Arab Byzantine Coin Type." *ONS Newsletter* 182:7–11.

Schulze, Wolfgang. 2007. "A Hoard of Seventh Century Folles Found Near Aleppo." *NC* 167:27–76.

Schulze, Wolfgang, and Tony Goodwin. 2005. "Countermarking in Seventh Century Syria." *Supplement to ONS Newsletter* 183.

Schulze, Wolfgang, Ingrid Schulze, and Wolfgang Liemenstoll. 2006. "Heraclian Counter-marks on Byzantine Coins in 7th Century Syria." *Byzantine and Modern Greek Studies* 30:1–27.

Sears, Stuart, and Donald Ariel. 2000. "Finds of Late Sasanian and Early Muslim Drachms in Historical Palestine." *'Atiqot* 40:139–50.

Sheedy, Kenneth, et al. 2001. *Pella in Jordan, 1979–1990: The coins.* Sydney.

Sijpesteijn, Petra. 2007. "The Arab Conquest of Egypt and the Beginning of Muslim Rule." In *Egypt in the Byzantine World, 300–700.* Ed. Roger Bagnall. Cambridge. 437–59.

Smith, Robert Houston. 1973. *Pella of the Decapolis.* Wooster, Ohio.

Stacey, David. 2004. *Excavations at Tiberias, 1973–1974: The Early Islamic Periods.* Jerusalem.

Stratos, Andreas. 1968–1980. *Byzantium in the Seventh Century.* 5 vols. Amsterdam.

Strus, Andrzej. 2003. *Khirbet Fattir—Bet Gemal.* Rome.

Syon, Danny. 2002. "A Hoard of Byzantine Solidi from Hurvath Kab." *INJ* 14:211–24.

———. 2004. "Bet She'an." *HA-ESI* 116.

Tabari. 1987–1990. *The History of al-Tabari: An Annotated Translation.* Vols. 18–22. Albany.

Theophanes. 1997. *The Chronicle of Theophanes Confessor.* Tr. Cyril Mango and Roger Scott. Oxford.

Treadwell, W. L. 2000. "The Chronology of the Pre-reform Copper Coinage of Early Islamic Syria." *Supplement to ONS Newsletter* 162.

Tushingham, A. D. 1985. *Excavations in Jerusalem 1961–1967.* Toronto.

Tzaferis, Vassilios. 1983. "The Excavations of Kursi-Gergesa." *'Atiqot* 16 (entire issue).

Vorderstrasse, Tasha. 2001. "Coin Circulation in Some Syrian Villages." In *Les villages dans l'empire byzantin.* Ed. J. Lefort et al. Paris. 495–510.

Waagé, Dorothy. 1952. *Antioch.* Vol. 4.2, *Greek, Roman, Byzantine and Crusaders' Coins.* Princeton.

Walker, John. 1941. *A Catalogue of the Arab-Sassanian Coins.* Catalogue of the Muhammadan Coins in the British Museum 1. London.

———. 1956. *A Catalogue of the Arab–Byzantine and Post-Reform Umaiyad Coins.* Catalogue of the Muhammadan Coins in the British Museum 2. London.

Walmsley, Alan. 1987. *The Administrative Structure and Urban Geography of the Jund Filastin and the Jund al-Urdunn.* PhD dissertation. University of Sydney.

Waterman, Leroy. 1937. *Preliminary Report of the University of Michigan Excavations at Sepphoris, Palestine in 1931.* Ann Arbor.

Wightman, G. J. 1989. *The Damascus Gate, Jerusalem: Excavations by C.-M. Bennett and J. B. Hennessy at the Damascus Gate, Jerusalem, 1964–66.* BAR International Series 519. Oxford.

Wilson, J. F. 1989. "The Bronze and Silver Coins." In *Excavations at Capernaum.* Vol. 1, *1978–1982.* Ed. Vassilios Tzaferis. Winona Lake, IN. 139–79.

PHOTO CREDITS

Illustrations in the first part are set at 1.5 times the actual size of the object unless otherwise specified. Illustrations in the catalogue depict the coins' actual size. All coins illustrated are in the Dumbarton Oaks collection, except for the following:

American Numismatic Society: 41 top, 68 bottom

Ashmolean Museum, Oxford: 41 bottom, 65, 66 top, 68 top

Clive Foss: 36, 71 bottom

Israel Antiquities Authority: 33 bottom

Andrew Oddy: 29 top, 32, 41 bottom, 44 bottom, 47 bottom

Shraga Qedar: 60

Tony Goodwin: 14, 29 bottom, 30, 31 top, 46 top, 48 bottom, 62, 66 bottom, 101 top and bottom